The Photojournalist's Guide to Making Money

MICHAEL SEDGE

Foreword by Rohn Engh

ALLWORTH PRESS
NEW YORK

05 04 03 02 01 00 5 4 3 2 1

Published by Allworth Press
An imprint of Allworth Communications
10 East 23rd Street, New York, NY 10010

Cover design by Douglas Design Associates, New York, NY

Page composition/typography by SR Desktop Services, Ridge, NY

ISBN: 1–58115–076–8

Library of Congress Cataloging-in-Publication Data:
Sedge, Michael H.
The photojournalist's guide to making money / Michael Sedge; foreword by Rohn Engh.
 p. cm.
Includes index.
ISBN 1-58115-076-8
 1. Photojournalism. 2. Photography–Business methods.
 3. Photographs–Marketing. I. Title.

TR820 .S37 2000
070.4'9'0688–dc21 00-050298

Printed in Canada

Contents

Dedication

Early in my career, I established a small stock photo agency in southern Italy. I'd like to dedicate this book to the photographers who had confidence in me and my dreams at that time: Ken Cole, Gerard Fritz, Norman Mosallem, Guido Picchetti, Ted Salois, Bob Schwartz, Robert Wickley, and last—but actually the first—Bob Zehring.

Among my happiest memories are writing commission checks for each of these talented professionals.

Foreword

by Rohn Engh

FOUNDER AND DIRECTOR, PHOTOSOURCE INTERNATIONAL

To make money at anything, you need two elements: a good product and someone who wants to buy it.

Let's assume you have the first—that's the easy part (as you'll learn in this book). Finding the second part is easy too—if you love what you're doing. If wild horses can't pull you away from photojournalism, you can succeed by following the tenets Michael Sedge puts forth in *The Photojournalist's Guide to Making Money.*

Michael doesn't show you how to take effective photojournalistic pictures. You already know that. He shows you how to make a good living in a profession you love. The practical and power-packed insights that he shares with you are the fruits of his quarter-century of succeeding at his profession. You can be sure his path has included falling, picking himself up, and moving "onward and upward." Michael shares these experiences with you and shows how to avoid pitfalls—and also looks ahead at the portents for photojournalism as we all break ground in a new territory—the Internet.

Marketing, a word that has mushroomed in prominence in the last half century, has come to mean not "selling," but placing your product convincingly to reach those who would be most receptive to buying it. This difference in emphasis is appealing to those in creative fields who find it difficult to "hard-sell" their work.

As a photojournalist, Michael Sedge clears many marketing barriers away for you, and effectively shows you how your photojournalism can be shared with millions and how you can make sure you are paid fairly for it. He shows you how to step off the treadmill of "single sales," and instead multiply yourself, sliding into a world where your photographic efforts are rewarded twenty- and thirty-fold through the process of syndicating yourself.

Michael shows you how you can harness the World Wide Web to accelerate this process, making it possible for you to be in many places at the same time.

Photography is a universal language that is understood by everyone. No longer do you need to lease your photos and stories to single markets for fees that actually *restrict* your sales (because many markets can't afford them). He shows you techniques that he has developed, tested, and mastered over the years to get your product (yes, you are a *producer* of a *product*) "out there" and available to a worldwide audience.

Will you end up driving a Rolls Royce as a result of this book? Probably not. But you can learn how to be rewarded amply in a profession you enjoy, and live a satisfying life in the process. You have the choice of joining that rare category of people who truly enjoy their profession and would never choose to retire from it.

As a photojournalist, you are recording and commenting on life around you. Your photos and articles will not only serve to support you and your family, but serve as documentation for future generations. In a sense you become a historian commenting on the world as you see it. Eventually, your photos will go into archives that will become useful to future generations.

They will also serve as an annuity for you and your grandchildren. This brings to mind a friend, Flip Schulke, a photojournalist in the 1960s who captured the political turmoil of those times in the United States. In addition to photographing the demonstrations and strife that many other photographers were capturing, Flip sensed the significance of an emerging political figure, Dr. Martin Luther King, Jr. He looked deep into Dr. King's life, befriended Dr. King and his family, and captured many intimate moments in their home life and informal vignettes, revealing the impact of the times on this family.

At first, Flip's photos rarely interested photo buyers. The buyers were more interested in coverage of the riots, murders, and demonstrations. Not until twenty years later did Flip Schulke's photos begin to sell. Now they are featured on PBS specials, on CD-ROM's, in made-for-TV movies, and in museums and universities. Much of his photo coverage is available to students in colleges and high schools in the form of new media products.

Flip never envisioned that his interest in Dr. King and his family would still provide him with a stream of annual income nearly fifty years after he made his photographs.

This is one—albeit special—example of what can happen as a result of your role as a commentator on and historian of your times. How do you measure success in the field of photojournalism? As in most creative fields, it cannot be measured by monetary gain, the size of your house, or the degrees you have acquired. A personal assessment can be the only measurement.

This book will help you forge your own directions. Photojournalism is not immune to the politics and hierarchies that usually develop in any professional community. Over the years, the field of photojournalism and the range of journalistic concerns have evoked almost a religious fervor among photographers and photography groups.

In this book you'll encounter the many faces of photo-journalism. They range from blue-collar, down-to-earth, no-name photographers, tramping around the globe, to elitist, holier-than-thou peacocks, protecting their territory.

Michael Sedge will show you the path. Your own ambition and persistence will lead you to your goals.

I

It's More Than Photography

There are tens of thousands of individuals in the world today calling themselves photojournalists. But what exactly does that term mean? Is a portrait photographer a photojournalist? Is the travel writer who picks up extra cash with her camera a photojournalist? Is the photographer on assignment for *Family Circle* a photojournalist? Or is this an elite group peopled exclusively by hardcore news photographers like those employed by the Associated Press, Reuters, *Newsweek,* or one of the global stock agencies such as Blackstar, Gamma-Liaison, and Sygma?

Here's a paraphrase of what the editors of *Webster's New Word Dictionary* consider to be a . . .

pho·to·jour·nal·ist *n.* a journalist who presents news stories mainly through photographs.

While I agree that most news photographers are, indeed, photojournalists, I disagree with the limitations that *Webster's* editors have established. Today's photojournalists, I believe, have a much broader base—one that goes far beyond news.

It's my belief that any photographer who tells a story with his or her images amounts to a photojournalist. This includes the studio photographer who captures the telling expression of his subjects, the *Family Circle* photographer who visually portrays the making of a recipe, and the travel photographer who brings to life the city of Hong Kong through graphic pictures. Each conveys a message. Each visually tells a story. And that, my friend, is what a photojournalist is all about.

Or is it?

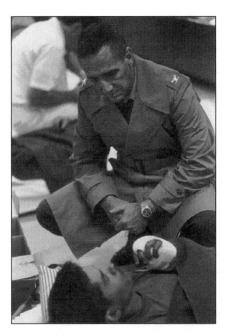

Telling a story with images—that is what photojournalism is all about. This picture of a U.S. Navy chaplain appeared in newspapers around the world following the bombing of the U.S. Marine barracks in Beirut.
© *Strawberry Media*

In addition to talent, every top photojournalist today has a passion for his or her craft. Capturing history, beauty, and aspects of life that tell a story is, for them, enjoyment, not work. Take, for instance, Katharina Hesse, whose images of the fiftieth anniversary march in Tiananmen Square, China, graced the special millennium issue of *Newsweek International*.

"I've spent the last few years photographing everything from military parades to punk rock bands," she says. "And I've never been bored."

But in today's competitive marketplace, is a love for one's work enough? Is the drive to create visual stories sufficient to make one successful? The answer to this question is, quite honestly, *no*.

Let me explain. There is a clear difference between photojournalism as a "hobby" and photojournalism as a "profession." Those seeking to be included in this latter category cannot rely on their talent alone. Today's professionals must also be business people, marketers. They must understand customer needs and satisfaction, packaging and delivery, product strategy, and methods of expanding their business while, at the same time, promoting themselves.

Photojournalism must become your "business," not your "job."

Many, including myself, will also argue that photojournalists must also be writers. The craft of writing, as well as photography, is part of the curriculum of many of today's top photojournalism schools, such as University of Missouri, Syracuse, and Northwestern. According to one professor, "The word *photojournalism* has two parts—*photo* and *journalism*—in it, and the two can never be extracted from one another. Words are as essential to the life of photojournalism as is the photo."

This concept can well be applied to marketing. For whenever one can offer more than one service—writing *and* photography—one's value increases, particularly for editorial customers. So do not try to isolate the "photo" aspect of photojournalism. Focus, rather, on a harmonious working relationship whereby you are both literary and visual.

If you've been working in the field of photojournalism for any length of time, you might be thinking that you have already achieved a fair level of success or professionalism. A good way to test this is surfing the Internet. Using one of the many search

engines—Yahoo!, Altavista, Hotbot, Mamma, etc.—run a search for your own name. How many "hits" did you get? If your name came up forty-five times or more, you're enjoying fair success. If not, then you need to strive a bit harder to promote both yourself and your work.

Another test, this time to see if you have the right frame of mind for the business of photojournalism, is to look at last year's tax return. What did you list as your occupation? If it says "photojournalist," "photographer," "journalist," or anything similar, then you still have a ways to go. On the other hand, if you classified yourself as a "self-employed business" you are on the right track.

I began my own photojournalism career nearly twenty-three years ago as a stringer for *Newsweek* and Time-Life. Since then, I've sold thousands of images to editorial clients around the world. I have owned and operated two stock photo agencies and provided photographic services to major corporations like Bank America, Holiday Inn International, MCIWorldcom, McDonald's Systems, and Mobil Oil.

Despite these accomplishments, I am the first to admit that my work is probably inferior to 70 percent of today's professional photographers. What makes me successful, however, is my organizational, business, and marketing skills.

Entrepreneur magazine once called me "a "wizard of marketing." My appearance in this nationally distributed publication came as a result of a self-promotion campaign that I began in hopes of gaining exposure for my business. In turn, I was able to use the magazine's quotes and article to further propel my career. This ultimately brought me to, among other things, a high-paying, seven-year contract with MCIWorldcom.

In writing *The Photojournalist's Guide to Making Money*, my intent was never to create a book of photographic techniques; there are hundreds of such volumes already lining the shelves of libraries and bookstores. I therefore assume that you already possess the equipment and skill required to be a profes-

sional photojournalist. As such, my goal in the chapters ahead is to provide step-by-step guidelines that will allow you to establish yourself as a photojournalism *business*—and it *is* a business.

> *Photographers striving to be successful in the free-lance arena must represent their talents as a service organization. Magazines, book publishers, and even stock photo firms are much more willing to work with photographers who are serious about their craft and give the impression that photography is their full-time career. Simple and inexpensive steps to achieving this goal include setting up a D.B.A. [doing business as, company], obtaining a business checking account, and printing letterhead and business cards . . . and securing a separate [business] phone line and a fax machine . . . I run two Web sites from my bedroom and most of the publishing industry assumes that we are a huge conglomerate. Portraying your operation as a professional services firm establishes you as a expert in your field which, of course, results in more clients and higher revenues.*
>
> —ANGELA ADAIR-HOY, PUBLISHER, BOOKLOCKER.COM

Through real-life examples and illustrations—both from my own experience and that of other successful photo entrepreneurs—you will pick up business techniques, tips, and tricks to give you a competitive edge over the competition. Using this knowledge as a base, you'll be able to develop and fine-tune your own business and marketing skills.

We'll also explore traditional requirements for any company, such as legal matters, business structures, accounting, and taxes.

Business: Seventy Percent of Success

Granted, without the proper "product" (in this case, your images), no business can survive. At the same time, though, being a good marketer can account for more than 70 percent of

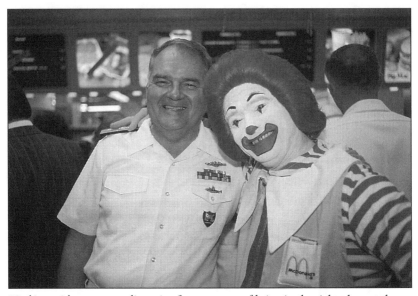

Working with corporate clients is often a matter of being in the right place at the right time. Photojournalist Bob Schwartz teamed up with the Strawberry Media Agency for this shoot for McDonald's Systems Europe. © Strawberry Media

your success as a photojournalist. Let me give you an example. How can you break into editorial markets when competing against internationally known stock houses? That's a question many photographers have asked themselves. It was also the dilemma I faced, nearly twenty years ago, as the owner of the Strawberry Media Agency. While I considered several possibilities, I eventually developed the so-called "unsolicited package" technique, which has since gotten my foot into many tightly closed doors.

In the mid-1980s, while operating a small stock photo agency, I was looking for a way to undermine the success of the competition like Allsport Photographic and Bruce Coleman and, in turn, to increase my company's clientele and income. Realizing that I could not go head to head with these giants of the stock business, I had to come up with innovative ways to win

the confidence of prospective customers. I figured that there were two ways to achieve this goal: (1) provide lower rates; and (2) get to the photo buyers before they realized they needed a stock image.

To accomplish the first step, I established a company policy, which I enshrined in a marketing slogan: "We work under *your* terms." In other words, we began selling our stock images at the customer's established "freelance" rates. Editors and art directors could now get stock variety and quality and still maintain overhead costs at reasonable levels.

This put us one step ahead of other companies that offered images at fixed rates, often much higher than publications normally paid for freelance submissions.

I next started submitting monthly, unsolicited image packages to editorial clients—an unprecedented ploy. These were not completely "cold call" submissions, however. First, I focused on smaller, non-news publications, such as travel, general interest, and specialty markets. Why? Based on my experience, these periodicals normally determined their editorial calendars far in advance and could provide us with a list of articles and special issues they were planning for the entire year. Working from these lists—provided on request from the editors or art directors—we were able to pull a selection of strong images, which on their own told a story, and send a monthly package to fit the client's specific needs.

When sending out images, we took into consideration the editorial lead time for each magazine. We also took great care in professional packaging, including a presentation folder (with our company logo, telephone numbers, address, etc.), a cover letter explaining our offer, and images divided by topic in new, plastic holders, with captions.

After one year, we had sold nearly 300 images to the four publications we'd selected for the "unsolicited package" test. This included a couple of international clients. In addition to stock sales, we'd also received several specific assignments once

the clients became familiar with our service. As a result of our efforts, we boosted our income from these periodicals during this period by nearly 1,000 percent.

Needless to say, we continue to offer unsolicited packages and work on "the client's terms."

While all of this sounds good, and it is, what did I actually do here? This is what you should begin asking yourself. You should start thinking about your own marketing strategies, analyzing successful marketing campaigns used by others, and then start contemplating how you can apply the same techniques to your own photojournalism business.

In the case above I used several marketing methods, always to the customer's benefit:

1. I began by reaching the market, obtaining lists of their long-term editorial schedules.
2. I filled the customer's need by providing images they required, when they needed them.
3. I provided good customer service—no obligation, no minimal fees or handling charges.
4. I presented and delivered our "products" professionally.
5. I beat out my competitors by staying one step ahead of them.
6. I created a "name" and "reputation" for my company, resulting in increased business.
7. The overwhelming volume of clips garnered in this one-year period provided an excellent base for media kits to be sent to other potential markets. The overall message here: Recycle promotional materials and use each success as a stepping-stone on the way to new business.

Working smart, operating like a business, playing the marketing game, and making it a continuous challenge are what successful photojournalism is all about. So hop aboard the train. You're

about to take a journey into *The Photojournalist's Guide to Making Money.* It's a fascinating tour, full of provocative concepts and possibilities—a tour where almost anything is possible and nearly any goal can be reached. The only limitations will be those you establish for yourself, because the proven techniques for making money with your camera are here for you to exploit. So go ahead, turn the page, and welcome to my world . . .

Robert Wickley, long-time Air Force photojournalist, captured these theater actors. This image was sold to several publications, including R&R Magazine, *Germany.* © Strawberry Media

2

The Business Image

In 1978, my first images appeared in *Off Duty Europe*, a giveaway magazine distributed to U.S. military installations overseas. Upon first seeing my work in print, I experienced an immediate "high," which, I now realize, most photographers experience at such moments. I still feel this emotion each time I see my byline on a printed image, article, or book.

Like many photojournalists, I took that initial sale—all of $82.50—as a sign of success, and proceeded to submit new material to newspaper and magazine editors across the country. Eighty-two rejections later, I decided that something was definitely wrong with my approach and that my *Off Duty* sale had been a mere fluke. While wrong about the latter, I was correct in the assessment of the way I was doing business.

Fortunately, for me, I encountered Charles Leocha at this point in my career. Charlie was publishing a digest-sized magazine at that time, called *New Entertainer*, for the U.S. and NATO military communities in Naples, Italy. I learned many things from Leocha—who has since gone on to become a successful

book publisher—and eventually worked for him as an associate editor. Without a doubt the greatest of these lessons was that you must operate like a business if you are to be successful. In today's competitive marketplace, it is not enough to simply be a "freelance" photographer. You must also be the chief executive officer, the sales and marketing manager, the accountant, and the secretary. But most important, you must "think" like a business rather than an individual.

I specifically recall one morning in the offices of *New Entertainer*, when a would-be publisher by the name of Ramon Hernandez asked Leocha how many people it took to start a magazine. His reply: "One, as long as the individual is business-minded."

Years before, Charles Leocha had established himself as World Leisure Corporation. His letterhead, his business cards, his invoices, and his product all projected the World Leisure Corporation name and logo. Therefore, while conducting day-to-day business with Leocha, clients felt they were dealing with the large, international, World Leisure Corporation conglomerate. All of this based on a name and business structure.

All individuals, including photo buyers, want to do business with stable, professional people. Working under the umbrella of a company provides potential clients with a sense of security, false as it may be. It is this psychological illusion that you, as a photographer, must appeal to if you are to be successful.

Following Leocha's advice, and lessons from a few adult-education business courses, I transformed my freelance operation into an editorial service business under the name of Strawberry Media, Inc. (Yes, there is a reason for the name. I live in the southern Italian city of Afragola, which, in Italian, means the "land of strawberries." Believe it or not, some clients have picked up on this. And those who do not, always seem to remember the "strawberry man.")

Because I am also a writer and operate a stock photo agency, my letterhead, business cards, and presentation folders—in which all submissions are delivered—became instant

marketing tools, carrying the logos for Strawberry Media Photos and Strawberry Media Editorial. In recent years, my business has expanded to include Strawberry Media Promotions and Strawberry Media Communications. While my mainstay has always been photography and writing, simply listing these alternative services has greatly increased my annual income through advertising and marketing work.

The long-term goal of any good business plan is to consistently expand your market share. As such, don't hesitate to diversify your services whenever possible, whether you start offering corporate images, portraits, or even lecturing and teaching. Your clientele should grow according to the growing number of services you offer and the projected size and appearance of your business. I began working for regional magazines, for example, and ultimately landed such clients as the Associated Press, AT&T, Bank America, Newsweek, the Discovery Channel, and Time-Life.

When **Off Duty** *magazine contacted the author, asking for images to illustrate the magazine's Christmas fragrances special, he inquired which brands would be advertising in that issue. He then highlighted these fragrances in his studio shoots—filling the customer's need, as well as pleasing the advertisers.* © *Strawberry Media*

Because I live in Europe, I also list two business address-es—my own, and that of my parents, in Tennessee. Suddenly, in the eyes of potential clients, I operate not only a multiservice company, but an impressive international agency as well. That is exactly the impression I want them to have.

One of the primary reasons to operate under a business title rather than your own name is image. When you reach a certain level of professionalism, image plays a major role in your success, or lack of it. I received my first assignments from the Discovery Channel and *Newsweek* because they were looking to contract a professional business rather than an individual freelancer. According to one editor, "Our executives and accounting people feel more comfortable dealing with businesses."

For most photographers, operating as a sole proprietor is the easiest business structure. Because your marketing goal is to appear as large as possible, however, you may want to look into other company structures. A perfect example of a freelance-photographer-turned-business is Robert Zehring, a former NASA public affairs officer who once told me:

> I discovered years ago that the top picture buyers of the world seem more comfortable dealing with a business, rather than some freelancer. Here I was with some of the world's finest images of space, Antarctic expeditions, active volcanoes, and the World War II aircraft sunk in the Pacific Truk Lagoon, and I could not sell them because I was merely "another freelancer." Once I became a "photographic business" and presented my services and stock as such, clients began to come in.

When selecting a business title, you may want to consider a name other than your own—though many of today's top-rated corporations began as family names. Look into names that would have global impact, something that will stand up in the

second millennium. By example, review some of the multinational company names being used today—CNN International, Image Bank, MSNBC, News Blitz International, United Press International—for inspiration and ideas. I also suggest a flashy, eye-catching company logo.

More information on how you can set up a sole proprietorship in your state, including the D.B.A. (doing business as) rules can be obtained by calling or visiting your local chamber of commerce and/or better business bureau.

Many independent business people, including myself, have opted to work as corporations. To most people, for example, Jack Ryan Enterprises, Inc., means very little other than the fact that it is a corporation. If I told you that this company owns the copyright to such works as *The Hunt For Red October, Clear and Present Danger,* and *Red Storm Rising,* you would probably realize that Jack Ryan Enterprises, Ltd., is, by another name, none other than Tom Clancy. In a 1996 interview, Clancy explained to me that his pre-bestseller life as a financial consultant provided him with a better understanding of business than most freelancers possess.

Andrew Rosenbaum, another independent contractor, specializes in European business and Web site work and operates under the corporate title of Allegra Communications. "It offers considerable fiscal and business advantages," he says. "One has much more flexibility in handling social security and taxes. And clients process invoices from companies differently than those of sole proprietors. Since I do a lot of international work, it simplifies payment."

Personally, I have owned and operated three companies during the past twenty-two years. While paperwork does increase when you incorporate, you also receive certain liability protection with this type of business—particularly as you expand and become more successful. It is extremely simple to set up a corporation, including state and federal registration. In fact, it can be done by phone or on the Internet. Two organiza-

tions offering this service—both of which I have used and highly recommend—are Delaware Registry, Ltd. (800-321-2677) and The Company, Corp. (800-542-2677). Internet users can request information through the appropriate Web sites at *www.delreg.com* and *www.ftsbn.com/~incorporate/the company_ corporation.htm*. You can also request information by e-mail at *corp@delreg.com* and *companycorp@ftsbn.com*.

If you do decide to incorporate, be sure you fully understand the five types of business structures under this system and select the right one for you. The advisers of Delaware Registry, Ltd., and The Company, Corp., can explain each of these.

Another alternative, which fits the needs of many photographers, is the limited liability company (LLC). As one business owner put it: "I like that there are no corporate taxes to calculate and pay. And the big plus is that our private assets are protected and separate from the LLC."

A business front is often the only thing separating a "freelance" photographer from today's top corporate clients. Establishing yourself as a business should therefore be a priority in your marketing strategy. Once this is accomplished you can better focus on the challenge of dazzling new clients with your work and coming up with creative techniques to sign them up. The key factor, for now, is beginning to think of yourself as a business. For that is what you are, or should be. With this mentality and the advice that follows, your success will surge like a river that has reached the open sea. Dan Poynter, owner of Para Publishing, put it very simply when he said, "Having a business is just good business."

Internet users can find general small business information, including answers to common questions and 675 searchable pages, at *www.bizproweb.com*. Other sites that offer helpful tips and guidelines for home businesses include *www.bizoffice.com* and *www.smartbiz.com*.

More Business Stuff

As a business, you'll have to take into consideration factors like office space, equipment, communications, banking, record keeping, and taxes. Photographers—and generally most independent business people—do not enjoy this aspect of the job, but it must be done.

The first thing you'll learn is that receipts are a must. You can write nearly every expense you incur off your taxes, as long as you have the expense documented with a receipt and logged properly into your accounting records. For accurate record keeping, I have found Microsoft's *Money* software program to be both user-friendly and sufficiently sophisticated to handle most accounting tasks required by a small business.

To ensure your success as a business person, the first thing you must realize is that the world operates on invoices. In recent years, in fact, there has been an increasing trend among editorial picture-buyers to require that bills be submitted before payments are issued for images used.

Again, you must remember the big-business image. Forget that you are dealing with individuals and maintain a business-to-business perspective. As the British National Union of Journalists suggests in its annual Freelance Fees Guide, "Unless the client you work for operates a system of self billing, you should invoice promptly for the work done; without an invoice, a client may not even know that payment is due."

This happened to me with *Holiday* magazine. I provided a selection of images and accompanying text, which was quickly accepted and published. I waited for payment. Thirty days passed. I waited. After sixty days I called the editor. "Uh, Mike. I'm sorry. We must have lost your invoice. If you fax me a copy, I'll get the payment sent out immediately."

I now include an invoice with all images I send out and bill immediately upon completion of assigned work.

Banking

Establishing a business bank account is also a must. Before doing this, shop around and compare fees. Make sure that you get an account that accumulates interest—many banking institutions will offer you a business account, but funds in the account may not earn interest.

If you are working with, or plan to do business with international clients, you will also want to review the check-cashing policies of your bank. In twenty-five years I have had eleven bank accounts in various countries and for different reasons. One reason I changed financial institutions was because the First National Bank of Tennessee insisted on charging me exorbitant rates for cashing international checks (including those from Canada).

What you are looking for is a bank that charges no—or minimal—fees to cash foreign checks. Because some clients outside the United States will offer you the option of payment by international bank transfer, you should ask potential bankers what fees, if any, are charged for such operations.

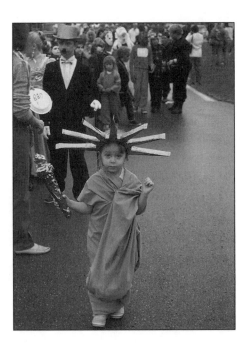

"Miss Liberty" was captured by Robert Wickley, and later sold to Family Magazine *for $75.* © *Strawberry Media*

A few years ago I received a $100 cash transfer from Germany, and the U.S. bank charged me a $25 service fee. By the same token, I transferred $12,000 from my U.S. bank to my Italian account. On the U.S. side, a $120 fee was charged. When the money got to Italy, another $90 was subtracted by the receiving bank.

Bank fees and interest rates are just two considerations when you are shopping for a financial institution. Naturally, you want the lowest possible fees for check cashing and incoming wire transfers and the highest interest rates possible. Another issue that might come up as your photographic business grows is taxes on foreign-earned income.

Taxes

Tax issues on money earned through foreign sources is not all that complicated in the United States, though there are a few items, such as double taxation in some countries, that you should be aware of. For free help, Julian Block, noted expert and author of several best-selling tax books, suggests the following IRS publications: Publication 17, *Your Federal Income Tax;* Publication 334, *Tax Guide for Small Businesses;* and Publication 910, *Guide to Tax Services.*

To obtain these, you can call the IRS, toll-free, at (800) TAX-FORMS. More information and tips on taxes for independent business people can be found at the following Internet Web sites:

www.irs.ustreas.gov
www.dtonline.com
www.hrblock.com/tax/refund
www.1040.com

Perhaps the best advice I can give you regarding business taxes is that provided to me by a syndicated columnist and tax attorney in Larchmont, New York.

Establishing up-to-date records is the first step towards gaining control over your tax tab. Educating yourself on the current tax opportunities and pitfalls can be an important second step. . . . You ought not rely exclusively on paid advisers to keep on top of tax-law changes or other legislation that might make it necessary to revise your plans. At the very least, you should be knowledgeable enough to raise good questions and evaluate answers when you deal with a professional. The informed client gets the best advice.

Legal Considerations for Photographers

While general documentation and licensing is similar for all businesses, there are certain legal considerations unique to photojournalistic and media services. You must, for instance, have a general understanding of property rights, intellectual rights, copyrights, freedom of information, and photojournalistic ethics, in addition to business practices.

One of the foremost organizations offering guidance and assistance in these areas is the National Press Photographers Association (NPPA).

"[These are issues] confronting visual journalists around the world," explained KXAS-TV photojournalist and NPPA President Linda Angelle in a 1999 statement. "Today NPPA has committed to providing its members with information so that they can make the best possible decisions about their rights."

The National Press Photographers Association, founded in 1946, has nearly 11,000 members worldwide, working as newspaper, television, magazine, and freelance photographers, as well as editors and photojournalist educators. They offer an excellent Internet site at *http://metalab.unc.edu/nappa*.

The organization's Business Practices Committee also has a Web site offering a variety of useful information, including: Frequently Asked Questions about Photographer's Rights in Business Relationships; American Society of Media Photographers (ASMP) Copyright Guide for Photographers; Copyright

Web Links; Sample Business Forms; and the Business Practices Committee Annual Report. This information, found at *http://metalab.unc.edu/nppa/biz*, is available to all photographers, not merely ASMP members.

I have found no other site on the Net that offers such complete information for novice and professional photojournalists. For example, under the Copyright Guide for Photographers heading, you'll find step-by-step guidelines under the following categories: licensing, transfer of copyright, work for hire, fair use, copyright and collections, buyouts and all rights definitions, registration information, copyright notice format, and more. The data has been put together in collaboration with the ASMP.

In addition to Internet resources, my bookshelf contains two titles that, for me, no professional photojournalist should be without. The first is *ASMP Professional Business Practices in Photography*. The second is *Business and Legal Forms for Photographers*. If you are going to operate as a company—and you should—than you must understand and comply with business standards and practices (see Appendix A, Business Resources).

Exploring the Waters

Once your business is established, it's time to get into the marketing game. This can sometimes be intimidating and even frightening. To the inexperienced, it's like swimming in unknown waters. In reality, with a well-designed marketing plan and focused target goals, you can slowly explore the waters, slipping in first one foot, then an entire leg, followed by total immersion.

Here's what can happen when total immersion comes too quickly: In 1993, while sitting in on a meeting at MCI Communications, I listened as a marketing executive outlined a $1.2 million idea to bring a free concert to U.S. service members in Europe. After the presentation I suggested testing the concept with a small, target audience; for example, a single base in Germany. If the returns—that is, MCI WorldPhone Calling Card applications—were good, they could then move forward with the

larger production. I suddenly found myself up against the power players of the company, and withdrew quietly.

Six months later, MCI's *Cool, Country, Comedy & Cowboys* road tour—consisting of over 100 people, including Miss USA Kenya Moore, singer Mary J. Blige, country vocal group Pirates of the Mississippi, *Saturday Night Live* comedian James Stephens III, and three members of the Dallas Cowboys football team—hit the streets of Europe. Of the twelve shows, three were ultimately cancelled for lack of sufficient audience. Of the anticipated 40,000 new MCI customers the Washington executive had projected from his "ivory tower," only 1 percent was realized.

Now that, my friend, is frightening!

Our goal, in the pages ahead, is to give you an overview of market planning as well as techniques and methods to best implement your plan. We'll then focus on narrowing your scheme into smaller "action plans," just as battle commanders section off

"Soldier Ready" was sold by the Strawberry Media Agency to several clients, bringing in over $1,500, half of which went to the photographer. © Strawberry Media

their targets and send in teams to each area. This will allow you to test market your strategy before spending a great deal of time and money on methods that, for you, are not successful.

Publishing *Is* Marketing

Whether you realize it or not, if you are a published photographer, you are already on one of the most lucrative roads to self-promotion and marketing. Quite simply, publishing *is* marketing. Any time you get your name in print and viewed by mass audiences, you are becoming better and better known in your field. Most photojournalists, however, fail to capitalize on their published works.

Recently, for example, I was interviewed for *Writer On Line*, an Internet publication for writers. The focus of the story was my experience in international sales and my new book *The Writer's and Photographer's Guide to Global Markets*. A friend and colleague, British author Jeremy Josephs, was also interviewed a few months later. This morning Jeremy wrote saying that, while he agreed to the interview, he was not getting much out of it financially. Obviously, I thought, he was not looking at this golden opportunity through a marketer's eyes.

I sent the following reply: "While you are correct in that the token $50 offered by the publisher hardly seems worth the effort, I was able to turn my story into a money maker. I first used the Internet address of the story as a "signature" at the bottom of my e-mails so clients I communicate with could read about me. Second, I cut a deal with the *Writer On Line* publisher to print a monthly "Going Global with Mike Sedge" column (about 500 words). Using my name in the title will promote "me" each month. The column will also promote my book. Additionally, *Writer On Line* will have a form linked to the column, whereby readers can order the book. The publisher also agreed to host a personal Web page for me, at no cost, and to run a banner on the front page of *Writer On Line* that will also link

to the book order form. Finally, I got him to agree to $75 a column . . . rather than the standard $50." (This latter was a matter of principle.)

Paying for the above services—that is, a personal Web page, a book order page, a banner, and so on—would have cost approximately $4,800 a year. Using the initial article as an introduction, I was not only able to avoid these costs, but reap about $2,400 a year from book sales and the column fees—bringing my total annual savings to $7,200. Then there is the added value of constant Internet exposure, which is hard to put a price on.

Later we'll explore more ways to use your published works as marketing tools—including getting on today's popular radio and television talk shows. For now, however, you should concentrate on "thinking" like a marketer. Opportunities are everywhere. The difference between success and failure is often one's ability to recognize and take advantage of these situations.

3

Marketing Basics

When I was young, growing up in Michigan, I spent many winters constructing giant snowballs. There was something exciting about taking a tiny ball of icy, well-packed snow and rolling it into a boulder too large to budge. In some respects, a photojournalist's career is very similar to creating snowballs. It begins small. As you work and your clientele grows, so does the size of your snowball. The more visibility you achieve, the more work you are offered and the faster the sphere rolls. While most photojournalists continue on a slow, steadily growing path, there are those—albeit very few—who, often to their own surprise, reach a high peak, looking down into a snow-covered valley. For them, a single push sends their tiny snowball effortlessly down the mountainside, picking up momentum, growing as it goes, until it is too heavy to move by a single individual.

Blessed are those whose snowball reaches this stage, for they are in the elite company of such names as Eddie Adams, Robert Capa, Dorothea Lange, W. Eugene Smith, and Henri Cartier-Bresson. At this point in their careers, there is no need

for them to market their work. Others will do it for them. Employment opportunities will fall on them like snowflakes. Some offers they will accept, resulting in even more self-rolling snowballs. Other opportunities will be declined, causing the snow to melt.

> *To make the perfect photograph, and to completely tell the story in that photograph, is the goal of all photojournalists. But unless you can show that photograph to the world it means nothing. Learn to market your work.*
>
> —JOEL E. JACOBS, THIRTY-EIGHT–YEAR
> VETERAN PHOTOJOURNALIST

For most of us "earthbound" photojournalists, however, there is always room for growth—in the form of increased exposure, additional work, career advancement, and greater pay. Your professional snowball may just be starting—small enough to hold in your hand. Or you may already have years of experience and a sphere larger than a basketball. No matter what your individual situation, whether you are a novice or a veteran photojournalist, coming up with and executing effective marketing strategies can launch your career into new heights of exposure and employment.

Just how fast your snowball grows is up to you. Whether it turns at the pace of freezing water, or races forward like a sled on an icy track, depends entirely on you. It is you, and you alone, who will determine whether your career remains a snowball or becomes an avalanche. No one has more interest in your success than you do. So if you do not take a proactive role in promoting your work and yourself, no one else will either.

A photojournalist career without marketing skills is similar to making snowballs with freshly fallen snow: It simply does not work. There is no substance, no packing power. Just as you create a tiny ball, it falls apart, and you find yourself starting all over again.

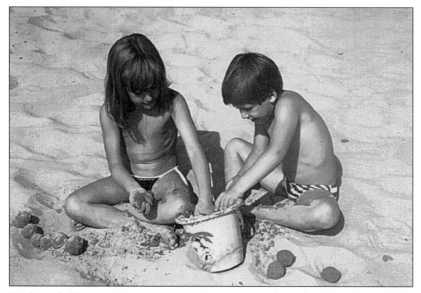

Used as a half-page, color image in Family Magazine, *the author's "Sand Meatballs" has made $524 to date.* © *Strawberry Media*

Understanding the psychology of marketing should therefore be as important to you as your photographic and writing abilities; these two factors—marketing and talent—will determine the future of your professional career. Everything you do to sell your work, from addressing an envelope and printing text and captions, to teaching a local seminar and having lunch with an editor, is marketing.

mar·ket·ing *n.* 1. All business activity required in buying or selling a product or service, including communicating, advertising, packaging, shipping, pricing, etc.

Last week, for instance, and despite protest from my wife, I purchased a new computer. I explained to her that the new machine would allow me to better format, edit, and print my words with varied fonts, thus enhancing the appearance of manuscripts.

Receiving such professional-looking packages, editors would subconsciously have a positive impression of my work even before it was read. This, in turn, would increase my changes of a sale.

There were also other professional functions found in a new computer: better digital imagery, better-quality invoices, accounting software, package tracking programs, and the like.

In short, the new computer was part of my marketing strategy. In addition, I said, the cost could be deducted from our taxes. Whether she believed me or not, I now have a new machine.

College professors will tell you that there are six elements of marketing:

1. Identifying a need
2. Service/product strategy—that is, setting yourself apart from the crowd
3. Informing potential buyers of the product and/or services
4. Packaging and distribution
5. Price determination
6. Customer service

Inasmuch as each of these areas will be discussed at greater length in subsequent chapters, it is sufficient at this point for you to understand the existence of each aspect of marketing. Lacking knowledge in one or more of these categories can greatly damage your chances for both short- and long-term sales. Early in my career, for instance, I was given an assignment by the Japanese magazine *Mini World*. Upon completion, and with a short text, I sent the package to the editor via airmail. A week later, and a day after deadline, the package still had not arrived. As a result, the editor was facing a big problem, my professionalism was questioned, and my services were never called on

again. Why? I had not given serious consideration to the "distribution" aspect of marketing.

In an effort to save money, I had opted to use the postal service over a more costly, but faster and more reliable courier service. Because the work was going to an overseas client, I would have made the deadline, the sale, and, in the long run, probably received future assignments had I utilized Federal Express or UPS delivery. I had broken one of the six rules of marketing and, as a result, my relationship and my future with this publication suffered.

The Psychology of Marketing

Marketing, as we know it today, feeds on the consumer's subconscious desires to be associated with high-quality products and the people who create them. Understanding and properly following the six steps of marketing will go a long way toward generating this positive image between you and your clients. Editors will want to work with you—buying your photo essays and offering assignments when they need a photographer—if you properly market and promote yourself and your work. Not taking the right steps, or doing the job halfway, however, will have just the opposite effect, as illustrated above.

Rohn Engh, photo marketing wizard and author of *sellphotos.com*, says, "Knowledge is useless unless it is applied. That's the first thing novices learn when they venture into the business world. Photographers who succeed do so not because of their knowledge of photography or photo marketing, but because they apply what they know."

Frequently, the level of your success is directly proportional to your dedication to marketing. I personally feel that you should divide your time evenly between creating salable images and marketing—that is, a 50/50 balance. One cannot survive without the other. If a photojournalist is to be prosperous, both marketing and photographic skills are equal important.

I also believe that all photographers should possess some background in marketing. Adult education classes are an excellent source for obtaining such knowledge—in addition to this book, of course. One of the nice aspects of structured courses is that you can immediately apply what you have learned and, within weeks, have positive or negative feedback to share with instructors and fellow students.

One thing that very few, if any, marketing classes teach, however, is that it is all right to fail. This is only natural, since you are paying for knowledge that should lead to success. And yet, failure is part of every marketing campaign. You should not be discouraged by or afraid of failure. Each time your marketing efforts flop, you are building toward future success. You are learning what does and does not work in your specific field. All good business executives hope for total success, but rejoice when 60 percent of their efforts pay off. Perhaps Joseph Heller, in his book *Catch-22*, illustrated this best when he wrote, "Before the war he was an alert, hard-hitting aggressive marketing executive. As such, he was a very bad marketing executive. Colonel Cargill was so awful a marketing executive that his services were much sought after by firms eager to establish losses for tax purposes."

There obviously is a market for everyone and everything.

As a photojournalist, your marketing methods will be unique. We shall focus on various "tricks" of the trade as we move through the pages ahead. Knowing the psychology and techniques behind traditional marketing, however, will allow you to target your own sales efforts, broaden your market base, and build your professional career to a plateau where opportunities will ultimately come to you. This should be your goal. For once you have achieved this level of success, you will find yourself at the zenith of the photojournalism mountain, looking down into that beautiful, snow-covered valley. You then merely need to push your snowball and watch as it effortlessly rolls downward, growing as it goes.

Where Are the Opportunities?

by Phil Norton
Professional Photojournalist
© Phil Norton. All rights reserved.
Used by permission.

The industry is changing so rapidly at this turn-of-the-century that it would be foolish for one to attempt to predict the opportunities of the future with certainty. New technology—from the click of the shutter to printing an image on a page or, now, uploading it to a screen—is revolutionizing the role of the photojournalist every day. New mergers of media ownership—newspaper chains and magazine conglomerates acquiring Internet cable companies and television networks—are blurring the boundaries that have always kept different journalists' roles separate.

If you have a nose for the news and can convey it in pictures (whether still or moving) and in words (whether written or spoken) the opportunities in the new journalism realm are boundless. Remaining polyvalent, and open to using the new *means* of achieving the same *end,* will prevent you from becoming obsolete in a rapidly changing career environment.

Newspapers still offer great experience to enthusiastic, beginning photojournalists. Freelancers are always needed around the big dailies to fill in the gaps when staffers aren't available—for instance, on weekends, holidays, and during summer vacation—and for routine lousy assignments. Internships are also available to students who are instantly thrown into the staff schedule. You are handed all the film you ever dreamed of and access to lenses from 5mm to 600mm.

Trouble is, once you take assignments with the big newspapers, get published, and get paid, there's nothing left for a freelancer—no insurance benefits, no pension plan, and, worst of all, no images. The "work for hire" agreement means your visual creations belong to the company's archive. At best, you may be able to keep the outtakes, the second-best frames; such are the terms with some wire service organizations.

If you're interested in building your own stock photo collection, try shooting for smaller daily newspapers

The washed-out road along the United States–Canada border was shot on assignment for the Montreal Gazette *newspaper. The photographer, Phil Norton, was paid $125 CND, his half-day rate, plus expenses. "Having the official press credentials was the only way I could gain access to the area with a police agent," says Norton. "A life was lost here when a freak summer storm created flash flooding." © Phil Norton*

and community weeklies with the agreement that you buy your own film and keep the negatives and copyright.

I stumbled into photojournalism at my university's daily newspaper (Penn State). It was 1977 and magazines—glossy, color pages, big circulations—not gray newspapers, were where I wanted to be. I had been raised on *Life, Look,* and *National Geographic.* But something led me to shoot a tryout roll of film for the *Daily Collegian.* One of the thirty-six frames—some piglets nosing my wide-angle lens—ran top, front page the next day, and was taped onto dormitory refrigerators, and I was accepted onto the photo staff.

The *Daily Collegian's* assignments took me into every aspect of the college world, from president to ditchdigger. I even got to test my interest in feature writing on full-page photo/text essays. Putting my pictures on those big, broadsheet, black-and-white pages actually excited me as much as a color spread in any magazine could have. I

even relished the occasional $15 checks that were popped into my mailbox. I worked a few freelance jobs for the *Philadelphia Inquirer* and *Us* magazine, getting to use a state-of-the-art laser-photo transmitter once (1979) but, more often, rushing unexposed rolls on the next bus east.

I'm fortunate to have had that taste of the "good old days" of photojournalism, partly because it makes me appreciate today's state-of-the-art digital.

Going completely digital is a *fait accompli* at some newspapers and just a matter of time at most others. Ever since I began working as Stock Photo Administrator at *The Gazette* in Montreal (1996) and using film scanners and digital transmission of images around the world with the click of a mouse, I was convinced that my home darkroom was going to be traded in for a Mac and a modem.

After four years of big investments of money and time, I now have my digital "darkroom." In hindsight, the decision to go digital seems so obvious, but there have been key dilemmas along the way, such as which platform to adopt, Mac or PC; which software to use for archiving; should I scan slides and negs myself, or have the lab scan to Kodak PCD? And, now, digital camera or film camera?

Personally, I am sticking to film for its proven permanence and the fact that every image is saved, not just the "good" ones. It is often the most ordinary or unnoticed person or element in a negative that will be most valuable in the future. With digital cameras, it is not yet practical to archive every outtake. Another issue that arises with digital files once they are sent out: Who created the original? With a negative or slide, case closed.

I came to my present position as Stock Photo Administrator somewhat haphazardly. "Stumbling" my way into journalism at *The Collegian,* then falling into an archivist's job at *The Gazette,* you might say I had no real career plan at all. But the truth is I have always pursued what has keenly interested me, and stock photography has shaped my lifestyle for nearly thirty years. I took jobs that offered opportunities to shoot stock, I bicycled cross-country to shoot stock, and perhaps I even moved from my native Pennsylvania to an unknown rural corner of Quebec to shoot stock. So ending up in a newsroom which offers 3 million images to outside customers fits me like a glove.

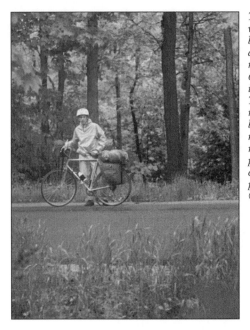

This self-portrait of Phil Norton was taken on a week-long, bicycle/camping excursion on assignment for Adirondack Life *magazine, which covers the 6 million–acre wilderness park in northern New York State. The camera was hung by its neck strap from a bare tree branch and the photographer ran out of the wet forest to pose nonchalantly by his bike. The picture was published as part of the layout, and the text/photo package earned $750.*
© Phil Norton

Newspaper journalism has always put the bread on my table, but stock photography has remained my passion.

Identifying your passion is what will guide you down the proper path in the wide world of photojournalism. Observe the lifestyles of the photojournalists you meet, whether they are on staff or freelancing. I know happy staffers and happy stringers; and I know stressed- and burned-out versions of both. The happy ones aren't necessarily making a lot of money but they're working on their craft to their full potential.

I remember a gold medal photography recipient at a Canadian magazine awards banquet accepting honors for his document of poverty. He said, "Isn't it ironic that we photographers often find ourselves so close to the poverty line?" yet I'm sure he would do it all again in pursuit of his passion.

Combining passions is another winning combination. I studied environmental science and, thus, broke into Canada's biggest magazines with story proposals on acid rain, forestry, and nuclear waste.

A branch of photography that is not my passion—portraits and weddings—elicits a quick and decisive *"no"* when customers inquire. I know the money is good, but I choose to direct my energy into markets that excite me.

One of those markets is handmade greeting cards. For fourteen years I have been "gluing pictures on paper" (as my wife so eloquently describes my profession) and delivering 5×7-inch photo cards with original 4×6-inch prints and envelopes to about thirty stores in the region. I now have a steady clientele for these photo cards and this branch of my business serves as both a good promotional tool and source of some income. I am now moving toward printing the cards from digital files with color-laser technology.

Advice for young photojournalists? Remember that photojournalists today are not just visually and technically savvy. They have to be smart. In order to know who and what to shoot, they must know the importance of what is happening around them—issues, trends, and celebrities, in business, politics, sports, entertainment, and so on. The journalistic ability to gather information, conduct research, and write stories is a definite asset.

Freelancers must also have an entrepreneurial spirit. They are in business for themselves so they must promote their services and products—assignment and/or stock photography—keep financial records and prepare and follow up on invoices, edit and file their negatives and slides regularly, and maintain more and more expensive photographic and computer equipment.

Aspiring photojournalists need to stay tied into a photography community—through ongoing relationships with newsroom colleagues, camera clubs, colleges, or online photo sites—and attend workshops offered by professional associations like the National Press Photographers Association (NPPA). You should enter professional competitions and constantly update your portfolio. Shoot lots of film. Make mistakes and learn from them.

Create a Web site so potential clients can look you up while you speak on the phone. Get listed in free direc-

tories that publishers subscribe to or search on the Internet. Start doing the job you want to do, even if you don't get paid yet. Make a personal appearance at the place you hope to work; personalities have to click.

For a foot in the door, and if you have a knack for sales, ask the newspaper's photo editor if he/she needs help filling orders for reprints and publication permissions. It's a great way to get a desk in the newsroom, become part of the team, and make contacts with outside publishers.

4

Customer Needs

It all started, for me, in Ms. Parrett's fourth-hour English class. I was, then, a handsome, seventeen-year-old captain of the Kearsley High School wrestling team and, in all honesty, an average student. That is, with the exception of English, where I always seemed to excel.

Even then, I had a keen ability to focus on what other's needed and, when it was to my advantage, took the appropriate steps to fulfill these requirements—two basic concepts of marketing. In the case of Ms. Parrett—who had moved to Michigan from California after a messy divorce—needs ran from someone to carry heavy bags to a sympathetic ear to listen to her: "I was in Los Angeles during the hippie movement and understand what today's kids think."

While my friends called me a "brown nose," when grades were dished out, my plate always seemed to contain a little more than the other average students. What I did not realize then is that I was building the foundation of what would eventually become a profitable marketing career. And, yes, I also learned enough about writing in that and subsequent classes to allow me to publish more than 2,800 articles and several books, to date.

At that early age I was already applying the laws of marketing. Ms. Parrett had a need (help carrying bags, someone to listen). I was fulfilling this need (carrying the bags, listening). In exchange I was "paid" with an extra + if not an entire grade jump. Because of this, I was a labeled a "brown nose" by fellow students. Eighteen years later, *Entrepreneur* magazine would redefine this action, calling me a "marketing wizard."

It's all perspective, I guess.

Identify a Need

The first thing you must do to achieve marketing success in your photojournalism business is to step into the shoes of your customer, figuratively speaking. Daniel Goleman, author of the bestselling book, *Working with Emotional Intelligence,* suggests that individuals with high emotional intellect have a knack for listening to and understanding others' points of view. They also possess the ability, says Goleman, to utilize the knowledge and insight they gained from listening to get ahead or achieve, whereas many others fail in the same circumstances. You want to be among those individuals who succeed. By listening and understanding the needs of your clients, you will.

> *As the editor of* Newsweek International, *I'm privileged to work with the very best collection of foreign correspondents in the business. But their reporting would have only half its impact if it was not married, week by week, to pictures from some of the world's greatest news photographers.*
> —MICHAEL ELLIOTT, NEWSWEEK INTERNATIONAL

Whether you are trying to get an assignment as a war correspondent for a major newspaper or periodical, land a corporate advertising contract, place your images with an editorial client, or sell pictures from your stock, you must always be thinking, "How can I help you?" rather an "How can you help me?" Newspaper and magazine editors have a number of pages to fill

each day and month. Book editors must generate a certain number of projects, with images, each year. Advertising agencies require the best images available—and are not afraid to pay top dollar to get them. You, on the other hand, are there to fulfill these needs with your photographic and writing skills.

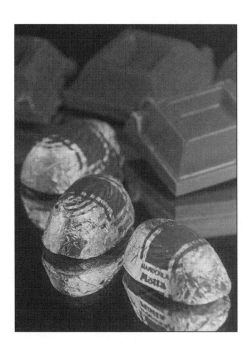

When Singapore Airlines' magazine, Silver Kris, *asked the author for a story on chocolate, he immediately began to think of ways to illustrate this piece, with an image that "says chocolate." The package brought in $725.* © Strawberry Media

Your efforts to "fill a need" should not stop there, however. They can also be carried over into numerous other areas. If you enjoy public speaking, for example, you may find that local schools are looking for an experienced photographer/teacher, or perhaps a group needs someone to lecture on the thrill of being a photojournalist. Yes, there is a certain air of glamour that comes with the job. This is because you are doing something that many people dream of. Your work is published, you are where the news is, and you are leading a life of independence. As a result, opportunities for promoting yourself and your work are endless.

> *Marketing is an essential enterprise for any profes-
> sional. . . . If you do not introduce other important
> people to your abilities, strengths and published work,
> how will they know you can deliver what you
> promise? With each subsequent product—I refer to all
> my work as products—I try to become familiar with
> what that particular . . . [client] needs in the future.*
> —ANDREA CAMPBELL, AUTHOR, *HELPING HANDS:*
> *MONKEY HELPERS FOR THE DISABLED*

For me, the "fill a need" concept is so important that I recently
added the following catch-phrase to my company stationary:
"Our job is to make your job easier." This phrase came about
after a client had commissioned a $5,000 job, then called to
explain that due to editorial changes the work could not be used.
She went on to say, in an apologetic tone, that, according to the
contract, I was required to redo the work at no extra charge.

"Mary," I replied, "my job is to make your job easier. If it's
not what you want, then it will be done again."

She was thrilled. Not only had I filled her existing need,
but I had removed the "bad guy" burden from her shoulders. In
doing so, I had followed another of the six cardinal rules of mar-
keting—customer service. I guaranteed that the finished product
would fit her immediate need and ensured that the customer
was happy with the product. My reward? In addition to full pay-
ment for the work, I received two more assignments from this
editor over the next five months, and more will probably come.

Sounds simple, doesn't it? If it were always as easy as
that, of course, we would all be nationally known photojournal-
ists. Such is not the case. It takes a great deal of undercover
work to successfully fill the needs of most photo buyers, for
there are times when even they do not know what they need or
want. Even before you start, however, you must ask yourself:
"What do I have to offer?" There may be times when your
answer is *"nothing"*—and there is no shame in that. You must
simply move on to other markets.

What You Have to Offer

Let me give you an example. Let's say you are a young photo-journalist and you have had images published in two local newspapers and one national magazine. You would almost sell your first-born son to see your byline in *National Geographic* or *Condé Nast Traveler*. You even have a friend who works as secretary to the managing editor at one of these publications. From her you've learned that during the next thirteen months the only editorial need is for foreign destination features, and the editor insists that photographers and writers have firsthand knowledge. Because a trip to Bali, Cairo, or Florence is not planned for your near future, you may be better off seeking markets with a wider opportunity, whereby you can fill an immediate need with your talents.

Another question that goes hand in hand with "What do I have to offer?" is "Who am I?" As strange as this may sound, rarely do you sit down and contemplate who you are and what you can provide a client that no one else can. Have you ever done it?

Before you can successfully explore the needs of photo buyers, and fill them, you first must know your strong and weak points—and now is the time to find out. Sit down with a pen and paper. At the top of the page write: Who am I? Halfway down the page write: What do I have to offer? Then begin to make your list.

Here is mine:

Who Am I?
Male
47 years old
American
Photographer-Writer
Married, with two children
BA in History/Government
Living in southern Italy
4 years in U.S. Navy
Hobbies: scuba diving, hiking

What do I have to offer?
Experience with U.S. military.
Firsthand insight into Italy
Cross-cultural marriage
Children in foreign countries
Text with my photographs
An American view of European issues
Diving off the coast of Italy
Hiking the Alps
Italian wines

The list could go on and on, but I think you've gotten the idea. Everyone—*EVERYONE*—has something to offer the right client. When *Newsweek's* special supplements editor, Mark Svenvold, was looking for someone to handle an assignment on Italian fashions, a colleague in Los Angeles suggested he contact me. Why? Not because I am an expert or specialize in Italian fashions—I know very little in fact—but because I am (1) in Italy and (2) an American offering editorial services. In short, I filled the need with what I had to offer and who I was.

Based on your own listings, you should see a pattern of where you might best focus your marketing efforts. Let's say you've lived your entire life in Fort Worth, Texas. This instantly makes you, in the client's eyes, an expert on the city, the people, the history, the cowboy culture, even the rodeo and Billy Bob's Texas! You have, in your own backyard, hundreds of photo stories waiting to be discovered, explored, and produced.

Just as I did not tell Mark Svenvold that I knew little about Italian fashions, there is no need for you to explain to clients that you've never ridden a horse. Nor must you reveal that your only rodeo experience is what you watched on TV, and that while your friends were at Billy Bob's looking for the opposite sex, you were getting a Ph.D. at Texas Tech. Selectively revealing aspects of your background that you tell potential customers is merely another aspect of marketing—akin to

the television ads telling you that the price has been slashed 20 percent, without saying the new bottle design also holds 20 percent less product.

I believe that a good, professional photojournalist can tell a story about any subject with images and words. Therefore, when an art director or editor offers me a job—whether it be on Italian fashions, underwater archaeology, protecting NATO's Southern Flank, or how to become a Latin Lover (yes, I did that one a few years back)—I rarely, if ever, say *no*. My research and interview skills are sufficient for me to put together an editorial package that is rarely rejected. Your confidence and skills should also be at this level.

Once you have a good understanding of what ideas you can market best, based on your unique situation and talent, the real fun begins. Were this an Army maneuver, now would be the time to select a target (a magazine, a newspaper, a book publisher, an advertising agency, or some other niche). Next, an intelligence team would gather data and insight into the enemy (inside information regarding a client's needs). Finally, soldiers would move in for the attack (your presentation). In your case, a victory amounts to a sale. Follow-up assignments might be considered a total massacre.

Assuming you know the basics of locating a prime target for your work, let's concentrate on learning the needs of a client—that is, undercover work. Traditionally, photojournalists have turned to publications such as the annual *Photographer's Market* or newsletters like *Photoletter* and *PhotoBulletin* for leads. While excellent resources for addresses and general information, there are two problems with limiting yourself to these references. First, because books normally require a year or more lead time to write and produce, information contained in them is generally outdated. Second, when you read about a market in a popular publication or on a Web site, thousands of others are also reading the same material and submitting ideas or images to the markets listed. As a result, art directors and

editors at these publications and sites are flooded with material, and yours becomes lost in the waters.

The Advertising Department

Your approach should be nontraditional. Go where others are not. Use guerrilla marketing to uncover the needs of editorial clients who will be eager to receive your material, rather than those desiring only to stop the uncontrollable flow of submissions from eager photojournalists. Your first stop, in the case of a magazine, a newspaper, or a Web publisher, should be the advertising department. Despite what editorial, production, and distribution people may tell you, it is the advertising folks who keep the cash flowing, keep the staff fed, and keep the publications in existence.

Newsstand and subscription sales of a magazine or newspaper rarely amount to much revenue in the overall scheme of publishing. Advertising, on the other hand, can make a publisher rich or send him to the poorhouse. In recent years, for example, top magazines like *People, Sports Illustrated, Parade, Time, TV Guide,* and *Newsweek* have enjoyed annual advertising revenues ranging from $384 million to $526 million. That is not a combined figure, but rather a per-publication revenue. Another example is *Better Homes & Gardens,* which, according to *Advertising Age,* recently posted annual ad revenues of $335 million.

Because of the revenue they generate, advertising people generally have a tight hold on the reins of power. Their departments are better staffed than editorial offices. They reply almost immediately to all queries—since they never know where the next advertising dollars may come from. And they also freely distribute information that, in other departments, might be considered privileged. For example, annual editorial schedules.

By writing or calling a publication's advertising department and asking for the latest media kit (sometimes referred to as an advertising kit), you will normally be overwhelmed with data. These kits generally contain: (1) readership demographics;

(2) circulation information; (3) reviews and general information about the magazine or newspaper; (4) a sample copy; (5) editorial calendar and information of any special editions. While the readership data will help you better focus your work, it is the editorial schedule that you really want.

Knowing what topics have already been approved and scheduled to run in the publication will allow you to focus your approach to specifically fill these needs. Keep in mind, however, that most magazines have a four-to-twelve-month lead time. Don't spend time proposing work that is to appear in two or three months, unless you have images in your stock. Begin at least six months ahead.

If you are asking yourself why an advertising department would send you—a photojournalist—a media kit, you need to go back and review the section about being a business. If you approach the advertising reps as a photographer or writer, most likely they will *not* send you one. On the other hand, if a *business* asks for a media kit, it often goes out the next day. This is another example of why I suggest you operate under a company name, rather than your own.

How do I know these things? Besides asking for current media kits from over twenty publications each year, I worked as an editor-advertising manager during the late 1980s for *R&R Magazine*, published in Germany. Wearing my editorial hat, I was always under tight budget restrictions, never used courier service, and rarely made international calls. Changing to my advertising cover, I consistently called clients throughout Europe, sent tons of media kits by courier and express mail, and immediately followed up requests for information from potential business clients.

I prefer to contact advertising departments by letter or e-mail rather than making a phone call, though all these methods will work. My approach is straightforward and most often the letter is addressed to the advertising manager listed in the masthead of the publication. A normal pitch goes like this:

As one of today's fastest-growing editorial-marketing agencies, we (always use the plural, as it indicates a large business rather than a one-person operation) are exploring potential advertising venues for our customers. One or more clients have indicated interest your publication. If you could provide a current media kit, including your advertising rates and long-term editorial schedule, it will better allow us to evaluate your magazine/newspaper in terms of our customer's needs.

The most important point is that I specifically ask for the editorial calendar in the letter or the phone conversation. Using this method to gain inside information, I have sold thousands of images and articles. In one case, with Off Duty Publications, I discovered that the publication was planning a special supplemental guide to the Mediterranean—my backyard—in the upcoming year. Armed with this information, I queried the editor of *Off Duty Europe* for an editorial package on Naples, Italy, one of the cities noted under the project. At the end of the letter, I added: "I look forward to hearing from you regarding this idea, or if you need other editorial material (articles and/or photographs) from the Mediterranean region."

A week later, editor Bruce Thorstad called to ask if I would consider becoming a contributing editor to their *Welcome to the Med Guide*. This translated to my providing all the photography and text for the special edition—including an image of my wife on the cover. *Off Duty* put out the guide for three consecutive years and each time the editors contracted for my services. Ultimately, lack of advertising resulted in the death of the guide. So, ironically, the advertising department was responsible for both my landing and losing this job.

Angela Adair-Hoy, editor and publisher of the Internet newsletter *National Writer's Monthly* and *The Write Markets Report, www.writersmarkets.com,* suggests that photojournalists

This image, of the author's wife on a beach in Italy, was taken specifically with a magazine cover in mind. Four months later, it graced the cover of Off Duty's Welcome to the Med Guide. © *Strawberry Media*

with the capability search the Internet for guidelines and editorial calendars. Using one of the many popular Net search engines (Alta Vista, Lycos, Hotbot, Mamma, etc.), Adair-Hoy recently found 378 editorial calendar listings.

"Most publications post their editorial calendar for advertisers," explains Angela. "But, we [photographers and] writers can take advantage of this information as well."

Whether you are trying to sell visuals for editorial use, for advertising, or to break into business media, inside contacts can be the key that opens the door to success. Those directly involved in corporate projects and editorial decisions know, before anyone else, what the needs of a business are. My recent work for the Discovery Channel, for example, initially came about as a result of information from a long-time friend, the senior manager of corporate communications, John Buffalo (I was best man at his wedding).

There are hundreds of individuals, besides art directors and editors, who have day-to-day insight into the picture require-

ments of a company. Secretaries, advertising personnel, production and distribution managers, even printers frequently know the needs of picture buyers far in advance. These individuals, in a sense, can become your eyes and ears into industry needs.

While I am intentionally trying to avoid the word *"spies,"* that, in the scheme of guerrilla marketing, is exactly what these contacts might be considered. However, the term I prefer is *"informants."*

A perfect illustration of this happened to me recently when I visited the local printer to reorder stationary. While there, the company owner said, "I just spoke with the marketing director at Holiday Inn. They're sponsoring a motorcycle rally next month and we'll be producing the programs."

This immediately got me thinking that they might need a photojournalist to capture the rally on film for future marketing needs. After obtaining the telephone number, I contacted the hotel director for an appointment. Over coffee, we negotiated not only the rally job, but a series of other photographic projects.

There is a catch-phrase in the military called *"OpSec,"* short for Operation Security. It was discovered during World War II that the enemy was picking up much of its intelligence information in bars, where U.S. service members would go to drink and dance. While at a nearby table and sometimes even at the same table, enemy agents would chitchat with American GIs. During their discussion, soldiers would ultimately reveal such things as "The troops are pulling out next week" and "I'd better get my fill of booze because it will be four weeks before I get another opportunity."

Unbeknownst to the soldiers, they had told the enemy agent—often an attractive, young woman—that American units were on the move for one month. This information, in turn, allowed the opposition forces to calculate which routes were more likely to be taken, to determine what potential targets were within a thirty-day range, and to plan counterattack measures.

Because most people do not utilize OpSec tactics, you might easily get inside information into photojournalist opportunities—much as I did through my printer—over a cup of coffee, a dinner, during conferences, or anywhere else publishing and corporate people gather. Not that such needs are necessarily secret. Most potential clients, in fact, will openly provide you with information for the asking. What you are seeking is company trends. Perhaps a new magazine is going to be launched by ABC Publications. More often than not, by the time a photojournalist learns of this via traditional means, all the contributing photographer and journalist slots are filled. If you knew someone at the company who informed you of the new magazine one year in advance, however, you could find out who the project decision maker was and propose yourself for such positions.

In 1985, while corresponding with Anne Crawford, then travel columnist for *Family Magazine,* I picked up from one of her letters that, "I'll be leaving the magazine next year to concentrate on book publishing." I immediately recognized an open door. After confirming with Anne that she had notified the magazine, I proposed myself, both to her and to Mary Jane Ryan, the editor-in-chief, to fill the vacancy. Anne supported the idea, which, in turn, convinced Mary Jane to go along with it. Eventually, I not only wrote the monthly "At Ease" column, but produced all the travel features and photos as well. This resulted in a nice monthly income in addition to numerous complimentary vacations.

There are two very valuable points made by this example: (1) you must constantly be looking for a need to fill, and (2) the importance of networking cannot be underestimated. If you are not looking for open doors, you certainly will not find them. It would have been very easy for me to have read Anne's letter and simply moved on. So always—*ALWAYS*—keep an eye open for potential needs by editors and other photo buyers.

Be a Network Nut

I cannot say enough about the value of networking. I have had more work—and better paying jobs—come my way through acquaintances, friends, and colleagues than from most traditional methods. There was a time when those geographically located in New York City and Los Angeles had an advantage over the photojournalist in, say, Backwater, Wyoming. They were able to establish a thick network of contacts from which to draw industrial information. Fortunately, with the invention of e-mail, this is no longer the case. If I can do it from Naples, Italy, so can you! I am, in fact, currently negotiating a $72,000 job with a company in Israel that began as a lead from a friend in the United States.

Like a good politician, a photojournalist who knows how to establish and utilize a network is destined to succeed. Being a joiner is your first step. During my career I have been a member of numerous organizations for photographers, writers, and publishers. Among them: American Society of Journalists and Authors; Association of Photographers; International Food, Wine and Travel Writers Association; National Press Photographers Association; Travel Journalists Guild; Publishers Marketing Association; Small Press Association of North America; and International Association of Independent Publishers, better known as COSMEP. There were a number of reasons for joining each of these organizations. Expanding my network of colleagues was without a doubt one of the primary motivations.

Every group I am affiliated with publishes a newsletter packed with industry news. They also offer directories of members and other beneficial services and information. What you do with these resources and data will determine the extent of the benefit you receive from your membership. Take, for example, the International Food, Wine and Travel Writers Association. Its monthly newsletter has provided me with leads to numerous picture buyers—though some photojournalists may not immediate-

ly see this. Each issue lists upcoming events, including guest speakers, and offers insights into the publishing industry. About the time I was seeking a publication to buy a photo feature on Rome's unique architecture, I saw an interview with five editors in this newsletter. One of them, from Asia, pointed out that the publication liked photo essays. Noting this, I queried the editor by e-mail and, five months later, *Silver Kris*, the in-flight magazine for Singapore Airlines, ran *The Coppedé Quarters*, over six pages. The four hundred words of text and twelve color photos the magazine used brought me $786.

On other occasions, the newsletter of the American Society of Journalists and Authors (ASJA) has reported quotes by editors attending ASJA meetings or conferences. By picking up on these quotes, I have been able to locate editors who were seeking the type of material I produce, or was currently working on. This has led to several sales and even book contracts.

Fellow members, no matter what the group, are perhaps the greatest of all assets. When you attend functions of your organization, mix and mingle with others. Get to know as many people as possible. I recall one press trip in particular, organized by the Philippine Tourist Board for members of the Travel Journalists Guild. Among those attending the ten-day event were Bob Milne, publisher of *TravelWriters Marketletter;* travel writer Alice Garrard; photojournalist F. Lisa Beebe; and photographer and frequent contributor to *National Geographic,* Randa Bishop. After days of skin-burning sun, tropical rains, and trekking through the jungles of Palawan, we'd established a bond. Bob would eventually talk me into publishing the *Markets Abroad* newsletter, which I did for eight years prior to the publication of my book, *The Writer's and Photographer's Guide to Global Markets* (see Appendix A). Alice has since gone on to work for Walt Disney Company, though we still stay in touch. Not long after the trip, I passed a lead onto Lisa Beebe that eventually landed her a photo column with *R&R Magazine.* Rhonda Bishop and I collaborated on a couple of editorial packages,

including a feature on jewelry for Philippine Airlines' in-flight magazine, *Mabuhay*.

This image of a farmer in Tequila, Mexico, won the Kodak Showcase Award for photojournalist Randa Bishop, and was exhibited at Epcot Center for six months.
© *Randa Bishop*

This example illustrates how photojournalists can benefit by sharing information and maintaining contact with colleagues. Following a meeting of the American Society of Journalists and Authors, the president of Tape Guide International, Inc., approached veteran writer Bern Keating. Tape Guide was seeking writers to work on a project in Rome. During the conversation, Bern mentioned me. Two months later we were both sitting outside a café in Piazza Venezia sipping a fine Pallavicini white wine, from Frascati, discussing our $1,500 assignments—plus expenses, of course. Because I was a photographer in addition to a writer, I was able to cash in on that aspect as well by producing a series of images that would ultimately be used in advertising the tape series.

Clubs and associations offer an easy means of establishing a photojournalist's network. It is up to you to take advantage of these. Appendix A, in the back of this book, provides what I believe to be groups that can be beneficial to all photographers and writers. If nothing else, it is a place to begin.

Don't limit your networking to colleagues. Reach out, whenever possible, and rub elbows with publishers, art directors, graphic artists, editors, agents, and anyone else in some way associated with paying markets. Several years ago, as often happens, a colleague introduced me to Andria Lazis-Valentini, director of Articles International, a syndication business based in Canada. Following months of sharing information, Andria called to say that she'd been speaking with the editor of *Jake* magazine, published in New Mexico, and that he was looking for unique European ideas. Since I'd recently completed a photo session based on Italy's after-midnight sexual home shopping networks, I proposed, and eventually sold, this package for $800.

I had maintained contact with Articles International, and willingly offered insight into global markets, and Lazis-Valentini had returned the favor with the *Jake* assignment. Such sharing of information is common among today's best-paid photojournalists.

"After a decade or two of writing [and producing photographs] for publication, so many journalists fall away into PR and other corporate work," says ASJA member Mary Mihaly. "I use those old colleagues as resources; one former city magazine editor now edits publications for Jones, Day, Reavis & Pogue (a mega–law firm, based in Cleveland) and she gives me four or five interesting assignments a year. Another friend now works solo as a PR person; she subcontracts a bimonthly newsletter to me that goes to clients of an insurance consultant. Another friend referred me to a psychiatry practice—for writing, not treatment—another friend, a housing consultant, just hired me to pitch his newspaper column."

Through networking, Mary has been successful in uncovering the needs of corporate and business clients and then fulfilling those needs. But her efforts do not stop there.

"Hand in hand with corporate work," she explains, "is nonprofit work . . . I collect decent hourly fees writing for nonprofits, including hospitals, libraries, and organizations such as Ronald McDonald House. It's all interesting and enriching work, and a break from dealing with faceless editors long distance."

As a photojournalist, you can learn from Mary's example and take advantage of the corporate opportunities that surround you through daily contacts. It's all a matter of good communication.

Since the days of jungle drums, nothing has done more to enhance and ease one's ability to network than the Internet. However, as Net guru and author of the *Writer's Guide to Hollywood Producers, Directors and Screenwriter's Agents,* Skip Press, points out, establishing a good network takes time and energy.

> *Networking isn't an overnight thing. If you're just beginning . . . you need to find a local workshop group. If that's impossible geographically, then you need to find one online. Even then, it will take some time for people to get to know you, and you'll have to prove the worth of your . . . ability to provide work and contacts for others.*

Posting comments and information on Internet newsgroups like *rec.photo, rec.photo.digital, rec.photo.marketplace,* or *alt.journalism* is one way to establish contacts. Too often, however, such groups are like throwing your time and effort to the wind. A much better way to contribute and receive professional advice and contacts is to join list discussions. As opposed to newsgroups, members of a discussion group are more like a closely linked club. In addition, replies come by way of e-mail messages, either directly to you or to the entire group.

One of the more popular and professional discussion groups is run by the National Press Photographers Association. It is open to all active members and you join through the organization's Web site: *http://metalab.unc.edu/naap/index.html.* A few other frequently used discussion groups can be found at the Web sites of Advertising Photographers of America (*http://apanational.com/message/disc5_toc.htm*) and Editorial Photo (*http://editorialphoto.com*).

These are not the only Web sites offering discussion groups, however. There are hundreds. Former and current military photographers, for example, have MPJ, the military photojournalists discussion group at *www.threeoaksphoto.com/mpjtalk/disc1_welc.htm.* CompuServe also offers a variety of newsgroups, discussion groups, and chat areas. The CompuServe crowd, generally, attracts more serious photographic professionals. To find a group that fits your particular interest, simply do a search of the Internet.

If you discover that a classification for your particular interest does not exist—say, photographers specializing in war coverage—you can create your own discussion group at Yahoo.com. The Yahoo clubs at *http://clubs.yahoo.com* allow you to establish Internet groups covering a variety of topics. Among the general classifications already created are: Business & Finance, Computers & Internet, Cultures & Communities, Entertainment & Arts, Books, Games, Recreation & Sports, Religion & Beliefs, Science, Sex & Romance.

Any group you create, as well as those already established, can be used to send people to your Web site. When you post a message, for instance, always include your Web site address under your name. Or, if you are specifically pointing out something about yourself or your work, you might say "Take a look at my Web site for examples." Then provide the Web address. Newsgroups can also be used as networking tools to generate business for you and others. Here is an example of how it might work:

JIM: "I specialize in celebrity photography. I was offered a freelance job in London last week, but had to turn it down. The cost of the trip would have been more than the editor wanted to pay."

YOU: "Hi, Jim. I plan to be in London next month, do you think the editor is still looking for someone?"

JIM: "Could be. Send an e-mail to Todd Mann at *toddm@editor.com*. Tell him I sent you."

YOU: Thanks. By the way, if you have any political figures, you might be able to sell a few to *Embassy* magazine. Editor there is Mark McWilliams at *mc@embassy.com*.

Newsgroups and networking are all about open discussion and sharing information. How effectively you use these depends a great deal on your willingness to participate and offer information. Over the past year, I have obtained many jobs based on input from colleagues in California, New York, Dallas, Ontario, Bali, Paris, and London. At the same time, I have provided leads that have led to several jobs for others, including one book. It's a big world out there with hundreds of thousands of opportunities. Don't be afraid to offer contacts to colleagues. It will come back to you ten times over, believe me.

You do not have to strain to make your networking efforts effective. I've found that one of the easiest ways to maintain a consistent flow of messages—and jobs—is to stay in contact with clients and associates with periodic "movement updates." These are merely e-mail messages informing friends, colleagues, and clients what I am working on and where I will be traveling in the coming months.

Last October, for instance, I sent the following:

While on assignment for various international media, I will be traveling throughout Italy, Germany, and

Bosnia over the next two months. In addition, I'll be touching London, New York, and Washington, DC.

In addition to travel, I'll be covering archaeology, fashion, wines and local cuisine.

If your upcoming needs require anything from these geographical areas or the topics above, drop me a line so that I can help you save money and provide you with the material needed.

And don't forget . . . we also have a large stock of images to choose from.

Best,

Mike

This simple message resulted in requests from the editors of Philippine Airlines' in-flight magazine, *Mabuhay; Holiday* (UK); *Diplomat* (UK); and the media arts manager, Elizabeth Brown, at Earthwatch Institute—she needed a museum image for their new catalog.

The Client Profile

Not all photojournalists are "people" people. That is, many prefer to work at a distance from the client. That, in my view, is a mistake that needs to be overcome. Those individuals who are making a career in the photojournalism business are the same people who go out of their way to meet with potential clients, whenever possible.

Though I live in Europe, I visit major cities like New York, Chicago, and Los Angeles each year to "make the rounds." There is something about personal contact that bonds those in the field with those behind the desk. In most cases, editors, art directors, and public relations managers have a hidden desire to

become independent business people themselves. So, in a sense, they admire people like you and me. They want us to succeed.

Prior to any personal visit, however, you must, once again, put yourself in the clients' shoes: know who they are, their likes and dislikes, as well as something about the environment in which they live and work. This will greatly enhance your chances of a meeting and, ultimately, a sale.

During my last visit to New York City, I met with Ted Moncreiff, arts editor at *Condé Nast Traveler*. Using my network of contacts, I was able to get my foot into the door with an introduction by a local public relations agent.

Prior to the meeting, I compiled a client profile, as I do with all past, current, and potential customers. This included the name of the contact, in this case Moncreiff, his address, phone and fax numbers, e-mail addresses, and so on. And, very important, the person's title—in this case "art editor"—which tells me where I should focus my sales efforts.

I next reviewed a couple of copies of the magazine, noting the coverage—that is, articles, photos, advertising. I particularly looked for features that Ted might have been responsible for. At the same time, I communicated with my friend, asking questions about the editor's background, previous positions, and anything else that might provide me with insight.

Armed with this information, I was better prepared for the meeting and was able to target Ted's specific needs, while bringing into the discussion aspects of our business, contacts, and personal life in which we shared common interests.

The client profiles of longstanding clients will include all sales, income, rights purchased, personnel changes, new editorial or business focuses that will affect what I offer, and any other items that might give me an advantage over the competition.

In one case, for instance, I noted: "August 15-Wife is expecting second child in December." Simultaneously, I placed a note in my monthly "to do" file in the month of December, which read: "Inquire about Jeff's baby."

I followed up by calling the secretary, asking if the baby had been born. When she said, "Yes, it's a boy." I immediately sent him a note of congratulations. My thoughtfulness paid off: I have had over $7,000 in work from this publisher in the past year.

When I have enough information to know the likes and dislikes of various clients, I might also bring a token gift to a meeting. Knowing that *R&R Magazine* had recently moved into a new office building, I purchased a plant while on my way to see editor Tori Billard. On other occasions, I have presented editors with calendars, pens, autographed books, and a variety of useful items. For individuals I have worked with for some time and know well, I might even bring a "special" bottle of Italian wine.

Remember that everything you do, including meetings and gifts, are part of the marketing process. The meeting is to listen, gather information, and present ideas. The gift, on the other hand, should have some marketing value, if possible. If you are giving someone a calendar, for example, be sure that it highlights your name, your company, and such information as mailing address, telephone, fax, and e-mail. While visiting an editor in Los Angeles, I observed the annual "Christmas present" calendar I had sent hanging on the wall.

"Glad to see you put it to good use," I told her.

"Good use," she replied. "It is one of the most valuable things in the office. And when I need an article or photos, I simply glance up and have your numbers. Beats going through five hundred business cards."

In this particular case, I had specifically selected a calendar that listed annual events—such as National Fitness Week, Black History Month, and the like. After my meeting, I sent the editor a letter suggesting editorial coverage of Alex Haley, author of the best-selling novel *Roots,* whom I had recent interviewed and photographed. As a close, I told the editor, "If you'll go ahead a few months in the wall calendar, you'll note that Black History Month might be a perfect time for such a feature." That clinched the sale.

I always have a stock of pens and other inexpensive office items—post-its, rulers, erasers, penholders, and the like—with my company name and information preprinted on them. This way, when it comes time to meet with potential clients, it is easy to slip a few into my briefcase.

Now what about that "special" wine? In this case I found a vineyard that would create a special label if I purchased a minimum of fifty bottles. I did, and received "Strawberry Media Wines. Bottled for the editor without energy, the publisher without pep, and the agent without aggression. For all your editorial needs, write, call, fax, or e-mail Strawberry Media. Then sit back, relax, and have a drink on us." This went over exceedingly well and, based on the work I received from the individuals who got a bottle of Strawberry Media special, it was one of my finest marketing efforts.

I normally go into meetings with a list of ideas, whether clients are editorial, advertising, or corporate. My list will contain five to ten topics or concepts, including possible titles or themes and a short overview of each. Naturally, I have done as much undercover investigation as possible, to determine what the customer needs, and I've specifically tailored my ideas to these requirements. I have also taken the time to review what the magazine, agency, or company has used photographically and editorially over the past six months to a year. When the proper time arises, I bring out my lists, hand one to the client, and say, "Here are a few ideas I'd like to go over with you, if you have the time. Otherwise I can just leave it." It is rare that I do not walk away with at least two assignments.

Meeting new and sometimes current clients frequently requires more listening than selling. Here is an excellent example of how I utilized networking not only to gain insight into industry personnel, but to set up face-to-face encounters. I had sent a proposal for an illustrated book to Ken Atchity, an agent in Beverly Hills. It dealt with Italy, where Atchity, I learned in my research, had lived and taught for many years. Upon receipt, he passed it on to his executive editor, Monica Faulkner. In turn,

she notified me that it was not for them, but that she had spoken with another agent, Toni Lopopolo, who was interested in it. I therefore authorized her to pass it on to Lopopolo. Eventually, Toni and I met.

In my premeeting, undercover work, I found out that Lopopolo had once been a top fiction editor for St. Martin's Press and was still very much respected in New York literary circles. I also found out that she had moved from the Big Apple to California two years earlier, she had graduated from New York College, and she had a love for dogs. I also picked up various other tidbits about her personal and professional lives.

Because of our mutual love for Italy and the publishing industry, we hit it off immediately. Over a superb Italian meal, Lopopolo discussed book editors who also had an interest in the Mediterranean peninsula—I took note of each. Having been in publishing for many years, Toni shared her experiences. All this gave me greater insight into writers, editors, publishers and agents, allowing me to create profiles on each individual.

At one point—I think it was when the espresso arrived— I mentioned a illustrated dog book idea I was contemplating. Knowing she loved dogs, and had two of her own, I was not surprised when she perked up. Then again, it may have just been the coffee.

I asked, "Do you know any editors who might be interested?"

"Dog lovers? There are lots in the editing business. Try Maureen O'Neal at Ballentine. And Heather Jackson at St. Martin's Press, Susan Kamil at Dell. Then there is Tom Dunne, who has his own imprint. In fact, Tom used his dachshund as the company logo."

I came away from our meeting with a wealth of information and insight into various book editors and publishers. In addition, I ensured that she would not mind if I used her name when approaching these individuals. This provided an added advantage, since most of the people we discussed were personal friends of hers. Generally speaking, editors look more closely—

The "Marine Corps Mascot" appeared in U.S. military publications around the world, and was part of a book on unique dogs. Because it "tells a story" it continues to sell year after year. © Strawberry Media

and favorably—at a project if it's recommended by a friend and, in this case, a former editor and agent.

The Phone Call

In your efforts to discover a client's needs, if all else fails, pick up the phone. While some professionals may disagree with this tactic, I have found it to be very successful. When I cannot get through to the editor, I normally attempt to befriend the secretary. In a few cases, I have even gone as far as to send an idea to the secretary rather than the photo buyer. Here is how one such phone call went:

> "*Woman Today* magazine, may I help you?"
> "Good morning. I'd like to speak with Lea Thompson, please."
> "I'm sorry, Ms. Thompson is in a meeting."
> To which I replied: "May I ask who I am speaking with?"

"This is Jennifer Knight, Lea's secretary."

"Hi, Jennifer. This is Michael Sedge calling from Italy."

"From Italy! I just love that country."

(The door just opened wide.)

"You've been here?"

"Oh, yes, twice. Where exactly are you located?"

"In Naples. I'm, you might say, in the shade of Vesuvius."

"You must love it. What can I do for you?"

(Now comes my pitch, using the knowledge I've just gained.)

"Since you've been to Italy twice, Jennifer, you've probably heard that Italians are supposedly great 'Latin Lovers.' I just wanted to ask Lea if she'd be interested in an editorial package— pictures and article—based on that theme, say, "How to Turn Your Man into a Latin Lover." And, if she is interested, would she mind my sending a written proposal by fax."

"Well," said Jennifer, "it sure sounds interesting to me! And we get fax queries all the time from our regular contributors."

"That's great. I'll just fax in a query then. Thanks for your help, Jennifer. And if you need anything from Italy, give me a call."

"Thank you, Mr. Sedge. Goodbye."

I then proceeded to prepare a query *not* addressed to Thompson, but to Jennifer. In our three-minute conversation I had found a common bond—Italy—between us. I opened the letter with:

Dear Jennifer,

It was a pleasure talking with you today—and I was serious about helping with anything you might need from Italy. If you could pass the query, below, to Ms. Thompson, I would be grateful.

Secretaries, for the most part, lead very busy, yet unglamorous lives. At the same time, their bosses are frequently in the spotlight. Paying attention to them often provides inroads, which, otherwise, might never be achieved. In the case of Jennifer, I later learned that she personally took the query to her boss, telling her what an interesting idea I'd proposed. It was also Jennifer who, ultimately, called with the assignment.

At Christmas—and after receiving payment for my work—I sent her a thank-you note along with a locally produced ceramic flower. You would have thought I had given her a new Volvo. She called with joy and thanks. Needless to say, whenever I need information from *Woman Today,* it is only a phone call away.

> *When I am down to two or three magazine assignments, I start calling the various editors I know and pitch ideas to them. It's crucial to do this well ahead of time, since editors can be very slow while your idea endlessly circulates.*
> —LISA COLLIER COOL, AUTHOR OF *BAD BOYS*

But what happens when you do get through to the editor, the art director, the agency manager? How do you get information then? First, you must never, ever call a potential customer with a vague idea or no idea at all. These are busy people, with very little time or patience for nonproductive discussions. When I was an editor, I was happy to receive serious calls. If a writer or photographer asked, "How much do you pay?" or "I'm going to England. Would you like something?" I had to control myself not to hang up abruptly.

Professionals do their homework and know what the client needs or, at least, the general type of material used. They know what the rates are, along with specifics like formats and style. And, most important, photojournalists should have a very focused concept of what they are offering. Here are a couple of successful examples.

"Michele Babineau."

"Good morning, Michele. This is Michael Sedge, director of the Strawberry Media Agency. . . .

(Note that I do not introduce myself as a photojournalist, but use the company as a front.)

. . . I've just gotten off the phone with the director of Cross-Country International, a company that offers horseback stag hunting vacations south of Paris. This sounded like a perfect activity for your readership and, since I will be in Paris next week, I'd like to propose a exclusive photo feature for *Robb Report.*"

(Note the key word: exclusive. *In this news-possessed world, everyone wants exclusivity.)*

"It does sound right for us," she said.

"Why don't I fax you a query." I replied. "This will allow me to include my credentials."

Six months later, *To the Hunt* appeared in the pages of *Robb Report* and I was $800 richer.

Another good example occurred recently when I called *Diplomat*, a bimonthly magazine published in the United Kingdom. The conversation went like this:

"This is Michael Sedge, director of Strawberry Media in Italy. I've recently been granted an interview with Admiral T. Joseph Lopez, commander-in-chief, Allied Forces Southern Europe, and wonder if you would be interested in exclusive rights to this feature."

"It's hard to say without knowing a little more about the admiral," said editor Mark Cockle.

I replied, "I can fax or e-mail you additional information if you'd like. If you could then let me know your decision by the end of the week, that would be sufficient. I can also provide photographs."

(Note: Whenever possible, give the client more than requested; whether it be text with images, graphics, logos, etc.)
"E-mail will work fine," Mark said.

The article, *Four Star Peacekeeper,* appeared in *Diplomat* the following September, and, ultimately, won me a NATO photojournalism award.

The key to these telephone success stories is that, first of all, I was offering material that practically no one else could. This meant that similar material had not appeared in the publications. Second, I was providing "exclusivity" (although in each case the magazines only got exclusive, first serial rights to the article and one-time rights to the images for the country in which they are published—because they preferred not to pay the higher price I requested for world rights). This last factor justified a call rather than letter.

What the calls really boiled down to, though, was whether or not the editors needed such material. Once that was confirmed, I immediately reverted to making my offer in writing. This made them comfortable and gave them an opportunity to discover who I was and what I had to offer. It also gave them an option to say *no.*

The advice and examples included in this chapter illustrate one thing: You must determine the specific needs of potential clients. There are numerous ways to find out this information. Those who get ahead and make the big money are, for the most part, photojournalists who use a combination of these methods. They utilize nontraditional sources to gather the requirements of editorial, advertising, and corporate clients. From advertising kits and inside informants to global networking and covert operations, you must be a guerrilla marketer if you are to win at the photojournalism game. Knowing the needs of potential clients is 50 percent of the battle. Armed with this

information, you can then focus on the attack—that is, your products and services.

Advice From a Photo Editor

Knowing the best way to get your foot in the door of a potential client is half the battle. To get an inside look at how the contemporary newspaper industry uses photojournalists, I posed a few questions to Chris Holmes, photo editor at the *Lansing State Journal*, Lansing, Michigan.

Question: I understand that you are part of the Gannett group. How do you cooperate with other papers in the organization?

Answer: We are occasionally asked by Gannett News Service, or *USA Today*, to submit photos for stories generated at the *Lansing State Journal* that they are running. We also at times will call a member paper if there is something going on in their area that we need coverage of. Other Gannett papers of course call us for the same type of service. GNS also supplies feature photos with stories they do, which our feature section runs.

Question: What advantages does newspaper photography offer a young photojournalist?

Answer: The chief advantage is the opportunity to cover a lot of different subjects and situations on a daily basis. The variety of experiences can't be beat and will prepare young shooters for whatever they encounter later in their career. Also the opportunity to deal with a variety of editors with different needs helps train the photojournalist to communicate effectively and learn to work with different personalities in the business.

Question: What are the drawbacks, in your view?

Answer: The constant battle to avoid burnout due to repetition. No matter what paper you work for, you will be asked to shoot a certain amount of no-brainer assignments,

which can sap the creative energy out of you. It's important to keep self-motivated and have your own projects and goals in shooting.

Question: What advice would you give photojournalists desiring to enter the newspaper field?

Answer: It depends on experience level. If they are already photojournalists, then they know what to expect to a certain degree. If they are student photographers wanting to be professionals there are some keys: (1) Get a life. That sounds odd, but it's important for young shooters to experience more than photojournalism twenty-four hours a day. There are professional photojournalists who live their work to the exclusion of all else. The best shooters have experienced life and have a perspective in their work that comes from knowing what their subjects are going through. Being the best technician in the world, with the best portfolio, will not make you a caring photojournalist. (2) Work diligently on getting a dynamic portfolio so you can get your first job. The portfolio—not an advanced degree—is what will get you the interview. Without the images, all the education in the world will not get you the job. Look at the images displayed monthly in the *News Photographer Magazine* and the year-end *Photographer of the Year* photos, and figure out how to emulate them in your work. (3) Be educated and well read.

Question: Do you work with freelancers at the *Lansing State Journal* and, if so, what do you look for in potential photojournalists?

Answer: Yes, we do use freelancers. And again, the key is the portfolio. Does the person have a good eye? Do the images they present to me evoke an emotional reaction (these are the best of what they have to offer [or should be])? Can they handle difficult situations such as nighttime football? How do they present themselves when they come to see me? After all, they will be

representing the newspaper while on assignment. If a freelancer is weak in some areas but is ambitious, I will work with him or her to improve weaknesses, but the freelancer has to have the motivation to show me he or she cares about getting better. Don't be a pest, but call in regularly. Show me what you're working on. Ask questions. Take advice.

5

Product Strategy

When people ask me what I do, I rarely, if ever, say that I am a freelance photographer. More often, my answer is, "I operate an international editorial services agency." Sounds impressive, doesn't it? It's almost as if I, single-handedly, run the Associated Press or Reuters. At this point, particularly at parties and other gatherings, someone will undoubtedly ask, "Exactly what is that?"

"I provide editorial packages—photographs, articles, books, and the like—for approximately forty customers around the world," is my standard reply.

This type of conversation is what I refer to as "business talk." And, as the old saying goes, if you are going to walk the walk, you've got to talk the talk. Exactly what walk and what talk you present is going to determine the category into which potential customers classify you. If, for example, you talk "service," "product," and "presentation," they will recognize these as marketing buzzwords, thus making you a "business" person. On the other hand, if terms such as "freelance," "query," and "self-addressed-stamped envelope" are common in your vocabulary,

you may find yourself under the classification of "someone who takes pictures for a hobby" or "part-time photographer"." For this reason—and despite any photojournalism courses you may have taken—you must first think marketing and then images. It's the guerrilla way of doing business, and it will ensure your success. As a photojournalist, you have a double-edged sword to use on potential buyers. Whereas most companies sell either "services" or "products," you can offer both. In fact, you even have a third option.

In the service category, first, you are a photographer for hire. Clients have a need (a photo shoot) and they contact you. After completing the job you provide an invoice and collect your fee. Second, you provide—after a sales presentation (normally a query letter or portfolio presentation)—completed products in the form of stock images, articles, and the like. The third option is *you*. Yes, you too are a product.

The Market Environment

Before you can establish a successful marketing campaign, you must first fully understand the market environment in which you work as well as the services and products you offer. What is the competition? How do your services and products differ from those offered by the competition? How can you make your own products and services more attractive to potential buyers? These are the questions you must answer for each sector of your business.

Let's begin by looking at your "service" as a photographer. Unlike the traditional method of doing business, whereby you come up with ideas and query editors or media directors, this segment of your operation consists of potential customers calling you when they need your "service."

Your photographic services will develop naturally as you sell more and more work to a variety of clients. This may take years, however. Fortunately you do not have to—and should not—follow the slow-moving, name recognition path, as most photographers do. Why? First, because clients who call for photographic services normally pay more. Second, because these

customers often come from the ranks of top-named publications and corporations.

As an example, in 1982 the editor-in-chief of BankAmerica *World,* the company's in-house magazine, called me. They needed a photographer/writer in my geographical area to produce a 1,000-word feature and photographs on a local bank. The job, which took all of three hours, brought me $1,000, paid on completion.

How did he get my name? I had prepared a brochure one year before and mailed it to three hundred corporate media managers.

Postcards, like this cover image of Cliff and Nancy Hollenbeck's Hawaii *book, make great promotional tools for photojournalists.* © *Cliff Hollenbeck*

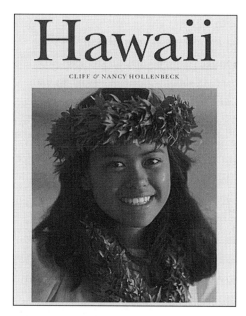

One of the best ways to start getting corporate work is to attend meetings and events sponsored by the International Association of Business Communications (IABC). There are chapters in most major cities around the world. Most members are people on staff in corporate communications, public relations, and marketing departments who are often looking for freelance help. Local chapters are usually listed in the business white pages.

—JACK EL-HAI, PROFESSIONAL JOURNALIST

Other examples of top-paying work that has come my way from clients requiring a photographic service include: AT&T ($3,200), Holiday Inn ($900), *Newsweek* ($1,000), Tape Guide International ($1,000), Time-Life ($1,200), the U.S. Navy ($1,500), and the USO ($12,000).

As you can see, it pays to dedicate time and effort to developing and building service customers. Later, when we get into your market approach, we'll dig more deeply into how to reach these potential clients and how to inform them about your services.

There are three reasons a client would typically request your services: (1) you live in a specific geographical area or have an expertise in a particular field; (2) his deadline is too tight for a staff photographer do the job; (3) he normally does not work with photojournalists but, in this particular case, needs a professional. It makes sense, therefore, that, in your marketing, you concentrate on these areas. For instance, perhaps you live in Orlando. This makes you the perfect candidate for anyone seeking images of Walt Disney World (geographical expertise), Sea World, and an array of other attractions in this city. On the other hand, suppose you have worked, as I have, in the telecommunications field. You no doubt have a better understanding (expertise) of this industry than most photojournalists do. This makes you a good choice to fulfill the photographic needs—marketing, advertising, and corporate communications—of the numerous communications companies across the country.

If you can work quickly and accurately, you're a valued asset to clients under tight deadlines. This sometimes means dropping everything else and working into the early morning hours to accomplish the desired task. However, this type of dedication, in my experience, can pay off big time.

Expanding Your Services

Many years ago, I received a call from James Kitfield, then editor of *Overseas Life* magazine, published in Germany. Mount

Etna had come to life the previous week, belching molten lava into the Sicilian skyline, and Kitfield, knowing that I live in southern Italy, called to ask if I could have images and a few hundred words to him within three days.

"If you include *great* photos," he continued, "there's a chance it could be our cover story."

My mind was reeling. The words were not a problem, but how could I meet the deadline for the images? Fortunately, the local media grapevine turned up Robert Zehring, a retired U.S. Air Force colonel and ex-NASA public affairs officer. With a passion for live volcanoes, Zehring had spent the past forty-eight hours tiptoeing along the slopes of Etna and had captured some spectacular images. Thanks to his talents as a lensman and my ability to produce words on demand, we landed the February 1981 cover with "Hot Foot Adventures."

By the way, we split the profits.

This experience got me thinking about the service I offered. Up to that point I had been primarily a writer, like thousands of others, offering a pen for hire. I now realized that this was not enough. By expanding my services to include photographs, I would not only set myself apart from the crowd, but also increase my income. The next day I called Zehring, who had a stock of nearly 500,000 slides. A week later we signed a contract whereby I would become a broker for his images. Over the next twenty years, the bylines of Sedge and Zehring would appear in hundreds of periodicals around the world—mine on the words, his on the images. I was collecting 100 percent of the profits for the writing and 40 percent of the photo income.

Employ photography. Dramatic pictures will sell a story more quickly than anything you can do.
—DOWNS MATTHEWS, PROFESSIONAL WRITER/PHOTOGRAPHER

Requests for my writing increased because editors knew that I could provide text/photo packages. What we had set up, basical-

ly, was one-stop shopping for editors. Whereas shoppers once went to individual stores for meat, bread, and other goods, they now go to a major supermarket and get everything they need—saving both time and money. We had simply applied this concept to the media business. Under our arrangement, editors no longer needed to shop around.

Soon art directors were calling with image needs. By 1990 my service operation had expanded to the point that I was representing fourteen photographers around the world and filling more than ten requests for pictures and articles each month—including such customers as the Associated Press, *Newsweek, Travel Holiday,* and Time-Life Books.

By incorporating photography, my writing business boomed, and vice versa. The enhancement of my services, however, did not stop there. For years I had worked with local printers for my company stationery, business cards, presentation folders, and other needs. It occurred to me while talking with the administrative director of the University of Maryland that nearly every school, company, and organization required writers, photographers, and printers to produce their books, catalogs, brochures, and promotional materials. So, as I had done with Bob Zehring ten years before, I was soon signing contracts with local printers to receive a 15 percent commission on all jobs I brought them.

Less than a week later I was writing, providing the photos, and handling the printing of an eight-page, full-color brochure for the USO Mediterranean Headquarters. My profit, after paying all expenses, would be $7,000.

By getting away from the stigma of a "freelance writer" and expanding my services to offer photography and printing, my business jumped light-years ahead of the competition. My phone, fax, and now e-mail are constantly active with requests. This should also be your goal. It is not that hard to achieve if you consistently provide fast, professional-quality products and always look for opportunities to expand your services.

You should be a writer as well as a photographer. If words are not your strong suit, then you need to establish a network of writers to collaborate with. Your images will help sell their stories, and their stories will help sell your images. It's a win-win situation. It amazes me, in fact, that more photographers do not advertise and promote their collaboration services to writers.

Your Products

While you, as a photojournalist, provide a service, your business also offers products. For the most part these are the stock images you produce. Unlike a service job, whereby a client calls you, it is your job to approach and sell your products to potential buyers. We have already discussed a few methods to enhance your sales, and will be covering more in the pages to come. First, however, it is important to understand the competition and how to make your products more attractive to the potential buyers.

For years, individuals seeking compact, dependable automobiles were buying the Volkswagen Beetle—myself included. After a decade of resistance, manufacturers like Ford and General Motors finally introduced their own lines of smaller cars. Almost overnight, VW sales dropped. Why? Because there was now a more attractive product on the market and people always want something new, something different, and something that offers just a little more.

The same can be said about photo buyers. Day in and day out they receive material. Over and over and over they get the same, boring items. Then, out of the blue, an inspiration falls on their desk. That inspiration should be you.

I like to think of my editorial packages as shiny, new, Fords, with metallic paint, while those of others are used, rusted-out VWs. When an editor gets my submission, I can imagine her smile. Why? Because I make her job easy—and so can you. In doing so, you will also rise from the slush pile to the ranks of "most desired" photojournalists.

Because I have worked to create confidence with editors, I am now at a point in my career whereby I rarely have to provide a query letter for an assignment. Yesterday was a good example. I was offered an opportunity to interview Renzo Rosso, founder and president of Italy's Diesel fashion house. I immediately sent an e-mail to several publications around the world—*Mabuhay* (Philippines), *Italia* (USA), *R&R* (Germany), *Diplomat* (UK), *Informer* (Italy), and Articles International (a syndication outfit in Canada). The fact that I have worked with the editors at each of these companies and have become one of their trusted contributors allowed me to write:

> I have just been given an exclusive interview with Renzo Rosso, founder and president of Diesel, Italy's radical, racy, and wildly successful fashion house. With global sales reaching toward the $1 billion mark, Diesel has become the "bad boy" of Italian trends—and the young, active buyers of the world love 'em.
>
> Can I interest you in, say, a 1,500-word feature, a sidebar on the expanding Diesel stores, and another on Diesel's Internet Web site (where people can order the latest fashions)? As always, I will also provide a vast array of images.

This two-paragraph message gained me three assignments and $1,500—plus lots of free clothes boasting the Diesel logo.

I'm a firm believer in breaking the rules. In doing so, I've been able to survive—and maintain a family of four—in this cutthroat media business for over twenty years. I frequently tell freelance photographers and writers that the standard approach to selling photos and stories to editors is a formal query letter. While that works, I have experienced ample success with a simple, one-line e-mail. Also, during the shoot, perhaps I'll find a side story that merits attention. Despite the editor's request, I might simply take the extra shots and send them along; some-

times with text, sometimes only with captions. The key is not to get locked into the traditional mentality of "This is how it is done." Keep an open mind. Be creative. Don't be afraid to experiment. That is how new and better products come about, whether it be a car, a new mouse trap, or a salable image.

Here are a few rules, however, that all guerrilla marketers *should* adhere to if they want to set their products apart from the crowd:

- Always offer to do your first job on spec. When you work with new clients on assignment, the client is taking a risk. Who is to say you will come through with what you've promised? To avoid this hesitation, offer your first work at no obligation. You should have enough confidence in your photojournalistic ability and skill in targeting the market to assure yourself that the client will accept the completed work. At the same time, you want to stipulate that in the event it is not right, you will be given an opportunity to reshoot. This is how I broke into *Robb Report, Club International,* and *Company* (UK).

- Always provide more than you're asked for. Let's say you've succeeded in selling a photo essay idea on U.S. Navy SEALs. The editor says twenty transparencies should be sufficient. After the shoot, you decide, however, to provide two pages, each containing twenty images, as well as five hundred words of text, including quotes from SEAL instructors and recruits. What you have done is provide a complete package. This makes the editor's life easier because he does not have to spend time and money searching for a writer. It also allows the art director greater freedom to choose from the array of material you have provided. By offering more, you have given the publication the option of using more and, thus, paying you more. The bottom

line is that everyone wins and, in the eyes of the client, you become a highly valued photojournalist (a member of the elite).

- Always deliver *before* the required deadline. This gives clients more time to review the material and, if needed, to request additional images.
- Always offer one free reshoot.
- Include a digital copy of your images, in addition to prints/slides. If you provide only print copies, the client will probably be required to get them scanned. Remember, your job is to make the client's job easier.

These are very simple rules to follow, and they will ensure that you and your products are sufficiently different from those your clients normally receive; therefore, they will make a lasting, positive impression. Packaging and sales approach is also extremely important in your product marketing, and we'll cover that in an upcoming chapter. At this point your focus should be on what you are offering—your product and services—and ways to make them the best.

Your Photojournalism Career

In most cases you will have to work fast to profit from the opportunities your services and products generate. For instance, when *Newsweek* asked me to cover the U.S. military installation bombing in Beirut, the editors insisted on exclusive, first rights to the images. Because they paid all expenses, a daily fee, plus $200 per image and even more if a shot made the cover, I agreed. However, knowing that the photographs would make a good contribution to my stock, I added a stipulation whereby I was free to sell the images to future customers after *Newsweek* ran their story.

My motives were two-fold: (1) *Newsweek* would be paying for my time and expenses; (2) using the *Newsweek* assignment as a lead, I would gain instant credibility with other publi-

cations I approached and could offer them banked images. And I was correct. Within one month after the original story appeared, I was selling the images to a U.S. military publication in Washington, DC.

Over the years I have developed a +2 formula for business success. Each time I provide a service or product, I try to get at least two spinoff benefits. In the case of the *Newsweek* assignment, for example, I enhanced my stock at no cost and was able to now utilize the magazine's name for future marketing efforts. Four months later I would also get a third benefit, when the photo editor of *Time-Life* called.

"I received your name and number from the Rome bureau chief of *Newsweek*. We're looking for a photographer in your area . . ."

Your images can often spin off into books as well. During the onset of the adventure travel boom, I was producing photo features on hiking in the Alps; bicycling along the Italian coast; scaling the volcanoes of Italy; diving among sunken, Roman cities; and even panning for gold a short distance from Milan. Using these as a proposal base, I landed a contract with publisher Michael Hunter for the highly illustrated, four-color *Adventure Guide to Italy.*

Spinoffs and cross-marketing are excellent ways to sell more of your services and products to potential buyers. Don't try to bite off too much all at once, however. Staying with the +2 theory, you can increase your sales at a steady, controllable pace.

My work has, ultimately, led to teaching and lecturing jobs—as it has for many successful business people. This takes us to your final "product." That is, *you.*

In 1988, after a series of marketing efforts to promote myself, I was featured in such publications as *Entrepreneur* and *Small Business Opportunities* (more on how you too can get such coverage in the following chapters). This coverage, together with some good networking, resulted in a call from MCI Communications. The company had a need in its marketing department

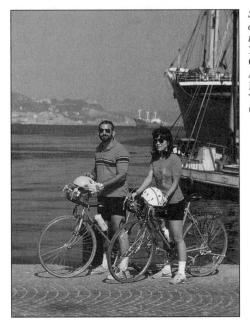

Setting up shots like this one of cyclers in Italy has been a key to the success of Strawberry Media. This image has appeared in Off Duty *magazine; Philippine Airlines' in-flight publication,* Mabuhay; *and the author's book,* The Adventure Guide to Italy. *© Strawberry Media*

for someone with my skills, not only for hands-on work, but to train others.

"We'd like to contract you for your abilities," said senior manager Randall Slocum.

At that moment, I realized that I was a product. Because of my self-marketing, one of the largest companies in the United States was about to hire me to fill a need; not as a result of my many published works, nor my knack for creating images and words on demand, but because of my *knowledge* and ability to teach it to others. During the next six years, I would make nearly $300,000 from MCI. Why? Because my product (me) filled its needs.

You, too, can fill such needs by examining your own talents. What groups would pay you to lecture? Pay you to teach? What can you offer businesses that will help them increase their profits? Remember, the flip side of filling a need is putting yourself in the client's shoes. What is the client's ultimate goal in hiring you?

In his book *Empire Building by Writing and Speaking,* Gordon Burgett says, "I believe that each of us knows something that others want to know or should know. What you know, or could, is the seed of your empire. And you share that kind of knowledge through writing and speaking."

When marketing yourself as a product, never limit your activities. Had I focused my efforts on, say, local newspapers, *Entrepreneur* would have never featured me and, as a result, the MCI job would have gone to someone else. Likewise, as a photojournalist you should market/promote yourself to a wide range of media outlets—as a photographer, a lecturer, a teacher, or a talk show guest.

Too often photographers, particularly early in their careers, or those living far from a major city, feel they have nothing of value to offer. If you are in this category, you need to study your "product" a little closer. An increasing number of radio and television talk show producers are turning to photojournalists with a particular expertise. Let's say, for instance, you were one of the photojournalists covering the World Trade Organization's conference in Seattle when the protesters made global headlines. Suddenly you are newsworthy—because you were there—and could easily become a radio or TV talk show guest. In most cases, photojournalists get involved in news stories every day—school shootings, political meetings, sports playoffs, and the like. National media cover all these topics, and producers of these shows need guests with knowledge of each topic.

At the close of the last millennium, several television programs—from CNN to NBC—were featuring photojournalists as expert commentators on their news programs. The only thing keeping you from participating in such programs is the producer's lack of knowledge concerning your work and your availability.

Thoroughly understanding the services and products you have to offer potential customers will make it easier to create a successful marketing strategy. Considering that your business

consists of three sectors—photographer for hire (service), stock images (products), and yourself (product)—you should spend time exploring ways in which to enhance each area, making each one more attractive to customers and, thereby, trumping the competition. In the day-to-day media battle, you must consider each segment of your business as a Task Force. Each has the ability, on its own, to achieve success. Working together, as a team, however, your photographic service, your stock, and your personal appearances can blanket the battlefield, cover more territory and ensure a major victory. You must go into each battle with confidence, and a winning spirit. There is no one more qualified than you are to fill your client's needs. There is no other photojournalist who can produce work as well as you. There is no other individual who has the knowledge and ability to pass it on to others as you. This is the mentality required to go into battle. Once you have this, you're ready for the attack.

Deck work aboard the aircraft carrier, U.S.S. George Washington, *was illustrated in a series of images that brought the author $1,000 from Mobil Oil's* Compass *magazine.* © *Strawberry Media*

Stories Through Images

What's it like to be a major player in contemporary media? To cover world events? To be in the heat of the action? What responsibility and role does the photographer play in telling the story—the real story?

I previously mentioned the World Trade Organization event in Seattle, Washington. Long-time photojournalist Jim Bryant was on the scene for that occasion and, below, provides some insight into the photo opportunities he faced as well as reflections on today's media. More important is Jim's "lesson" in telling the *true* story with one's camera and being a responsible reporter of contemporary news, without stooping to pure entertainment.

Photo-op of the Century

By Jim Bryant
© *Jim Bryant. All rights reserved.*
Used by permission.

Photographers from every part of the world, including this cameraman, were on hand to document the great and exciting times at the WTO's conference in Seattle. Outside of the incredible image impact generated from this "Battle in Seattle," of the masses against the WTO, was it really an event worth such extensive coverage?

From where I stood—and I stood generally in the thick of it all, being tear gassed, pepper sprayed, and even poked by police batons just to provide photo coverage while taking a week's vacation from the *Port Orchard Independent* to freelance for United Press International—the WTO was completely unorganized to begin with, and the protestors were mostly there for the action and had very little in the way of a cohesive and well-thought-out complaint.

But what the anarchists did to get attention—starting fires in dumpsters, breaking windows, and looting shops—robbed the demonstrator's anti-WTO message of its true meaning when the police were forced to use tear gas, pepper spray, and brute force to control the crowds.

The people intent on capturing the moment [on film] seemed at times to outnumber those actually demonstrating. This event went far beyond those whose job is to capture the moment. Protestors were ever aware of the lens being pointed at them—in the middle of a tense standoff between police and demonstrators, one man turned to the TV cameras and screamed, "How do you like your ratings now, media?"

This was The Three Stooges verses Our Gang! It was a complete non-event, except for the countless thousands of images taken of the demonstrators and riots. I imagine there will be a great many awards handed out to some photographers for the incredible impact of their images but as far as I am concerned there just wasn't a story here . . . even if it was a story mainly of the demonstrators versus the WTO and how it affected those living in Seattle. Substance verses impact. I suppose the real question is which images will win awards for the journalist, photographer, TV reporter, and cameraman, and boost TV ratings and sell more copies of the newspapers.

From most of the Seattle newspapers I saved, the photos of action got the front page of "A" section. The substance of the WTO issues got buried near the back of "A" section and on the business pages. I kept reading about this being a war between big business and the non-government organization that wanted to save family farmers, the air, the land, the trees and whatever else they could come up with saving . . . even turtles. This is just too simple; the arguments are voiced through articles and sound bites and tossed like grenades at the other side. The complexity of these issues are occasionally expressed in a well-thought-out fashion on the editorial pages of the *Times* and *Post-Intelligence,* but for the most part it is the sound bite and photos that define the issues for the common man. There are voices of compromise and reason out there trying to make real headway on the issues of world trade and an increasing interdependence between the rich and poor countries, but as long as the media shovels bites and impact at us these voices are drowned out in a sea of noise. It no longer matters what your ideals are as long as you know what buttons to push to turn on the media machine.

Am I old-fashioned to be sensitive to this issue? It's so easy to ignore the real issues while being mesmerized by the sensational. Look at what our TV and newspapers have to offer and it is clear what excites the common viewer. Do we [as photojournalists] have to drop to that level to entertain with that type of news? Do we partially subsidize and encourage this approach through the awards we receive for the impact and drama of our work? What do you think?

6

Packaging and Distribution

P ackaging and distribution are two primary aspects of any marketing campaign. Each year companies like Coca-Cola, Proctor & Gamble, and Ford spend millions of dollars to package and distribute their products in a way that will enhance sales. Their marketing staffs realize the importance of appearance and timely delivery, and so should you.

The method in which your work is submitted and presented will have a direct impact on the buyer's' emotional state—positive or negative—as they consider your material. It is my belief—and that of millions of successful business people—that you should use everything in your power to ensure that a buyer's initial look at your product is positive. Whatever you are trying to sell—a photo essay; book illustrations; your services as a photojournalist, a corporate or advertising photographer, a lecturer—you should always strive to make your product stand out from the crowd; make it unique. For example, I have invested a great deal of time as well as a few dollars in my stationery. While this may seem like a simple matter, I feel that good stationery

helps make sales. This is particularly so if it presents a professional "big company" image.

I had three goals in designing my stationery: (1) to promote all the products and services I offered, (2) to create a standard logo for each sector of my business, and (3) to make my company—thus myself—sound larger than life. In achieving these goals, I also succeeded in making the Strawberry Media stationery a marketing tool. Rather than take a standard approach, with the company name and address at the top, I ran a 4.5 × 28-centimeter box along the left side of the paper. This was then divided into six, even-sized boxes. The first box contained the company logo, Strawberry Media, in red. Under this was "promotions" in blue. Next came a box with the same red logo but, under it, in yellow, the word "communications." After this were the "editorial" (in black) and the "photo" (in green) boxes. Different typefaces were used for each of the words below the company design.

These four distinct logos, while carrying the business name, each pointed out various aspects of my operation. They told potential clients that I am not a typical freelance photojournalist. Rather, I am involved in a full-range of promotional, communications, editorial, and photographic activities.

The Big Image

I did not stop there, however. With the last two boxes I listed the address, phone, fax, and e-mail numbers for my North American office as well as my European office.

"When I noticed that you had offices on both sides of the world," one editor told me, "I was immediately impressed."

If the truth were known, anyone visiting my Shelbyville, Tennessee, office, would find my father sitting at a computer forwarding e-mails, opening business letters, and performing other administrative functions for me. The European headquarters, on the other hand, is a one-room office that I have established in my home. This does not, however, make the Strawberry Media

operation any less efficient than an editorial or stock photo service based in New York City.

If you are located in New York and have a relative or trusted friend in, say, Los Angeles, you could easily promote yourself as a multioffice operation. I am currently exploring a third office address—this time near Dallas—from which a friend will forward any business inquiries. The key is to project a large, corporate image, and have reliable people to pass along all inquiries.

My quest for impressive packaging goes beyond letterhead. The Strawberry Media logo themes were carried over to my envelopes and business cards. I then had four-color presentation folders designed, boosting the four different business logos. Whenever I am submitting photo essays, news images, articles, book proposals, or other projects to a potential client, it is delivered in one of these folders. Upon opening it, the prospective client finds the matching business card and cover letter on matching stationery.

As with any business, operating a professional photographic service requires an investment of both time and money. Don't be stingy when it comes to your packaging. At the same time, though, be sure you maximize the design, making it both informative and a sales tool. My own stationery and presentation folders offer a professional look and, at the same time, the multiservice design has generated a good deal of crossover work. In 1994, for example, I was writing press releases for a major company when, from my stationery, a sales manager noticed that I also work in the promotional fields. This resulted in the company hiring me to coordinate a direct marketing campaign. In turn, this developed into an annual contract that included advertising design as well. Because the ads required photography, I also handle this aspect of the company's business.

Another example occurred just last week with Earthwatch Institute. I had been trying to sell an editorial package to Mark Cherrington, editor of *Earthwatch* magazine. Even though

my efforts were unsuccessful, the editor had noted that Strawberry Media offered stock images, so he passed my name along to Elizabeth Brown in the publications department. She needed images for their new catalog and eventually purchased two shots for $265.

Temple of Poseidon at sunset, Sounion, Greece. This image, made by Randa Bishop, has sold many times—first in an advertising campaign. This was one of seven pictures sold for this job, bringing the photographer $28,000. This was also the lead image of the campaign, which appeared on TV as well as in Travel & Leisure, Gourmet, *and other North American publications. © Randa Bishop*

Offering a Complete Package

Recently an editor called me with an urgent need. He offered me only two days in which to shoot and deliver a selection of forty images, with captions, and five hundred words of text. To make things worse, while the magazine was produced by a high-tech printing operation, the editor was not connected to the Internet, or e-mail. I accepted the challenge just the same, as these are the kinds of jobs that good photojournalists become famous for.

I completed the shoot and writing in one day, then packaged everything in my traditional style, called UPS, and twenty-four hours later it was sitting on the editor's desk. That evening he called to say, "You can accredit this sale to your speed and superb packaging. The art director and printers love working with you."

What made my packaging—rather than my images and words—so unique that it would clinch this sale? Why was the art department and production staff so impressed?

In my package, I provided the text and captions in hard copy (printed form); prints of the images; graphics (which were not part of the original request) produced with a color printer; a CD containing the digital images and graphics, captions and the text in two standard word-processing formats (.DOC and .TXT). All of this went into a clear plastic envelope which, in turn, was placed into a Strawberry Media presentation folder. A cover letter was also included. I then completed the package with a business card—which fits into a slot inside the folder.

In the not-too-distant future, all editorial materials—text, graphics, and images—will be submitted electronically. Until that time, photojournalists like you will be required to know the capabilities—and limitations—of each client you work with. It is safe to assume that all editors today work with computers. Not all of them, however, accept digital images. In fact, it amazes me how many photojournalists utilize the Internet, thinking editors will accept digital images when, in reality, very few do.

To demonstrate this, I sent a message to Strawberry Media's forty regular editorial clients around the world—that is, customers that purchase at least six text/photo packages from us each year. Of these, only three accepted digital images. So, while you may be working digital, the global publishing industry, in general, is still years behind.

To overcome compatibility problems, always ask customers what formats they can read, or prefer. For those who do

accept digital images, be sure to provide work in standard picture formats such as JPEG, GIF, TIFF, and so on.

"I really like your *Philippine Jungle Adventure* article," Cindy Alpers, editor of the Internet magazine *Tropi-Ties*, told me recently, "but I cannot use it unless you can provide digital images."

The same week, James Randall, editor of Mobil Oil's *Compass*, faxed to tell me that, "Unfortunately, we cannot use images from a disc. We need slides or prints."

These two extremes illustrate the state of contemporary publishing. There are still mom-and-pop operations out there that work on a shoestring. At the same time, there are ultra-modern publications that require all material in digital format, transmitted by Internet or on CD, ready to print. The future of the publishing industry lies with the latter. For now, though, play it safe with your packaging and *always* ask the client if electronic submissions and the inclusion of a computer disc would be helpful. If the answer is *yes,* than by all means take the additional time and effort required to provide them. If, on the other hand, you are told *no,* you will have increased your professionalism in the eyes of the client by offering such a service.

If you offer text, supply it printed as well as on floppy disc in "txt" and "doc" formats. This cuts down on the editor's work—since there is no retyping required. Offering dual formats ensures that your text will be easy to read and manipulate. If you are sending articles by e-mail, there are also special requirements. For instance, should your work be sent as an attachment or as text in the body of the message? Again, it is always best to ask the editors if they do not specify.

Courier Delivery

Whenever possible, I send material electronically. Such delivery saves my time, as well as the client's. In addition, it dramatically reduces the overhead cost of shipping. When a package must go by so-called "snail mail," however, I sit that little creature on a rocket by using courier services exclusively.

There are several reasons why you should always use courier or express mail to deliver your work. First and foremost is the speed at which packages arrive. Much of the work you do will no doubt be timely. This means that it should reach the editor's hands as soon as possible. Even when deadlines are not a factor, getting the completed product to the editor quickly will make a good impression as well as get you paid that much faster.

Utilizing courier service also maintains your "big business" image. I know of no company that sends its important documents via regular mail. And, in my view, there is nothing more important than the work that generates the money on which I live. For this reason I opened an account with United Parcel Service (UPS) several years ago. By maintaining an account, I receive lower rates than I would pay at UPS pickup points. Additionally, the contract guarantees that the courier will pick up packages from my home/office, thereby saving me time. All I do is call the toll-free number for next day pickup. As a business, you also have the advantage of paying upon receipt of an invoice.

The final reason I suggest using courier or express mail is the Internet tracking systems provided by these companies. I did some work for *Pacific Stars and Stripes,* in Japan recently and sent it by UPS. A month later, I received a message asking when I would have the material completed. Going to the UPS Tracking Internet page—*www.ups.com/tracking/tracking.html*—I was able to view every movement of the shipment from the time it left my office until it was signed for at the receiving end, simply by inserting the Way Bill number. I then sent an e-mail to the advertising manager saying, "On November 17th, Becky Johnson signed for the material." Within an hour the editor had the package, and I had an apology.

UPS is not the only company offering online tracking. Here are others for your reference:

Airborne Express	*www.airborne-express.com/trace/trace.htm*
DHL	*www.dhl.com/track/track.html*
Emery Worldwide	*www.emeryworld.com/track/eww_trac.html*
Federal Express	*www.fedex.com/us/tracking*
United States Postal Service (for Express Mail only)	*www.usps.gov/cttgate*

7

Customer Service/Satisfaction

Many business empires have been built on superb customer service and satisfaction. And yet, these two words—*customer service*—are rarely, if ever, part of the photojournalist's business vocabulary. The true guerrilla marketer takes advantage of customer service, turning it into multiple sales and an expanded clientele. But satisfying customers is more than a postassignment task. It should begin with your initial approach, or proposal, and span the entire length of your business relationship.

I began thinking customer service many years ago when I received a message from the founding editor of *Robb Report*. It read: "We never give assignments to writers (or photographers) with whom we have not worked previously." Taking him at his word, I prepared my first editorial package (text and photos on Tuscan cuisine) for this slick, monthly magazine on spec. I was confident that I could produce material he would love. I was wrong. Fortunately, he was one of that rare breed of editors willing to nurture talented individuals, and he gave me a second shot. Detailing the specific problems he had with the original article and images, he asked for a second package. The result was "Tuscany Trails," a four-page spread that earned me $800.

When the editor of R&R Magazine *called the author, saying, "We need something that says 'games,'" he gave her exactly that. And she gave him $75.*
© *Strawberry Media*

Though the editor has since retired, I have gone on to do other work for *Robb Report*. The lesson learned from that first sale, however, forever influenced the way I do business. Whenever I pitch an idea to a first-time editorial client, I always offer to do the work on speculation. The reason for this is simple: In most cases, the editor has no idea with whom she is corresponding, or whether I am capable of producing material that matches her readership. Offering to provide material with no obligation gives the editor a guarantee. I am basically saying, "I will ensure your satisfaction, or you pay nothing."

Risky? Perhaps. Successful? Undoubtedly.

Many professional organizations of which I am currently a member, and in one case on the Board of Directors, disagree with noncontracted (that is, *spec*) work. If the truth were known, though, I believe we would find that perhaps 75 percent or more of their members are operating under such circumstances. The

fierce competition between freelance photographers and writers today requires us to accept on-spec work if we are going to acquire new clients. Photojournalists who insist on contract work and consider on-spec jobs a lowering of their professional standards are often the same people holding staff photographer positions—meaning they have a weekly paycheck coming in. I prefer to look at it from a marketing standpoint. Doing a job at no obligation is merely offering a guarantee. It is customer service at its zenith. More than that, it is opening new roads to future business. It is a marketing tactic—step one, so to speak—to reaching the contracted assignments.

The Italians have a saying that fits this situation perfectly: *"Chi non risica, non rosica."* While this translates to *Who doesn't risk, doesn't eat,* the concept boils down to this: If you never try, you are never going to achieve anything. Nothing ventured, nothing gained. That is why I offer on-spec work to first time customers—because it has allowed me, and can allow you, to make some great achievements. This technique has given me the opportunity to break into several national publications that, otherwise, might have rejected my queries. It enhances my chances of getting a green light from editors with whom I have never worked. Two months ago, for instance, I sent an proposal to Mark Walter, editor of *The Seybold Report on Internet Publishing,* a monthly trade publication. My interest in the magazine was twofold: (1) I had recently done some work on the Web site of the Italian fashion house Diesel, which I felt could be expanded to fit Seybold's needs and, (2) Seybold paid between $1,000 and $3,000.

Walter replied that the idea sounded interesting, but "I can't commission you to do it (because we have never worked with you), but I will pay for any work that we publish. Once we get beyond this, we could work on a longer-term and more regular relationship."

The completed package appeared in the February 1999 issue of *The Seybold Report on Internet Publishing* and brought

me $1,500. Since then, Mark and I have worked together on several projects. After the initial icebreaker, he wrote, "There is no need to work on spec for future work. We'll provide guaranteed assignments."

My thinking, when working on spec, is that, should the client ultimately not buy the material, I can always sell it elsewhere. At the same time, though, I make two stipulations in my "no obligation" approach. First, I insist that if the editor is not pleased with the completed material, I will be given an option to reshoot or rewrite, whatever the case may be. Second, I specify that future work will be by assignment only. In over twenty years of operation, I have had to use the reshoot option only three times—and in only one case did the editor ultimately not buy the new material.

Accepting All Jobs

Another aspect of customer service is accepting jobs that you are not always enthusiastic about. Currently I am working on a package for *R&R Magazine,* published in Germany. The topic is European motorcycle riding. It seems that the advertising department was given a truckload of money by Harley-Davidson. As a result, a motorcycle theme was scheduled for the July issue. There was only one problem: The editor had no story and no photographs.

When I was thirteen, I was in a motorcycle accident. That ended my interest in two-wheel vehicles. Because I have been selling material to *R&R Magazine* for twenty years, however, I was more than willing to help the editor when her plea came in. Why? Not because I needed the stress of a tight deadline, nor the mediocre fee that the magazine pays, but because it was my "duty" as a professional to assist the client when she needed it most. That is the essence of customer service.

All marketers realize that you cannot satisfy everyone. Customers who are pleased with your work, however, should be nurtured—cultivated like a rare plant. These individuals will be

the mainstay of your future income. In fact, recent studies indicate that 80 percent of a business's income normally comes from 20 percent of its clients. It is only natural, therefore, that you would want to focus most of your efforts and customer service on this 20 percent, while opening new avenues of income by continuously adding new clients.

When you take your car to a mechanic who gives you poor service, you undoubtedly will never go back there. If you receive fast, reliable service on the other hand, chances are excellent that you will return. Fortunately, you do not have to wait for a client's next oil change to gain additional work. In fact, you need to strike while the iron is still hot.

Upon completion of an assignment, you should immediately be thinking of new projects for the client. The book you are reading is an excellent example. Following the publication of *The Writer's and Photographer's Guide to Global Markets,* published by Allworth Press, I immediately queried publisher Tad Crawford about writing a book on aggressive sales tactics for writers. This resulted in *Marketing Strategies for Writers,* followed by *Successful Syndication,* and now this title. A chain of four books, simply because I was always thinking ahead and prepared to offer the client something that was needed, prepared professionally, and submitted on time.

Ask For More

If you have sold images or a story to a publication, this is the time to propose an ongoing relationship. In most cases, staff photographers are nothing more than freelance photojournalists who have successfully become part of the magazine's stable. They are also the ones producing most of the images and receiving the largest percentage of the company's photography budget. Getting yourself on the masthead and among the ranks of regular contributors should be your ultimate goal, if you produce editorial material.

During the past two decades, I have proposed myself as a contributing editor, or some other post, to over 120 newspapers and magazines. I've been successful about 10 percent of the time. My name has appeared on the masthead of *Armed Forces Journal International, Cardiology World News, Diplomat, Family, International Daily News, International Living, Internet.com, Off Duty, Scientific American Discovering Archaeology,* and *Writer On Line,* to mention a few. I have been a photo columnist, a travel editor, a technology editor, a foreign correspondent, and a bureau chief. Titles aside, I was basically a photojournalist assigned a weekly or monthly feature or column, with photographs. In one case, I eventually produced the editorial contents for three columns—photography, cooking, and travel—under different names.

The main point here is that, upon successfully selling an editorial package and ensuring that the client is pleased with your work, you should take the initiative to propose yourself as a regular contributor. Oftentimes, this means coming up with a niche that is not already filled by another photographer. *Scientific American Discovering Archaeology,* for example, is published in the United States. Because I live in Europe, and most of the magazine's contributors are based in America, it was easy for me to propose myself as the publication's Mediterranean/Middle East editor—particularly after my first editorial package became their cover story. I now hold this prestigious position.

Frequently, in my long-term proposals, I offer my services on a monthly basis and provide a listing of the first four projects I intend to produce. Each idea will consist of a one paragraph "pitch," giving the editor sufficient information to grasp the theme of the story. The proposal, at worse, will receive a *no* from the editor. At best, it will bring me steady, monthly work and increase my annual income by $18,000 to $36,000.

When putting together your own "contributor" proposals, always keep marketing in mind, that is, what does the editor need? How can I help the publication generate revenue through

From an archaeological site in Pisa came the remains of this sailor and his dog. The author sold it, along with three hundred words of text, to Scientific American Discovering Archaeology *for $300. It then sold to* Illustreret Videnskab, *in Denmark, for $200.* © Strawberry Media

my work? What niche market is the publication missing? A good way to do this is to pretend that you are the publisher. As such, your job is to generate money by increasing your advertising revenues. Now review a few recent issues of the magazine or Web site. Ask yourself, what niches are being overlooked? Where can we expand our readership? Or advertising? Or editorial? In the case of *Scientific American Discovering Archaeology,* my work opened the door for a collaboration between the publication and the Discovery Channel. When my photography column appeared in *R&R Magazine,* Minolta and Olympus suddenly became interested in advertising.

Always look for ways to help a client, even if there is no immediate return to you. Such customer relations yields long-term employment. When assignments and contracts do come in, always offer the client a guarantee. This is particularly impor-

tant for corporate work. The kill fee option—when clients offer to pay a percentage (normally 20–25% of the fee, plus expenses) of the agreed price if they are not satisfied with your work—is the best way to handle this. It gives the client an option to pull out of the deal, but ensures that you will receive some compensation for your time and effort.

If you are like most photojournalists, you approach an editor or photo buyer whenever you've come up with an idea that seems right for him, or when there is an event that needs coverage. Guerrilla marketers, including myself, will tell you that that is not the way to operate a successful business. Working this way, you are in the editor's mind, in most cases, only when you approach him. What you want to do is be in editors' minds constantly—and you want those thoughts to always be positive. The reason for this is very simple: continued work. Over the past three months, three editors and one art director have called me with assignments. Why? Because I was the first person they thought of when they needed material. I was on their mind.

Gifts and Goodies

To achieve this "ever-present" status, I take a series of actions to stimulate repeat business as well as enhance my company's visibility. In many completed editorial packages, I include discount coupons. These might offer free text (up to five hundred words) with the purchase of five or more photographs. Or I'll offer stock images (up to ten) at half-price. While the returns have not been overwhelming, I have had fair success with specially focused offers such as these, particularly toward the end of the year when clients are normally overextended on their budgets. The key to such coupons is to have an expiration date—twelve months, for example—to protect you as well as to stimulate immediate use.

I maintain a list of customers and periodically send them small gifts, which highlight the Strawberry Media name

and address, or promotional mailings. For Christmas I frequently send calendars for the New Year, so clients will have my address, phone number, fax number, and e-mail address at their fingertips.

One of the most productive freebie marketing products I've developed has been a customized disk of computer screensaver images, taken from our stock. It was a simple task to merge a promotional message over the image with Corel Draw—and there are several other programs you can use for this. As part of the message, I included both the company and my name and contact information. Next, I saved five of these "Computer Billboards" onto a floppy disk and sent them, along with instructions on how to apply them as monitor backgrounds, to my client list.

It only took two weeks before the thank-you letters began to arrive. One client—a university administrator—said, "Great screen backgrounds! Thanks! I've gotten a lot of comments on the volcano image since I configured it into my computer. The best thing, though, is that I won't have to go digging any more when I need to contact you."

Everyone likes to get freebies and, if it increases your business, you should dedicate time and resources to such items. It is important, however, that you always focus on items that will keep you and your company consistently in the minds of your clients.

8
Your Marketing Plan

L
ike anything done well, marketing requires planning. Setting out on a marketing venture without a precise plan is like taking a trip without a map; you can make right turns, left turns, but never seem to reach your final destination. Therefore, the more precise you are in your planning, the easier it will be to reach your goals.

The first factor in any marketing plan is a budget. Without knowing how much you have, or are willing to spend, it is literally impossible to prepare a working strategy. Without assigning money to your plan, what you are in effect doing is dreaming of what you would "like" to do, rather than what is realistically possible. Strange as it may seem, I have worked with many of today's Fortune 500 companies and had the marketing directors say: "Prepare a marketing plan for us, then we'll see if we have the funds to cover it."

Why is money so important? Just as a battle commander with a limited number of soldiers can protect only a certain amount of territory, a marketing director with a restricted budget can only spread the word so far. Let's say, for example, you plan to do a mailing to editors of fifty travel magazines. If your package is professionally done, the postage alone could cost over $200. After you have purchased stationery and presentation fold-

ers, and copied clips of published works to include in the package, if you do not have the $200 for postage, what you are doing, in reality, is spinning your wheels, dreaming. So be realistic about your goals and your expectations based on your budget.

There are ways to cut costs and still carry out a highly professional marketing operation. Using the Internet is an excellent way to dramatically decrease overhead. Samples of your work can be scanned and transmitted as e-mail attachments or you can direct potential clients to your Web page. Another method of lowering marketing costs is to create an introductory brochure for your services and products. This kind of brochure can be generated at a local print shop for very low cost and, if designed correctly, will fit perfectly into a standard envelope. Be sure, however, that the paper stock used does not exceed the one-ounce, first class mail weight limit.

During my years of operating the Strawberry Media Agency, I would periodically get promotional postcards from photojournalist W. Lynn Seldon, Jr. These were always printed in color, always very professional, and always had a message. For example, when he opened a Web site, the postcard read, "Lynn Is On-Line, *www.lynnseldon.com.*"

This was a very inexpensive means of letting potential clients know that his services were only a click away. On the address side of the postcard, in fact, there was even a brief overview of what the Web site offered: "Overview of services. Published articles and pictures. Books in print. 125,000+ searchable stock list. Sample photos, plus photos on demand."

Naturally, you do not want to waste money, but you also do not want to be so tight that it hinders quality. Keep in mind that after you have made the decision to operate as a business, you must then set aside a fixed amount of funds for marketing purposes. This budget, or lack thereof, will determine how your plan is laid out and executed.

For the most part, photojournalists should create two parallel marketing plans: the first to sell their services and stock,

the second to sell themselves. While each area has a specific focus and scope, they generally overlap one another. Each time you publish images in an article or book, you are, in a sense, marketing yourself. Too few photographers understand and take advantage of this fact—missing out on the promotional benefits of having their name in print. Those who do profit from this area are often those appearing on such programs as *Good Morning America* discussing topics that range from world affairs and national disasters to school shootings and police investigations.

Today on CNN, for example, a photojournalist who had covered the war-torn Balkans was a guest, talking about the success of NATO's role in Kosovo. Given the number of people who watch CNN, there was no doubt more than one photo buyer, book editor, or publisher listening to this individual. Some, in fact, may very well have been thinking that photos of that region might make a good book. He then may have made a mental note to call CNN for the photographer's telephone number. Such things happen more often than you might expect.

*Don't go overboard and dilute your efforts by trying to
do everything at once.*
—JOHN KREMER, *1001 WAYS TO MARKET YOUR BOOKS*

While laying out and executing a dual-marketing plan, much of
the basic logistics may be the same. Stationery, business cards,
and samples of published works will be required in both cases.
The chapters ahead will probe more deeply into creating each of
these, as well as a promotional media kit.

Keep It Simple

There is nothing difficult about a marketing plan, though I've
known many corporate sales directors who like to make it seem
so to justify their positions. For me it is a matter of $P+C=S$. That
is, Proposal plus Consistency equals Success. I begin by focusing
on a target market. Say, for instance, that your goal is to sell four
photo features each month. To achieve this, do your market
research, then send out two proposals a week—each on a differ-
ent subject. At the end of one month, you will have sent out eight
proposals. At the same time, maintain a list of publications
where you can send ideas if the original letters come back reject-
ed. To expand your efforts—and use the shotgun submission
method—try sending each query out to five markets around the
world (each one targeting a different country).

Eventually, assignments will come in. Don't stop your
marketing efforts there, though. This is where the "C" or consis-
tency comes into play. Keep sending out two new queries each
week. After three years of utilizing this method, I found myself
with over 250 queries out and more than twenty assignments at
any given time. I ultimately stopped using the $P+C=S$ method
because I could not keep up with the work flow—a position I
hope you will soon find yourself in.

The $P+C=S$ plan can also be applied to book projects, cor-
porate work, and even self-promotion. It should, in fact, be inte-
grated into all your marketing efforts. If you find it too difficult

to maintain the pace—and eventually you should—then divide your efforts between marketing of services, products, and self. For instance, week 1 send out queries for editorial work; week 2 send out self-promotional media kits. Alternating weeks will keep you stimulated and also allow time for your mind to think of new ideas and markets.

You may be asking why you can't simply do a mass mailing of your media kit. You could. There are several problems with this method, however. First, marketing costs would be high right away, rather than spread out over a period of time. Second, you might experience a rush of interest then, six months later, find yourself sitting alone with no work and no media interest in you or what you have to say. For these reasons, your efforts should be precisely targeted and consistent. Don't let a week go by without doing something to sell your work and market yourself.

Though I am always looking for opportunities, I maintain a monthly and annual list to ensure that nothing is forgotten. It is now, for instance, February. My list says:

(1) Week 1: Query ten newspapers around the world—same query to each—for photo essays on Summer Cruises in the Mediterranean.

(2) Week 2: Send media kit to ten TV producers, offer to speak on the importance of images in the media of 2000.

(3) Week 3: Send book query to ten publishers in New York. Topic: A coffee-table book of the top ten archaeological discoveries of the twentieth century.

(4) Week 4: September is back-to-school month. Send media kit to ten universities and offer my services as an instructor for photojournalism seminars.

This very simple, one-line plan keeps me on track. As ideas and projects come to mind, I add them to the list. The result is a constantly growing marketing plan that is easy to follow and, if necessary, can be altered based on daily developments and incoming assignments.

The key is to have a written "map" to follow weekly and monthly. Make sure that all your efforts fit the budget you've set aside. And, most important, maintain a consistent plan to sell your work and yourself.

5x5 Matrix Marketing Plan

When asked what a marketing plan should be like, author and publisher John Kremer pointed out that it should take into account the potential audiences, how you plan to reach these target markets, the price of your product and/or services, and what you expect to gain from sales—that is, your financial benefit.

"When I generate a plan," says Kremer, "I use a 5x5 matrix marketing plan. I list five major audiences for my book [or service], prioritized 1 to 5. Then under each of these five audiences, I list the five major ways I plan to reach each of them. I start by brainstorming lots of ways. Then I select the five best ways—as determined by what I think I can actually achieve—due to restrictions in my time, money, and other resources."

In these few words, the concept behind all marketing plans has been described. Kremer goes one step further, however, to point out that from this matrix, a time line must be projected, taking into account lead times. For example, if you were trying to sell images on winter sports to an editorial client, you would not want to market it in October or November, due to the required lead time. Similarly, trying to sell a seminar is best done several months before you would like to begin. This will give the organizers sufficient time to prepare their own promotional materials for your class.

In general, you should allow at least six months lead time for magazines, whereas newspapers can often work within a one-week window.

"Radio shows," says Kremer, "vary from about a week to one month. Within this time line, I prioritize the activities that I believe will provide me with the best return on my company's investment of time and resources."

Magazines, Specialization, and Advertising Clients

I first met photojournalist Bob Schwartz in the mid-1980s. He had recently transferred from Hawaii to Europe and, after reviewing his images, I quickly agreed to represent his work through the Strawberry Media Agency.

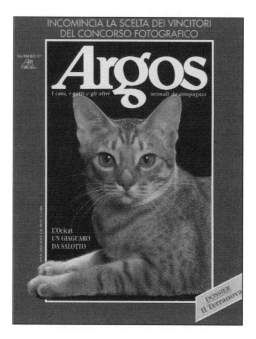

One of over fifty covers photojournalist Robert Schwartz has done for the Italian cat magazine Argos. *© Robert Schwartz*

Over the past two decades, we've sold hundreds of Bob's images around the world. While our initial sales focused on travel images and themes for magazine photo essays—that is, stamps from little countries, military battle reenactments, antique car rallies—Bob eventually began specializing in cat photography. He has become, in fact, one of the best cat photographers in the world, and certainly *the* best in Europe.

His business now focuses, almost exclusively, on advertising photography involving felines.

Because of his extensive photographic and marketing background, I felt it would be valuable for other photojournal-

ists, like yourself, to hear what Schwartz has to say about working with magazine editors, specializing, and handling advertising jobs.

Question: In your view, do you think a photographer should try to focus on working with only a few, select publications, to become known as "part of the team" so to speak?

Answer: In my view, a photographer should work to the limits of his production capacity and with whomever he can. This is especially valid for photographers who have not established a strong stock photo archive. I wouldn't limit myself to just a few magazines and, if I did, I would avoid situations in which all were owned by the same publisher. Publishing houses sometimes go bust or change owners, either of which could leave a photographer whose clients are thinly spread in a bind.

Question: What advantages does magazine photography offer a young photojournalist?

Answer: My theory is that each month publishers all around the world are faced with the problem of filling up millions of blank pages. Anyone who can lend them a hand by supplying the right material will most likely be considered an asset.

Question: What are the drawbacks, in your view, of working with magazine editors?

Answer: None, really. If one has decided to leave (or not pursue) the "9 to 5 steady-paycheck-way-of-life," magazines are a great way to go.

Question: What advice would you give a photojournalist interested in pursuing the magazine market?

Answer: Be professional! Some years ago, a magazine I worked for was sold to another publisher and, as a consequence, a completely new staff replaced the old editorial employees. Since this meant I would probably have "to prove myself" all over again to the newcomers, the insecurity that lurks in all freelancers reared its ugly head. I asked the former editor why he seemed to prefer me to my colleagues, even though some

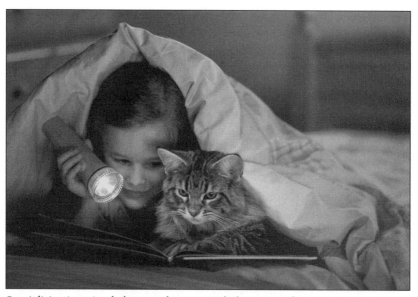

Specializing in animal photography—particularly images of cats—American photojournalist Robert Schwartz was able to capture the eye of Iams Pet Food International. As a result, he has become a top advertising photographer. Among his signature images is this photo for Doner International Advertising, London, England. © Robert Schwartz

of them were (in my opinion) better photographers. He said it was because when he asked me to do an assignment I never created problems and I never missed a due date. This surprised me, as I imagined this was a perfectly natural way for photographers to behave. A few years later I had occasion to hire some of these colleagues and discovered firsthand just what my former editor meant. They made supplying me with the photos I needed, when I needed them, seem an almost insurmountable problem.

The second tip is one I disagree with in principle, but have to acknowledge as valid in practice: Specialize. One will go further, faster if he is becomes known in any specific field.

Question: Any tips on getting in the door?

Answer: Except for perhaps patience and perseverance, there are no magic formulas that give instant access and which can be applied to everyone. Ensuring that the material or

idea one submits to the magazine is 100 percent in line with what the magazine is already publishing will show that one has studied the targeted market and thus greatly increases the chances the material or idea will be considered. Just keep knocking on as many doors as possible as often as possible, and eventually one will open.

Question: Could you provide an assignment example that you consider "your best" with regard to pay, editorial cooperation, and quality of publication?

Answer: Can't think of any that meet all three of the stated criteria (with pay being the usual weak link). The one that comes closest was a story idea I proposed to a pet magazine I had been working with for a number of years regarding a new breed of domestic cat that had been developed in Kenya. Because of some contacts I had developed over a period of nearly a year, I had a strong inside track to a story that would have been very difficult for just anyone to do. I decided that this "scoop" was worth more than the usual fees the magazine paid and, along with my story proposal, I submitted a fee proposal about five times the usual amount.

As luck would have it (and unbeknownst to me), my proposal came at a time when the magazine was about to relaunch itself, so the usual budget restraints were loosened and they readily agreed to my price. The Gulf War was on, so when I went to book the trip, I discovered that due to the war many people had canceled their tours. I could get two weeks in Kenya for two people for less than the normal cost for one week for one person. So besides being paid a rather handsome fee for the story, I also spent two weeks with my wife in a beautiful seaside resort with only ten other guests, in the sun and away from a freezing cold January Milan. The magazine ran a teaser poster from the story, plus a newsstand poster with the issue before the one with the actual story. In the issue in which the story appeared, I had the cover, another poster, and ten pages.

Question: Could you provide an assignment example that was a disaster for the same reasons (only the opposite).

Answer: I've never had any editorial assignment "disasters." I have had many instances in which a lot of on-the-spot improvising and frantic scrambling were needed to get the pictures, but I imagine that is true for anyone in this business.

Question: How did you break into advertising photography, after doing magazine work for so many years?

Answer: I've actually been in, then out of, advertising photography, then in again. When I was in Hawaii in the seventies, I did quite a bit of advertising and public relations photography and very, very little for magazines. When I got to Italy I wanted to travel more than work in a studio, so I switched to magazines and went around the world a couple of times. After several years of doing just about anything any magazine wanted, I settled into animal photography. The travel was still good, but starting to diminish as costs went up and magazine budgets went down. As my animal photography (mostly cats) was being published all over Europe, about five years ago someone at the head European office of Iams Pet Food saw my work and called me to Holland for an interview. I've been doing their ads ever since.

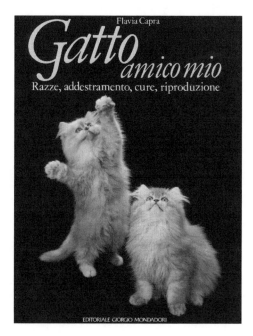

This book on cats, published by Giorgio Mondadori, utilized Robert Schwartz's images of cats. © Robert Schwartz

Question: What would be a good approach for a photographer wishing to get into advertising work?

Answer: Ad agencies love specialists, so the first thing to do is decide on one's specialty, then do some self-assignments to have examples of work to show. Find an agency that has clients in (or real near) one's specialty, seek an appointment with the agency to show one's book, and hope. If one is really good, or if it just happens to be the day the art director has decided to change photographers, the door may just open.

My experience in Hawaii was pretty much as I described here—a lot of knocking on doors and dragging around a portfolio. My experience in Europe was better—they came looking for me.

Question: What are the benefits to advertising work?

Answer: Pay is real good. As opposed to magazine work, ad photography is a real team effort between the photographer, art director, ad agency people, and client. And unlike magazine shots, ads are usually very structured, created shots as opposed to capturing life as it passes by one's lens.

9

Selling Your Expertise

By 1982 I had already achieved a fair amount of success as a photojournalist for local publications and newspapers. Like thousands of others, however, I entertained visions of bigger and better things, of national publication, of global success, of exotic and even hazardous assignments for the likes of *Time* and *Newsweek*. This was the same year, after a semester of college marketing at the University of LaVerne, California, that I began to think of myself as a product.

> **pro·duct** *n.* 1. Anything that fills a need or desire and can be offered to a market.

Because a product is generally categorized as an object, a place, an organization, a service, or an idea, you rarely consider a person—let alone yourself—as a product. In a marketing sense, however, that is exactly what you must become to achieve commercial success. Granted, as a photojournalist, you will most often be hired for your services, that is, producing press images, photo essays, or photographs for book illustration. Or perhaps

you will be contracted to teach a photojournalism seminar, or give a lecture. While these are all services you provide, the true product is *you*.

All marketing experts—particularly guerrilla marketers—realize that a successful product must have three primary characteristics. It must first provide a benefit. Second, it must have a brand name that customers recognize. And, third, it must come with a guarantee of after-sale satisfaction. How do each of these apply to you? That is the exact question I asked myself in 1982, and what you must ask yourself now. Your immediate reaction, as was mine, might be that you offer no benefit, that no one recognizes your name, and that you cannot provide any form of guarantee. Before jumping to such conclusions, however, let's look more closely at each of these categories.

What Benefit Do You Offer?

There is a mystique to the photojournalism profession that almost instantly gives you a celebrity status. My career has gained me invitations to the homes of ambassadors, Hollywood producers, and politicians. It has opened the door to guest spots on television and radio programs. Long before reaching this level, however, I was considered, by many, to be a local VIP. Why? Because my name regularly appeared in print. People saw my photographs and, when I provided text, they read my words. What I said and captured on film influenced people, whether I was covering a political rally or suggesting a low-budget vacation. I was, quite simply, part of what is commonly termed the "power of the press."

I quickly learned to use—but not abuse—this power to my advantage. When in London I received complimentary tickets to top musicals thanks to the PR department of Andrew Lloyd Webber's production company, The Really Useful Group. In Rome, I dined at La Sans Sausi, famed hangout of Jackie Onassis. The director of the Philippine National Tourist Office made me his guest in Manila. And I was offered a complimenta-

ry helicopter ride over New York City, simply to obtain photographs from a unique angle.

These few examples demonstrate how you and I are different from the rest of the world. We are the press, the media, and the news. In an exaggerated sense, we generate the ideas and concepts that people will discuss over breakfast and dinner. We provide the facts that will alter the decisions of the public. And that makes us unique. That makes us special. That makes us celebrities.

Inasmuch as we can utilize our media status to gain access to places where the normal citizen cannot go, and can produce images and articles of varying degrees of influence, what real benefits do we—as products—have to offer?

To answer this question, we need to go back to the essence of guerrilla marketing: filling a need. If you were an editor in need of illustrations, a photojournalist could certainly be beneficial. If you were a business executive in need of event coverage, PR images, or illustrations for the corporate report, you would no doubt be looking for a top professional to handle the job. And what about the university administrator who has scheduled a photojournalism seminar? Where does she go for an instructor? Then there is the local Rotary Club, which needs to book keynote speakers for each of its monthly meetings. A local photojournalist would fit that bill perfectly. Perhaps you have noticed the increasing number of writers and photographers appearing on regional and national television programs in recent years, or speaking on the radio about particular topics in the news—many of which they have covered.

The needs for photojournalists are literally endless, and so are the benefits you can offer. By marketing yourself, you are offering to fill needs that grow daily. You are the expert, the celebrity, and the magical person with the ability to take magazine and newspaper readers to new worlds, to make them laugh, cry, and wonder. Yes, you do offer benefits. Once you realize this, new horizons of opportunity will begin to appear.

But what about name recognition? There are certainly people who have seen your work; perhaps you even have a following. If not, don't worry. Name recognition is something you can build. When I began my first "Mike Sedge" marketing campaign, for example, I was literally unknown to all but a few local readers. Within six months, however, I was featured in several business and specialty publications, including *Entrepreneur*. Suddenly I was getting letters from former high school friends, living thousands of miles away. My relatives began calling me "the celebrity."

As the snowball grew, so did the money-making opportunities—teaching, lecturing, and staff photographer positions, brochures, and, ultimately, a corporate media contract resulting in nearly $300,000 over the next seven years.

> *Don't just toot your horn . . . BLOW the DAMN BUGLE! You may have the most terrific book (or product) ever, but if no one knows about it . . . it won't sell.*
>
> —JAN LARKEY, WRITER, SPEAKER, CONSULTANT

Name recognition is a matter of perspective as much as it is a matter of position or status. To illustrate this, take a look at the following names and see how many you recognize:

1) Bill Gates
2) John Hendricks
3) Madeleine K. Albright
4) Mary Ann Elliott
5) Norman H. Schwarzkopf, Jr.
6) T. Joseph Lopez
7) Stephen King
8) Frances Mayes
9) Steven Spielberg
10) Jeffrey Katzenberg

If you are like most people, you guessed all of the odd numbers, that is, 1, 3, 5, 7. And yet, the people listed beside the even numbers have as much prestige as do those before them. In fact, they hold very similar positions. While Bill Gates is CEO of Microsoft Corporation, John Hendricks is founder and CEO of Discovery Communications, Inc. (the Discovery Channel). Mary Ann Elliott, CEO of Arrowhead Space and Telecommunications, Inc., was recently nominated as one of Washington's most influential people, along with U.S. Secretary of State, Madeleine K. Albright. We all know General Norman Schwarzkopf from the Gulf War, but how many recognize the name Admiral T. Joseph Lopez, former commanderin-chief of Allied Forces–Southern Europe, during the war in Bosnia? Author Steven King, at number 7, is the Edgar Allan Poe of the twentieth century. But did you know the author of *Under the Tuscan Sun* and the sequel *Bella Tuscany,* Frances Mayes? If you answered *yes,* I congratulate you. If you said *no,* it might surprise you to know that *Under the Tuscan Sun* was on the national bestseller list for nearly two years, and *Bella Tuscany* earned bestseller status as well. Finally, we come to Spielberg and Katzenberg. No doubt 75 percent, or more, of the U.S. population recognizes the director of *Jaws, E.T.,* and *Schindler's List,* but perhaps only 2 percent know who Katzenberg is. They are, however, partners in the film production company Dreamworks SKG.

So why do people recognize Spielberg, but not Katzenberg, or King and not Mayes? Very simply because the latter individuals are not in the media spotlight. For the most part, they do not appear on global television, do not participate in national radio interviews, and are not featured in national or international publications, while their counterparts are. As a result, Bill Gates and Norman Schwarzkopf have become household names.

Photojournalists can learn to build name recognition simply by taking advantage of media opportunities—sometimes even creating them. In addition, you can enhance your name—

even if you are unknown—by associating it with companies that you have worked for or have some connection with. In a cover letter or press release, for example, I could easily present myself as follows:

> Michael Sedge, a 25-year veteran photojournalist, has worked for many of today's top media. As a member of the American Society of Media Photographers, Sedge has published thousands of images and more than 2,800 articles, as well as eight books. He is a contributor to *Scientific American Discovering Archaeology* and has been featured in many magazines and newspapers.

There is nothing wrong with this presentation. It's to the point, highlights my longstanding professionalism and reliability, and indicates prestige by mentioning my affiliation with *Scientific American Discovering Archaeology*. Look at how much more impressive the presentation becomes, however, by dropping a few more names:

> Michael Sedge is a 25-year veteran photojournalist, with thousands of published images, articles and eight books to his credit, including the award-winning *Commercialization of the Oceans* (F. Watts). Among his global clientele are the Associated Press, Newsweek, the Discovery Channel, and Time-Life Books. Recently hired by *Scientific American Discovering Archaeology* to cover the Mediterranean and Middle East regions, Mr. Sedge has been called "the wizard of marketing" by *Entrepreneur* magazine.

In this single paragraph, I've suddenly generated name recognition. Not because a potential client would know *me*, but because I associate myself with world-famous names such as *Newsweek*, the Discovery Channel, and *Scientific American*. I could just as

easily have said, *Going Places Doing Things, The New Entertainer, R&R Magazine,* or *Tropi-Ties.* But other than a very limited readership, who knows these publications? Including these, in fact, would achieve just the opposite effect: They would lead potential clients to the question, "What are these publications, and who is this guy?"

I even go one step further in my quest for name recognition by including a quote from *Entrepreneur.* Reading this, a possible client might say to himself, "Wow, this guy has been around. I can't believe I've never heard of him!"

And that is exactly where you want him to be, thinking to himself, "I'd really like to get this guy to be a guest speaker, an instructor, a contributor for our magazine, a staff photojournalist. But can we afford him?"

Fortunately, I've been able to weasel myself into these positions many times, and so can you. In most cases the results are steady, well-paying jobs. In some cases, the potential client was right—she could not afford me.

My goal in this chapter is to get you thinking about self-promotion, as well as to provide insights that will lead you to your own name recognition opportunities. First, however, let's explore the last area that would qualify you to be considered a "product." That is, the guarantee that you can offer.

The second self-promoting paragraph above immediately indicates that I am reliable and, thus, implies a guarantee to anyone who hires me. The fact that you have past credentials is insurance that you can and will complete a job in a professional manner—whether it is a speaking engagement, teaching a seminar, or covering a local, regional, or national event. Your reputation, in other words, is your guarantee.

A photojournalist who does not meet deadlines, does not show up for appointments, does not provide a high-quality service or products will soon be weeded out from the garden of productive professionals. Why? Because he cannot offer the guarantee that clients must have in order to hire him. Can you

This photo of Six Flags theme park, taken at a unique angle, ran as a full–page image, and brought the author $100. © Strawberry Media

imagine going to a car dealer and ordering a new vehicle with no indication of when it will be delivered? You would no doubt go to another dealer. The same is true for your clients.

What's in a Name?

The first step in self-promotion, or selling yourself, is mindset. You cannot simply sit down and say, "Well, today I guess I'll put myself on the auction block." It doesn't work that way. Just as *The Making of a President* illustrated the activities that go on behind the "selling" of a presidential candidate, you too must be involved in the day-to-day ongoing marketing efforts that generate media coverage. These, in turn, will make your name known locally, regionally, and nationally.

Let's imagine, for example, that I am a local politician. A friend has suggested that I contact you because of your professionalism, media contacts, and ability to produce truthful, yet positive profiles through your photographs. We establish a meeting and during our discussion, I point out that I want photos for

PR, media kits, and newspaper/magazine coverage—that is, you will travel with the candidate and project him in a positive light through your images.

You think about it for a while, then accept the job. Now imagine that *you* are that politician. This client-employee relationship is the mindset you must have in order to do justice to your self-marketing. Your editorial business is now the PR firm and you are the client. This campaign is not *The Making of a President* but *The Making of [Your Name]*.

There are two forms of media exposure: advertising and promotion. The distinction between the two is quite simple: You pay for the first, the second is free. I don't know why any photo-journalist would ever advertise, though I have known some who did—with very little success, I might add. What you want to garner is free promotion. You want articles about yourself to appear in as many media outlets as possible; you want to appear on television; you want to be a guest on radio shows; you want to be invited to talk to groups. The more exposure you get, the more work you will receive.

Veteran travel writer and frequent contributor to *Travel & Leisure* Bern Keating and I once collaborated on a series of audiotapes covering Italian walking tours for Tape Guide International, Inc. One day I asked Bern, "How did you get involved in this project?"

"I'd been invited to talk about travel writing at an ASJA meeting. After the lecture, the owner of Tape Guide came up to me and offered the job."

Assembling a press kit, or media kit, as they are sometimes called, is the first step in your promotional efforts. Just as a politician needs material for her kit, so will you. Some of the standard items in such packages are a press release, a feature article, a list of questions and answers, and a photo of you. This material will, most often, fill the needs of any editor or producer receiving it. A business card should also be included, in the event that additional information or interviews need to be arranged.

If your business is established under a name other than yours, it will be much easier to produce a credible media kit. If not, ensure that your name is presented as a company, rather than a person. For example, John Smith & Associates or John Smith Company. Then, when you produce press releases, you become John Smith, founder and CEO of John Smith & Associates.

It's the big name game all over again. Another option would be to come up with a brand name for such activities. A brand can be any name, symbol, or logo used in selling a given product or service. You may be operating as Ellen Epstein, photojournalist. For your press kit, you might select a brand name of EE Editorial. In the past I've utilized such brands as Michael Sedge & Associates, the Sedge Group, Medusa Photos, and 3 Kings Communications. In each case I designed a logo from the brand title and used it on the cover of media kits as well as stationery and business cards.

When Naples won the Italian soccer championship, the fans went wild, as this image illustrates. Marketed by the Strawberry Media Agency, the photo appeared in publications throughout Europe and Asia.
© Strawberry Media

What's important is for you to distance yourself from the media kit presentation—in the eyes of the client. This means no first person *("I")* in the press release or article, unless it's used in a quote, and never use your own name as a contact point or to sign cover letters. There are ways to get around this, even though you may be a one-person operation. I utilize my Strawberry Media presentation folders for all press kits, along with the company stationery. Additionally, I have business cards printed for Gabriella Giugliano (my wife), and have given her a title for this purpose—public relations manager. Her name goes on all cover letters and she is listed as the "point of contact" for additional information.

Distancing yourself makes everything more professional, more big league. If you were requesting information on John Hendricks, founder and CEO of the Discovery Channel, would you expect to receive it directly from Hendricks? Of course not; he is much too busy for that. The company has a public relations office to handle such things. This is the exact image you want to project for your business. You are the Big Cheese, the Grand Swiss, and, below you, are the Tiny Cheddars doing your PR. Having an executive image will also make potential clients want you that much more. It's just human nature; everyone desires things that are difficult or impossible to have.

Creating Your Kit

The first line of attack in self-marketing is a press release. A good release is the secret to getting media attention and getting your name in the public eye. Here is where the *"journalist"* part of your photojournalism career must take over.

For many writers, a press release is something that one creates after publishing a book. Granted, authoring a book is an excellent, newsworthy excuse for sending out such notices. Guerrilla marketers, however, don't sit around waiting for such obvious opportunities. They create their own news. They are constantly thinking of reasons for an editor or producer to men-

tion them, to invite them to speak, to have them as guests on their programs.

I've written hundreds of press releases, many of which were for myself. Without flooding the market, I try to put out a notice that will generate name recognition and/or increase my clientele every other month. Here are some of the titles of my non–book-related releases:

- Local Photojournalist Teams up with Discovery Channel
- Sedge Nominated as Regional President of IFW&TWA
- Marketing Wizard Targets U.S. Military
- *Newsweek* Photographer to Speak at University of LaVerne
- NATO Commander Honors Peace-Keeping Photojournalist
- Italian Fashions, Through American Lens
- Images of Sunken Roman City Revealed
- Bosnia: Lost Generations

I utilized my assignment for the Discovery Channel to "make news" about myself in local newspapers and city magazines. By associating myself with the popular television network, I was instantly categorized a celebrity and, therefore, made the local entertainment sections. In the second release, I used my nomination to the regional presidency of the International Food, Wine & Travel Writers Association to gain exposure in both travel and gastronomy publications. Because I also sent this release to TV and radio stations, I was asked to be a guest on a television program about Italian cuisine.

Marketing Wizard Targets U.S. Military. This headline, followed by a 224-word news story about my efforts in media targeted to service members, led *Entrepreneur* magazine to feature me in a two-page spread, with a color photo. They utilized nearly the exact wording, calling me the "Wizard of Marketing." This, in turn, brought me the best-paying, long-term corporate contract I have had to date. It also generated several speaking

engagements and opened the door to other opportunities. The article appeared more than ten years ago and I am still reaping the benefits. Not long ago, in fact, I received a call from Bob Helms, assistant advertising director at *European Stars and Stripes*. He asked, "Are you still writing and doing military marketing?" Naturally, I said *yes*. "Great. I am going to give your name and phone number to a businessman in London. He is looking to contract someone to boost his sales in this market. I figured with your experience and media contacts, you would be the perfect person."

I eventually got the call, and the job.

Each of the other press releases focused on some aspect of the work I was doing at that time. When I covered fashion, I sent a release out to the top magazines in that sector. After covering NATO activities in Bosnia, including the NATO commander, Admiral T. Joseph Lopez, I was presented with an award for excellence in journalism. This was a newsworthy topic for both international newspapers and trade magazines. I then followed up on the coverage gained by this with a second press release on the continued struggle in Bosnia, as seen through the eyes of a photojournalist, even after the war.

The more closely you can link your press release to a news topic, the greater your chances of obtaining coverage. Using recent assignments, I have found, is a good way to become an instant expert on a subject—particularly if your goal is to get on television or radio shows. Say, for instance, you've covered abortion protests, race riots, political conventions, natural disasters, or similar events for a state or national newspaper or news agency. These are common topics of today's talk shows and you, having firsthand knowledge and coverage, are a perfect candidate to discuss them. You might even go one step further and offer producers an opportunity to show "exclusive" images from your work; everyone in the media business loves the "exclusive" buzzword. If you have covered the event for a major newspaper or magazine, try getting the publication involved in a

cooperative effort. In this case, they pay for the printing and mailing of the press releases in exchange for the magazine being mentioned in any radio or television appearances you make.

During the past month, several magazine editors and contributors have appeared on NBC's *Today* show discussing various topics—health, money, hurricanes, protects, aging, and the like. In nearly every case, the host says, "You can obtain more information on this topic in the next issue of *XYZ Magazine.*" For photojournalists, there is a very important underlying message in that phrase. It tells you to get a press release out to media sources as soon as you have an assignment from a major magazine. Why? Because it allows producers to schedule you as a guest at the same time that your images are set to appear in print. This, in turn, provides an excellent opportunity to get the magazine involved. The exposure will create greater sales of the publication as well as enhance advertising sales—and will certainly help you obtain future assignments.

If you are unfamiliar with press release formats, you'll want to take note of the sample that follows. Always provide a point of contact for additional information. List a telephone number and, if you have a fax, that number as well. You should also include an e-mail address. To maintain your "big company" image, I suggest establishing a second e-mail address that does not include your name—that is, a "business" address. For example, I often use *SMEDIAPR@cybernet.it* rather than *MSEDGE@cybernet.it.* Anyone receiving the release might therefore think that it came from the Strawberry Media Public Relations Department. That is exactly what I want them to think.

Your release should also contain a date or the words FOR IMMEDIATE RELEASE. If the information is time sensitive, you should state, "NOT TO BE RELEASED UNTIL (date)." A good example of time-sensitive material is the annual list of "The Most Boring Celebrities of the Year" put out by marketing whiz, Alan Caruba. While he wants the release to be in the hands of editors and producers, he also wants a simultaneous distribu-

tion of the information, resulting in a media blitz. To achieve this, Caruba specifies a day when the press release can be used.

Strawberry Media **NEWS** *release*

Contact:
Gabriella Giugliano
Public Relations Manager
Tel. (39) 081-851-2208
Fax. (39) 081-851-2210
E-mail. SMEDIA@cybernet.it FOR IMMEDIATE RELEASE

NATO COMMANDER HONORS PEACE-KEEPING PHOTOJOURNALIST

Naples, Italy -- Admiral Jack Sampson, Commander-in-Chief, Allied Forces Southern Europe, honored American photojournalist Michael Sedge today for his professionalism and reporting of positive, humanitarian aspects during the recent conflict in the former Yugoslavian territory of Bosnia.

"If there were a rose growing in a junkyard, Sedge would find it and capture its beauty," said Sampson. "This is what makes his journalism unique, heart-warming. Our goal, as military leaders, is not to fight wars, but to maintain peace. If more reporters took the example of Michael Sedge, our job would be much easier."

During the ceremony, attended by military officials from various Southern European NATO commands, Sedge was awarded a certificate and meritorious medal for journalistic excellence. It was the first time such an award has been given to a photojournalist.

"Too often, world media plays a negative role in conflicts such as Bosnia," explained Sedge, a native of Flint, Michigan. "Behind the scenes, there are humanitarian efforts taking place that are rarely seen or recognized. I consider it my responsibility to point these out. Others will provide the details of daily conflict and body counts."

The award was specifically given for Sedge's editorial feature in *Diplomat* magazine, published in the United Kingdom. The story, titled "Four Star Peacekeeper," photographically documented the efforts of Admiral T. Joseph Lopez, former Commander of NATO peace-keeping forces in Bosnia. Now retired and living in Arlington, Virginia, Lopez said it was one of the finest stories ever published on the efforts to maintain stability in this war zone.

Sedge, who directs the global editorial agency, Strawberry Media, has covered U.S. and NATO military affairs in the Mediterranean and Middle East for nearly twenty years. His clients have included The Associated Press, *Armed Forces Journal International, Army Times*, and *Newsweek*. Author of several books, Sedge was recently part of The Discovery Channel team in Alexandria, Egypt, which put together the book and television documentary, *Cleopatra's Palace: In Search of a Legend*. His Internet website can be found at www.cybernet.it/sedge.

Strawberry Media

Europe: Via Venezia 14/b * 80021 Afragola (NA) Italy
USA: 2733 Midland Road * Shelbyville, TN, USA

Editors and producers are busy people. Therefore, I try to make their jobs easier by flashing the words "News Release" in their faces, in bold type. This immediately tells them the information is free and if they want their story to be different from that of their competitors, they should call the contact point and get additional information or quotes—even set up an interview, if appropriate. This is the reason I highlight the words *News Release* and ensure that the point-of-contact information is prominently displayed at the top of the page.

In the headline you should always try to illustrate a benefit—the editor's, the producer's, the reader's, and even your own. In this case, I've provided the recipients with a new and unique angle on an old story—the war in Bosnia. For the reader I offer a human-interest aspect. And what's in it for me? The release, when published, offers new opportunities for business

as well as exposure and name recognition. Say, for example, the editor of *Armed Forces Journal International* is looking for a photojournalist in the Mediterranean. Reading this news item in a Washington-based newspaper—the city where *AFJI* is based—he might immediately consider me for the job. (This actually happened, by the way, and I am now covering the Mediterranean region for *AFJI*.) Or suppose a producer, receiving this release in a press kit, is looking for a talk show guest to discuss a global conflict? Suddenly, I am a candidate, given my credentials and recent award. Then, to go one step further, let's say the show is *Good Morning America,* and that a book publisher is sipping coffee, watching TV, before heading out to fight Big Apple traffic. He's been giving some thought to putting out a title on the military activities in the Balkans, but hasn't been able to come up with an experienced photographer with the proper picture archives. In one fell swoop, there I am—his photographer, his writer, and his expert. Ready, willing, and able—if the price is right, of course.

This is the snowball effect that press releases and continuous media coverage can create for photojournalists. This is also the reason that the most popular and successful photographers in America are constantly appearing on TV, radio, and in print media.

Always use the body of your press release to provide credibility. Who you are, what you've done. And remember to drop names of your important clients. For this release I've linked myself with Admirals Sampson and Lopez, thereby riding their coattails as well as my own.

Finally, provide a source for readers to obtain more information. If you have one, include a Web site where potential clients will find more details, including telephone and fax numbers, as well as e-mail and postal addresses. If you offer services and products besides photography—such as teaching, lectures, writing—this would also be the place to include such information.

Generally, press releases should be no more than two pages. Always try to come up with a news slant, if possible, and, as with all hard copy for media use, print it out double spaced.

In your press kit, you might include an article about yourself or some aspect of your business. This may enhance the chances of your gaining media coverage. If you target the market correctly—just as you would to sell your photos—the editor may publish your piece exactly as provided. More often than not, though, an associate editor will rewrite the article. To promote my book, *The Writer's and Photographer's Guide to Global Markets*, I prepared a feature on selling editorial packages around the world. It was published, as presented, on the Internet site *Writing Now*. Other publications, including *Authorlink, Inklings, National Writers Monthly*, and *PhotoStockNotes* ran altered versions of the story. *PhotoStockNotes* also asked if I would be interested in becoming a regular contributor. This ultimately led to my monthly *Going Global with Your Images* column.

In some cases, instead of submitting an article, you can substitute a one-page biography. I will frequently send media kits to editors if I am seeking a staff position. In these situations, I might include both an article and a bio. If you are hoping to land a corporate account, however, a biography of your professional credits will be more appropriate than would an article focused more toward media outlets.

Because press releases and articles included in your media kit will often stimulate additional questions from editors, producers, or others who receive the package, it is always a good idea to include one or two pages of questions and answers. Naturally, these should be focused on the general theme you are trying to convey with the package. For instance, when I wanted to promote my book on international marketing, questions and answers were directed to how writers and photographers could find global markets, the types of material that sells best to foreign editors, what you can expect to be paid, and so on.

On the other hand, if my press kit were focused on a military topic—such as the Kosovo conflict—I might include questions and answers dealing with the effects of NATO efforts, the hazards of serving as a war correspondent, a comparison of military strengths, and perhaps a statement dealing with the varied political aspects of the conflict.

Because press releases should go to broadcast as well as print media, including a question and answer sheet will give producers of TV and radio talk shows some idea of the responses you might give if you're asked to be a guest. In fact, the questions asked by show hosts are frequently those included in an initial media kit. The reason for this is that producers are fairly certain of your reply and, therefore, avoid any radical surprises.

You should always include a 5×7-inch, or larger, color photo of yourself. Like every aspect of your business, you'll want your photo to be as professional as possible. Don't try to get away with an instant, photo-booth snapshot or a cut-and-paste portrait from a summer beach picture. Take the time and invest the money to go to a professional photo studio. Explain to the photographer that the images will be used in a press kit, and get some top-of-the-line portrait shots. Don't be afraid to be creative. In some pictures, you might want to include a camera, a computer, some of your published work, or anything else that might act as symbolism of your business.

A good picture provides a double benefit. First, it offers an illustration for print media. Second, if you are sending out information to television producers, it gives them an opportunity to see that you do not resemble Frankenstein and, therefore, will not frighten their viewers.

Just as a lawyer would not think of defending himself, you should not consider shooting your own portrait, even though the technology to do so exists.

Finally, you may want to include other information in your media kit. For instance, some photographers, particularly when sending the kit to potential clients outside of the media—

for example, corporations or schools—will include clips of published work. For this, always use color copies to highlight your work at its best. If you are trying to land a radio or TV guest spot, you might provide a one-page pitch. If you have recently covered a political event, for example, you might suggest to a radio producer that you could bring along recordings of the debate that could be inserted into the program. Or maybe you created a photo feature on how to grow new plants from stem cuttings. For a television producer, having you illustrate the various steps involved in this cultivating technique could make an attractive presentation for viewers. These are the types of things that should go into a pitch letter.

My media kits also contain one page of testimonials—what people or publications have said about me. Just as you would list references on a resume, these one-line comments aid in building credibility, establish professionalism, and indicate what clients you have worked for and how they received your work. Here are some of the more common quotes I use:

> *"[Sedge's] work is excellent."*
> —J. RANDALL, EDITOR, MOBIL OIL *COMPASS*

> *"You are a valuable asset to our organization."*
> —R. SLOCUM, MCIWORLDCOM

> *"You are one of the finest and most professional journalists I have ever worked with."*
> —A. VALENTI, ARTICLES INTERNATIONAL

> *"Michael Sedge is a mail order genius."*
> —*INCOME OPPORTUNITIES*

> *"Sedge is the wizard of marketing."*
> —*ENTREPRENEUR*

> *"A true professional."*
> —JEFF HERMAN, THE JEFF HERMAN LITERARY AGENCY

"We are faced with one problem, how to obtain Mr. Sedge's professional services without having to pay what he is obviously worth."
—JEFF LEACH, PUBLISHER, *SCIENTIFIC AMERICAN DISCOVERING ARCHAEOLOGY*

"An expert marketer."
—DAN POYNTER, PARA PUBLISHING

Your entire package, when completed, should be introduced by a catchy cover letter. Remember that this should come from, and be signed by, your "public relations manager" and not you. A good cover letter will sell the editor, the producer, the executive, the school administrator, and entice them into looking at the enclosed materials. It will explain why you, your product, your service, or your message is valuable to them and their readers/viewers/listeners. In my cover letters, I like to pose a question, then answer it with statistics whenever possible. Here are a couple of examples:

> "Why are more than 70 percent of today's freelance writers and photographers working at the poverty level? Because they are thinking like freelancers and not businesses."

> "While live war coverage may increase the number of viewers of CNN, does it also have an effect on military strategy? The answer, according to top Pentagon officials, is a resounding *yes!*"

Wording like this not only leads into your message, but also captures readers, making them ask more questions and seek additional answers. If I were an editor reading the first sentence I might ask, "Well why *don't* they think like businesses?" When reading the second example, I immediately question *how* it

affects military strategy and *who* at the Pentagon says so. In short, I want more—and that will stimulate me to dig into the press kit.

With all the elements packaged into a presentation folder, you now have a media kit. Now what? Where does it go?

Where Does It Go From Here?

There are innumerable target markets for a press kit. Some of these include editors, advertising agents, producers, and corporate executives. Getting media exposure is much like selling images. You must target the information in your media kit to fit the needs of both the market and yourself. Let's return for a moment to our plant propagation photographs. If you recall, this is the photo essay on raising new plants from stem cuttings. With the proper press release, a copy of the published article, a question and answer sheet, and a biography, a good PR manager—that is, you—could easily pitch this to television talk show producers. The media kit, in this case, could go out to people like Barbara Fight or JoAnne Salzman, producers of *Live with Regis and Kathie Lee* or Mary Alice O'Rourke, Supervising Producer of NBC's *Today*.

"We like using authors as experts," explains Stephen McCain, associate producer of CBS-TV's *48 Hours*. "If we're doing a show on celebrity stalkers, we might have someone on to talk about the things people can do to lower the risk of getting in harm's way."

If you happened to be a celebrity photographer—who spent much of your time "stalking" Hollywood and New York stars—you might be a perfect candidate to fill such a slot.

This morning, while driving to the airport, I tuned into National Public Radio's *Morning Edition*. The host was discussing stock trading on the Internet. "For more information on this subject," he said, "we have with us Jeffrey Smith, a correspondent for *Business Week*, who has written an article on home trading in the latest issue of the magazine."

This was a perfect example of how photographers and writers—even if they were only producing photo essays and articles—were making their way into the public eye (or in this case, ear). You no longer have to be a war correspondent or the author of a best-selling novel to interest television and radio producers in your expertise. All you need are good researching skills, knowledge of your subject, and a well-presented package. Oh, yes, and an ability to not choke up in front of the camera or microphone.

"Talk is hot, whether it's on the radio, TV, or Internet," explains Marilyn Ross, co-founder with her husband Tom Ross of the Small Publishers Association of North America and coauthor with her husband of *Jump-Start Your Book Sales.*

As an illustration of this, in 1983 there were only fifty-three radio stations with news/talk formats. Today, according to *American Demographics,* there are more than a thousand.

Most radio talk show hosts conduct telephone interviews, thus eliminating the need for you to go to the studio. To ensure that photojournalists take full advantage of radio opportunities, Marilyn and Tom Ross offer the following tips:

1. As soon as the phone rings, assume you're on the air. This won't usually be true, since the producer typically comes on first, but you never know when your comments will be broadcast live.
2. Try to listen to the station and the show ahead of time. If it's out of your area, one way to get a sense of the station's format is to call the station and ask to be placed on hold: You'll hear the show airing!
3. If you're offering a demo tape, don't send it to two stations in the same area. Nobody likes to be considered a runner-up. Producers prefer exclusives—especially in big markets.
4. Stand and deliver. When you do an interview from a chair, you're slouched and your diaphragm is scrunched. Stand. Walk. Pace. You'll sound more dynamic. You

may want to pick up a longer phone cord to allow for this flexibility.

5. Relate your book (or other product, including yourself) to newspaper headlines. Maybe you have an alternative viewpoint. Attack the commonly held notion. Explode a myth.

6. You may want to "plant" friends or loved ones to get the call-in ball rolling. Coach them with a leading question.

7. Remember that radio producers and hosts talk . . . to each other. There are sites on the Internet, such as Bit Board and Morning Mouth—closed to the general public—where they gab about outstanding guests. They also have conversations where they network. Be outstanding and they will seek you out as butterflies hunt down nectar.

8. Always be on your best vocal behavior. You are "auditioning" from the moment you open your mouth. Think a producer is calling just to check that detail? Nope. She wants to hear your voice inflection, how enthusiastic you sound, if you're quick on the mental uptake, and so on. Same thing when you call her. Turn on the charm.

(Reprinted from *SPAN Connection,* with permission of the authors.)

I use two sources for up-to-date lists and information on television and radio talk shows, though there are numerous others. The first is *Bradley's Guide to Top National TV Talk Shows.* The second is *Book Marketing Update* (see Appendix A). The latter is a twice-a-month newsletter, perfect for keeping larger directories updated.

Print Media

Focusing on topics that fit a particular publication or market is the best way to gain print media coverage. A few years

back I spent a great deal of time working on so-called adventure topics—volcano exploration, rafting, Alpine trekking, and the like. In a sense, I became an expert in this field. Because my illustrated book, *The Adventure Guide to Italy*, also appeared at this time, I gained an added benefit. To minimize my effort and maximize my promotional return, I sent out press kits not only promoting my book, but promoting myself as a talk show guest. This resulted in two radio interviews, three newspaper articles, and one television interview. In turn, when Mount Etna erupted a short time later, editors began calling me to cover this hot-foot adventure based on my "expertise."

> *I think it's important for a writer [or photographer] to market themselves as an "expert" on specific subjects and topics. To this end, I advertise in the* Yearbook of Experts, Authorities, and Spokespersons *which includes an index of those areas of expertise I want to emphasize. The* Yearbook *also insures that I am continually interviewed by both print and broadcast media outlets, not just in the U.S., but internationally.*
>
> —ALAN CARUBA, MARKETING EXPERT

On another occasion, after spending two weeks in my summer apartment in Florida, I prepared a press kit slanted toward my success as a photojournalist and the rewards of being a time-share property owner. It was immediately picked up by *Holiday*, the magazine of RCI timeshare owners, and run with a color photo of my wife and myself. The subtitle of the article read, "Who better to tell how timeshare ownership and exchange makes for better holidays than an RCI member? Freelance journalist and author Michael Sedge, who has published more than 2,500 articles and several books including *The Adventure Guide to Italy*, shares his experience of owning at Vistana Resort, Lake Buena Vista, Florida."

This unique view of a temple in Istanbul has appeared in several North American travel publications, as well as in in-flight and European leisure magazines. All told, the picture has brought in over $3,000. © Strawberry Media

In the years following this media coverage, I sold nearly 100 photos to *Holiday* editors to illustrate features that they commissioned from me, as well as those of other writers. Since the magazine is distributed to resort managers as well as time-share owners, I picked up two more jobs for images to illustrate hotel and resort brochures.

The more exposure you receive, whether it be television, radio, or print media, the greater your photojournalistic opportunities will be. Your goal should be not only to generate additional income, but to raise yourself to celebrity status. You might begin with a news blurb in a hometown newspaper and a speaking engagement at the local library. No matter how small or large, your self-promotion efforts must be consistent in order to pay off. As Robyn Spizman, author of sixty-three books and a television reporter for WXIA-TV Atlanta, points out, you must rethink your attitude. Don't feel uncomfortable blowing your own horn. Someone needs the information you possess and using the media is the best way to get it to out there.

An area where most photojournalists fall short is in following up on press kits. Two weeks after you've send out your packages, call or e-mail those who have not replied to ensure they have received the material. Ask if they would like additional information or a personal meeting to "further explore possible cooperation." There have been occasions when I was required to follow up with editors and producers three or four times before achieving any results. After a while, I believe, they agreed to cover what I was trying to promote simply to get me off their backs—whatever it takes!

Self-promotion and marketing will frequently lead to nonphotographic jobs such as teaching and lecturing. If this is where your interests lie, you can apply a marketing approach to such activities as well. How to do that, and more, can be found in the next chapter.

18 Ways to Promote You And Your Business
by Maggie Klee Lichtenberg
Writing and Publishing Coach
© *Maggie Klee Lichtenberg. All rights reserved.*
Used by permission.

1. Start with a change you'll need to make if you plan to be successful: Get over being shy.

2. Have the mind set to consistently take initiatives. Never stop: It's not enough to create one brilliant direct mail campaign. Repeat the mailing to your list two or three times. And never, never, never take an initiative without following up.

3. Plan one marketing effort each day. Every Sunday evening or Monday morning, choose a theme for your week and mark that theme in your calendar each day for the coming week.

4. Develop a PR plan for you and your company. Work with a publicist (or do your own PR) to land features and interviews. Create a simple press kit that contains your mission statement, a warm and friendly letter including company bio, press coverage, personal testimonials, and a professional black and white photo of you.

5. Show up a lot—be seen. Tell everyone what you're up to. Always have a book, a press kit, a flyer about your company ready to give away.

6. Have a short, laser-sharp intro about yourself—20 words or less—ready to go at all times. Be a graceful, yet tireless, self-promoter.

7. Commit to public speaking. Join a Toastmasters group for six months to increase confidence. Build positive relationships with everyone you meet.

8. Create an audiotape business card and give it away. This is an inexpensive, three-dimensional opportunity to share an experience of you.

9. Involve yourself in your community on an issue you are passionate about. In the giving you will receive.

10. Offer articles and photos to local media and professional newsletters on what you're doing. Write about where your passion comes from. Share who you are and why you are devoting this stage of your life to this endeavor.

11. List yourself and your company in all appropriate directories. . . . Seek out publications that specialize in your niche.

12. Let a long list of people know about your activities. Ask twenty-five friends and colleagues to go through their Rolodex, to make calls to five of their friends to inform them of your lectures, seminars, etc.

13. Pitch a feature on you and your unique company to the local cable and newspaper features editor. Creatively present what is exceptional about your endeavor, and why it will make a difference in the world. And last, but certainly not least, address your quality of life issues.

14. Make more of an investment in yourself. Ask: What assignments or activities can I streamline? What can I delegate? What can I eliminate altogether? What's the one thing I can let go of in order to take this company to the next level?

15. Learn to under-promise and over-deliver. Existing in a state of overwhelm doesn't serve us. Take on less and enjoy the thrill of an accomplishment thoroughly fulfilled.

16. Set higher standards for your own personal time every day. Take a half-hour walk—or take a nap—in the middle of the work day.

17. Stop tolerating. Make a list of twenty items you are procrastinating about and a second list of three goals you'd like to reach in the next ninety days.

18. To gain fresh perspective and a good rest, take twenty-four hours off four times a year. Go away by yourself on a soul retreat to a beautiful setting. Go fishing, for example. Personally, I don't fish but I hear it's the time between fish when we reconnect with our most peaceful inner selves.

(Excerpted from an article in SPAN Connection, with permission of the author.)

Maggie Klee Lichtenberg is a personal and business coach. A former publishing company executive (Simon & Schuster, Bantam, Grove Press, Beacon Press), Maggie was a featured speaker at the 1998 SPAN conference in Baltimore.

If you are interested in individual or group coaching, call her at (505) 986-8807, e-mail *margaretkl@aol.com,* or check out her Web site at *www.maggielichtenberg.com.*

"For individuals seriously considering coaching," she says, "I offer a free half-hour phone coaching session to support you to eliminate two issues that are draining your energy, and to target three reasonable ninety-day goals."

10
Business Expansion

Just as a soldier becomes involved in a variety of nonmilitary activities—evacuations, humanitarian relief, national disasters, national security—so too does the productive photojournalist. The more you are involved in self-marketing, in fact, the more peripheral activities develop. Speaking engagements, teaching, and public appearances have become a mainstay for many top photographers, often generating more income than their images.

I first got involved in photography through a course at the University of LaVerne. Seven years later I was teaching that course for the same school. As a student, I was like millions of others who dreamed of success and fame. I could someday be in the ranks of Eddie Adams and Robert Capa if only I knew the right approach and the right format. In addition to this, it had sounded like an easy college credit. Fortunately there is a never-ending flow of "want-to-be photojournalists" and, therefore, a constant need for professionals who can teach the skills and techniques of creative images, journalism, and freelance marketing.

Perhaps the greatest advantage of teaching, if you are an active photojournalist, is that you get paid to talk about yourself. During my one-day seminars, I bring examples of my published work, discuss the step-by-step process of how each sale was made and go into the finite details of marketing. I never pretend that I can teach someone else to be a creative photographer or writer—I can't. I do, however, tell potential students that if they possess the ability to capture images and write, I can show them how to sell their work. This is because my expertise, in addition to my photojournalistic talents, lies in selling what I produce. I am, in a sense, a picture and word "mechanic" rather than artist.

In the mid-1990s I accompanied the popular country music group, *Pirates of the Mississippi,* on a Germany tour, working as a marketing manager (meaning I was the tour photographer, writer, and promoter). During that time, the group began contemplating a song that would ultimately became the hit single called *I Think Locally.* That is exactly what you need to do—think locally, not create a hit single—if you want to break into the teaching field. If you have no experience, try contacting local libraries, social organizations like the YMCA/YWCA, or public schools. In most cases you will be volunteering your services as a guest speaker on such occasions. At the same time, however, you will be polishing your skills as a lecturer and, ultimately, teacher. There are also organizations that can help you develop your ability to communicate with others, face to face. Among these are the American Society for Training and Development *(www.astd.org),* Toastmasters International *(www.toastmasters.org)* and Langevin *(www.langevin.org).*

I expanded my career into the areas of speaking and teaching by first offering complimentary talks at local libraries and middle schools—I felt it safer to start with children. Through a friend I also lined up a discussion for a regional business association. This not only gave me confidence in speaking, it was a key factor in landing two corporate jobs. Armed with my newly acquired speaking experience—albeit limited—I was

ready to tell the world about my photojournalistic exploits, and make money doing so. But where was I to begin?

Once again my media kit came into play. Before arbitrarily spending money on printing, photocopies, and postage, I sat down and came up with several target markets for what I was offering. Among these were colleges and universities, clubs and organizations, bookstores and businesses. I then researched each area, gathering college catalogues to see what they already offered, checking to see what private associations operated seminars, exploring which local high schools provided adult education classes, and making a list of bookstores that frequently hosted speakers. For the business market, I was looking for medium-sized companies, without public relations departments, that could benefit from media exposure. This would allow me to offer a seminar on how to get free publicity through news photography and press releases. I found several.

The next step was to target my media kit to each market. I took on colleges and universities first, preparing a course outline for a two-day seminar. Based on the catalogues I'd collected, I was able to incorporate each school's classroom time requirement, and other aspects necessary for students to obtain credit for the course. This same basic outline, in a one-day format, was then used for clubs and organizations. I offered bookstores an even shorter version (four hours) of the class, to cover only the basic approach of photography. Businesses, on the other hand, received a full-blown, one-week seminar proposal.

Once ready for delivery, I called each potential client and asked to whom such proposals should be addressed. The following day UPS made the deliveries. Within a week I had lined up the course at University of LaVerne. Because I'd covered several archaeological expeditions in my career, I was also asked to give a paid lecture at the International Archaeology Society, which met every month at a local church hall. Over the next year I would continue to teach classes for the college, as well as conduct adult education courses and run weekend seminars for the

United Service Organization (USO). My lecturing gigs during this same period expanded to included businesses, travel groups, and a variety of clubs and organizations.

Oftentimes, as photojournalist Robert Schwartz well knows, finding a unique angle on an old theme can generate enthusiasm from art directors. This wide-angle shot from the Leaning Tower of Pisa is a great example. © Strawberry Media

Teaching Profits

Generally, colleges pay by the hour for semester-long courses. A seminar, on the other hand, will normally bring a flat fee. I've been offered from $10 to $30 per hour and $200 to $600 for one-day seminars. This wide range indicates that there are no real standards. What I like to do is investigate what is currently being paid to professors for seminars. Then, if I am happy with that, I go forward. If the rate seems too low, I'll offer a profit-sharing arrangement. In fact, with smaller organizations, adult education, and lectures, I frequently include this in my proposal. For example, if a two-day seminar is going to be priced at $75 a per-

son, and I anticipate thirty students, this means the school or organization will take in $2,250. I might, therefore, offer the class under a 50/50 percentage of the profit. Naturally, there's a downside to this arrangement: I lose out if only ten students sign up.

To increase student turnout, I do not depend on the marketing efforts of schools or organizations. I promote my own classes through press releases and press kits to local media, college newspapers, radio and television stations. For example, for the first two-day seminar I taught for ULV, administrators anticipated thirty students. I had agreed to accept a fee of $35 a student, expecting to make just over $500 a day—minus money involved in preparing and sending the press kits.

Two days after sending out the kits, I received a call from the local newspaper, the college magazine, and the university radio station. A week before the class I was also asked to appear on a regionally broadcast television program to discuss my professional activities. I naturally took this opportunity to mention the seminar. The media coverage resulted in sixty-eight students, more than the local campus had ever had for a single seminar. My cut was $2,380—but I actually took home even more. You see, when negotiating the deal, I had arranged to provide all course materials—copies of sample proposal letters, contracts, published materials, lists of references, and the like. The college administrator had agreed that $5 would be charged for the package, as part of the total course fee. This move brought me an additional $340.

Today I include my book, *The Writer's and Photographer's Guide to Global Markets,* as part of the "required reading," resulting in an additional $11 per student, after I've paid the publisher.

Where the big money lies, however, are classes or lectures to large corporations. You can charge from $250 to $3,000 a day to teach business people how to do their jobs better by using images and printed words. Or, if you have expertise in a specific business sector—for instance, advertising—you can lecture on that topic. Corporations normally refer to such classes as

"training." Perhaps this is because it makes attendees feel more like they are updating their professional education rather than returning to school for a "class" or a "seminar." Here, too, you should try to produce and provide "training" materials yourself—and add it to the bill.

Expanding Your Niche

Once you get into the swing of teaching and/or lecturing, you might discover, as I did, that the same marketing techniques used to expand your products can also be applied to increase profits in this sector of your business. With a slight change in approach, for instance, you can go from teaching, say, freelance photography to teaching Journalism 101. Or you could introduce a course on digital imaging techniques, if that is where your talents lie.

Like any business venture, starting up is the most difficult part of teaching. Once you have achieved success in your specialty field, however, it becomes very easy to expand your services into other areas. I began with freelance writing (how to sell your words) because I was comfortable with the subject matter. I then moved onto freelance photography. During the past two decades I have broadened this to include newspaper journalism, creative photography, advertising design, writing and selling nonfiction books, selling fiction, marketing your talents, and computer basics.

By expanding my teaching repertoire, I also developed a following of students, often attracting the same individuals over and over. It therefore became easy for me to estimate the number of students I would have and the amount of money I could expect from each class.

Today I've taken my teaching experiences online. Teaming up with popular Web sites for photographers and writers, I have been able to offer seminars by e-mail. My standard format is to provide an overview of the course and a press release to the Web site owners and let them handle the course

marketing, sign-ups, and collection of fees. This is done through a seminar Web page, which they put together.

Once I have a list of students, I send an invoice for my percentage (normally 70 percent) to the Web site. On the established starting date, I contact students by e-mail. Over the next eight weeks they will receive weekly assignments, reading materials, and Internet references, which lead them toward better marketing of their freelance images.

This activity takes up relatively little time—since I can do it even while I'm on the road—and brings in about $6,000 a year.

More and more people today are finding fun and profit in speaking engagements. In his book, *Niche Marketing*, which is subtitled "How to Make Yourself Indispensable, Slightly Immortal, and Lifelong Rich in 18 Months," author and publisher Gordon Burgett points out that, "Talks and speeches sound the same to the outsider but there's a huge difference if you're giving them for a living: Talks are free, speeches are paid!"

You should always keep this in mind, and strive to line up as many speeches as possible—though don't avoid "talking," particularly when it is about you and might generate additional work.

To enhance your chances of gaining speaking engagements, you can transform your media kit into a "speaker's kit." Included as part of your package should be: a pitch letter explaining why your are the best person to give a speech on your selected subject, a news release on your expertise, biographical information, samples of your work and/or articles published about you, and a photo of yourself.

Many speakers also include a *"one-sheet."* Containing the same information you might have in a brochure, a *one-sheet* is a single, 8½-by-11-inch sheet of paper. It might include a photo of you speaking; your speaking topics; your credentials; a list of clients, with five or six quotes from satisfied users of your speaking services (if you have such experience); and information on how to get in touch with you.

Internet users can view a sample one-sheet at *www.libov.com/speaking.html.*

If you are looking for a way to jump-start your speaking career, here are a couple of other tips:

- Get involved in the National Speakers Association. You can find information on this group at its Web site: *www.nsa.speaker.org.*
- Sign up for the free Internet newsletter *SpeakerNet.* This provides a wealth of tips and information on this money-making business. You should send an e-mail to Rebecca Morgan *(rlmorgan@aol.com)* to get on the mailing list.

Vertical images, such as this photo of sailors with flags, by Bob Wickley, offer opportunities for magazine covers. When you begin "thinking covers," you allow space in your composition for text and other information.
© Strawberry Media

Stock Agency Partnerships

I am a firm believer that you should work to the peak of your capabilities. At the same time, you have to be realistic. A sin-

gle individual can only do so much on her own. Therefore, in your business efforts and expansion, you should not overlook stock agency partnerships. (Note that businesses work under *cooperative marketing, joint ventures,* and *partnerships,* while freelancers work under *representation* and *agenting* arrangements. If you are going to operate as a business, be sure to use the proper terminology.)

Two decades ago, Bob Wickley, a graduate of Syracuse University's School of Photojournalism, approached me, as the director of Strawberry Media, offering a partnership. He would provide me with stock images and I, in turn, would market them around the world. After reviewing his material, I quickly agreed. One of the top Air Force photographers at the time, Bob's material quickly filled the needs of our clients.

Since that time, Wickley has retired from the armed forces, moved to San Antonio, and continued his career as a photographer—now working in advertising, aviation, and stock photography. In the following interview, Bob reveals some of the reasons why you should consider partnering with an aggressive stock agency as a means of expanding your business.

Question: What are the benefits of working with an agency?

Answer: I believe in having a good stock agency to increase photo sales. I have a couple of agencies that market my images. My greatest success has been with Superstock. I have been with them for twelve years. Recently they marketed one of my photos to the U.S. postal service. One of my Little League photos is on a U.S. postage stamp released in May 2000. I never would have had the opportunity to reach that market alone. I have had several big sales around the globe that I never could have made without a top photo agency. I am also with two agencies that specialize in aviation images. These agencies give me a reach I never would have alone, and the sales continue year after year—often the same images.

Question: You mention "big sales." What are we talking about as far as money from stock house sales?

Answer: Percentages vary. Fifty percent is the norm for a stock commission, although it gets a bit more complicated with Superstock. If I buy space in their catalog with an image appearing in it, I get 50 percent. If I do not buy the space the percentage drops, I get 35 percent of sales and it gets even more complex for international sales. But overall, it really pays to have images in a good agency. I haven't really focused my business on stock photography but shoot occasionally and try to get some images into the books. I have been able to count on $2,000 per month but this has dropped off gradually as I have not been too active in feeding the agency work. There are plenty of photographers who are pushing their business in stock, devoting a large amount of their business efforts into stock who are making $10,000 or more per month. I feel that I could reasonably make that kind of money if I got busy with shooting stock as a main part of my business.

"Venice Boy" sold to Holiday *magazine, in the United Kingdom, because it offered a glimpse of life as few people see it. © Strawberry Media*

Question: How much do you expect to make from the postage stamp sale?

Answer: I believe it will be about $15,000, but I am not sure. I will only get 35 percent whatever the sale will eventually be, because of the way the image was marketed.

Question: How do you submit an initial selection of images for consideration?

Answer: Lately I have been using low resolution, digital photos sent electronically or an ink-jet paper print. I believe in giving the client a photo that is good enough to view for consideration but not the final image (usually a transparency). I try to shoot extras and to hold in reserve. If prints are specified, I send copyrighted proofs to the client.

Question: Have you received any resistance to this method of submission?

Answer: Until recently, most people wanted to have a physical thing in hand—a slide. Many still do, but more and more people will accept a good quality digital image, usually on a CD. The problem here is the quality of the digital resolution. If the resolution is high enough, digital is more practical and easier to deal with, since it will appear in print and is already scanned—ready for printing. This saves time and effort for the publisher, printer, or editor.

Question: What other opportunities, beyond stock house partnerships, should photojournalists explore?

Answer: Photographers can expand their services by being aware of what photo add-on products are available and marketing them. I have been putting images on Photo CDs and selling them to clients. I also can offer digital retouching and digital output to clients. This has helped my bottom line and also positioned me as a full-service photographer. This has separated me from other photographers who did not offer these services. I have tried to keep up with the digital revolution and I have also learned where I can get these services performed well, and then I offer them with a mark up.

Maximizing the Internet

You and I live in exciting times. Technology has taken us from mechanical, to computerized, to Internet. I cannot imagine any successful photojournalist today not taking advantage of the so-called "information superhighway," because it can send your marketing ability to new heights. The Internet has revolutionized the way people do business. Global markets are suddenly at your fingertips. Opportunities abound, both for self-promotion and sales potential. It will not be long before every photo buyer in the world is working through e-mail and digital imagery, and rightly so. It eases their workload—since photographs can now be sent in formats that require no print or transparency—and allows them to work with a far wider range of professionals around the world.

> *I put some effort into maintaining my Web pages. I link to as much of my work on the Web as I can find, and strongly encourage anyone publishing my work on the Web to link back to my page, so that readers who are interested can click through and get information about my activities.*
> —WENDY M. GROSSMAN, LONDON

Your Web Site

Every photojournalist should have a Web page, if for no other reason than to provide a resume of his professional credits. Because of tough competition, most Internet Service Providers (ISPs) have begun offering free Internet Web pages as part of annual subscriptions. My server, for example, gives me up to one megabit of space for Web pages as well as two e-mail boxes.

I could have gone to a professional site designer for my page—and many people do—but found the step-by-step process for creating my own Web site in Microsoft Publisher so easy that I decided to go it alone. You can take a look at the results at *www.cybernet.it/sedge.* My goal was to list my credits, highlight my books, and provide testimonials from past clients—in addition to listing contact information.

If you are new to the Web game, or have never gotten around to creating your own site, you can get a quick course in using HTML (Internet format) at these sites:

- A Beginner's Guide to HTML
 www.ncsa.uiuc.edu/General/Internet/WWW/HTMLPrimerP1.html

- Introduction to HTML
 www.cwru.edu/help/introHTML/toc.html

- Netscape Enhancement Guide
 www.ibic.com/Program/NscapeHome.html

Armed with a Web page, I am able to direct editors and other potential clients there to review my credits. This, I believe, is the greatest advantage to an Internet site. The flip side of having a Web site, however, is letting customers know it exists. For this, you must promote the site.

One of the easiest ways to get people to visit your site is by exchanging banners, or tiny ads, with owners of other Web pages. A year ago I exchanged banners with another photogra-

pher. Because his work sold to hundreds of magazines and newspapers around the world, many editors who reviewed his pages were then drawn to mine. After all, it merely required them to click on the little box at the bottom of the photographer's Web site that read: "Don't Think You Can Afford a *Newsweek* Photojournalist? Click here to find out."

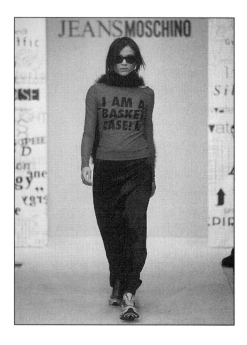

As part of an assignment for Newsweek, *the author needed to show the latest in Italian fashions. This same image was subsequently used by* Silver Kris, *published in Singapore, and* Diplomat, *published in the United Kingdom. The author made $2,500.*

I specifically choose this wording—after recently working with *Newsweek*—to stimulate curiosity, and it worked! Several assignments have come in as a result of this banner, and still do. My next step was simply to expand my Web marketing, increase the number of cooperative banner deals I could make, and to get my site listed in as many places as possible. The more you are seen—in print, in public, on the Web—the more traffic you can direct to your page, and the more work you will receive.

You should include your Web site address, whenever possible, in any published work. Each month I write features and

produce photos for several publications, some on the Internet, others in print media. In every case I request that the editor run a blurb about my professional work and include my Web site address. Anyone wishing to know more about me can therefore review this electronic "billboard." Three months ago, in fact, I received an e-mail from an editor in Los Angeles. During a trip to Asia he'd read one of my articles in *Silver Kris,* the in-flight magazine of Singapore Airlines. Upon his return to the United States, he'd looked at my Web site—the Web address was listed at the bottom of the article—where he obtained my electronic mail address. In his message he pointed out that he'd enjoyed the *Silver Kris* feature and illustrations, and wondered if first North American serial rights were available.

Piggyback Marketing

In addition to creating and promoting your own Web page, you should try to get Internet publishers with whom you work to market your services on their sites, whenever possible. *Authorlink.com,* for instance, has a section that highlights the photographers and authors who work for them, as does *Tropieties.com* and many others. Be sure to inquire about this when selling to Internet magazines. If you find out that the publication does offer contributor listings, request to be included. Then provide the editor with as much information as possible, including a photo. I began taking advantage of these opportunities five years ago. As a result, I currently have over twenty-seven Web sites where potential clients can find my personal and professional information.

Most people fail to understand that their Web site will not necessarily be part of the global search systems. That is, a photo buyer may be looking for "photographers," using Altavista, Yahoo, HotBot, Mamma, or one of the other popular Internet search engines, but your name and Web page may not appear there. This is because you are not registered with these companies. There are several ways that you can submit your

page to major search engines. Start by asking your Internet Service Provider, since the ISP may be able to do this for you. Another option is to submit your Web address to *www.execpc.com/~mbr/bookwatch/writepub/#pubsearch.* While this is normally used for publishers, you can include yourself as a provider of editorial services.

The secret to successfully marketing yourself, your services, and your products over the information superhighway boils down to exposure. The more you can get your site listed with search engines, in directories, in announcements, in Web magazines, on mailing lists, in Web news services, and newsgroups, the more traffic you will have and, as a result, the more your business will blossom.

Using a Signature

One of the easiest promotional tools to take advantage of is the signature feature offered by contemporary e-mail programs. If you don't already use one, you have no doubt seen them on incoming messages. For instance, my own signature currently looks like this:

Michael Sedge
STRAWBERRY MEDIA
Via Venezia 14/b
80021 Afragola (NA) Italy
Tel. (39) 081-851-2208
Fax. (39) 081-851-2210
E-mail. pp10013@cybernet.it
www.cybernet.it/sedge
www.absolutewrite.com/michael_sedge.htm

Each of the Web pages listed below my address, telephone, fax, and e-mail numbers currently links potential customers to a page containing information about myself and my services. The

www.cybernet.it/sedge site provides my general résumé, while *www.absolutewrite.com/michael_sedge.htm* connects to an interview written by Amanda Cerbone focusing on my latest book, *Marketing Strategies for Writers.*

Like a gun without bullets, a signature is a useless marketing tool unless it's properly maintained. Each month you should update your listings, ensuring that all links are current and accurate. If you've recently published work on the Internet, include it. At the same time, weed out any old listings and don't go overboard. I like to keep my listings to a maximum of three. Otherwise, readers may feel overwhelmed and avoid looking at the links.

Maintaining a good signature does not take long. It can, however, enhance your sales. After I began including a signature with Internet links, the requests for clips and information on my professional activities stopped coming in (and saved me a lot of time, plus photocopying and postage costs). Potential clients with Internet capabilities simply clicked on the links I provided and had more than enough information to know if I was right for a particular job.

Seeking Employment on the Net

I have been self-employed for more than two decades. I have no desire to ever work again as a salaried employee. The thought of a 9-to-5 job, requiring me to punch a time card, produce on demand, and report to a "boss" holds absolutely no interest for me. Then why, you might ask, does my name appear on several Internet job sites, wherein I am seeking employment?

Twelve years ago, when I had my own employees, I realized that each dependent cost much—MUCH more—than their weekly paycheck indicated. For example, if your gross salary as my employee is $40,000 a year, in reality you're costing me $54,000 after adding hospitalization, insurance, taxes, and so on. It therefore occurred to me that publishers and corporate managers—particularly those at start-up magazines, or those

who merely needed an in-house photographer/writer—would be far better off hiring me as an independent contractor to do their work, than to get tied to an employee. Convincing these individuals that my offer was a better deal than a 9-to-5 worker was my challenge—and should be yours.

Joel Jacobs, a good friend and colleague, edited the Italian magazine *The World of Beer* from his office in Dallas for many years, even though the publisher was in Milan. Similarly, *R&R Magazine*'s editor, Marji Hess, lives in Chicago. The publication, however, is put together, printed, and distributed from the company headquarters in Germany. The point is that contemporary technology allows many people to do jobs without having to be physically present.

Using my insight into these two aspects of editorial positions—that is, that employees cost about 35 percent more than contracted workers and that I could easily produce editorial material from my base in Italy—I set out to get jobs that allowed me to work "my way."

My first four tries—two corporate positions, a staff photographer job, and a newspaper photojournalist slot—didn't pan out. This was primarily because I was dealing with a personnel manager rather than directly with an editor-in-chief or publisher who understood the value I was offering. Next, I received a call from the World Wildlife Fund's Mediterranean Headquarters in Rome. They invited me for an interview to "discuss my unique proposal." The meeting—between three executives and myself—went well. Alas, the deal fell through when they offered two-thirds less than I wanted to handle their media and PR photography.

Ultimately, however, I convinced them to hire me as a freelancer rather than hire a full-time photojournalist. I've been working for them ever since. Eventually, additional jobs came from magazines and advertising clients, using the "help wanted" method of marketing.

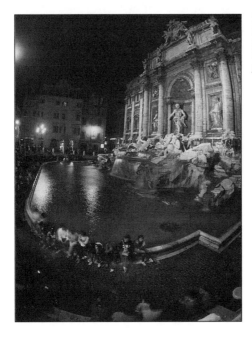

The Trevi Fountain at night, by Robert Schwartz, has appeared in numerous magazines, bringing in between $50 and $250 for each publication. © *Strawberry Media*

When a company advertises for an staff photographer, that means there is a need there. In most cases an executive or publisher makes the decision to hire. He rarely, if ever, considers an alternative solution. Therefore, it is your job to present these people with the alternative and sell them on your professionalism, quality, and reliability. I do this through my credits, high-caliber references, and clips.

A year ago, for example, I received a help wanted notice by e-mail from Jeff Leach, publisher of *Scientific American Discovering Archaeology*. Because the developments surrounding this position perfectly illustrate how you can utilize job openings to gain freelance work, I'd like to share the correspondence with you.

Senior Editor

Position Available Immediately

DISCOVERING ARCHAEOLOGY MAGAZINE

Must have strong writing and editorial skills applicable to a mixed lay and professional readership.

Working closely with the Editor-in-Chief, Managing Editor, and Senior Science Editor, the Senior Editor will be responsible for overseeing in-house writers, working with outside writers, interaction with art department, and writing for the magazine. Background in archaeology a plus.

If you have these qualifications please send your resume and samples of your writing immediately to: Editor-in-Chief *(jleach@elp.rr.com)*. Discovering Archaeology Magazine, 1205 N. Oregon, El Paso, Texas 79902, USA. Tel: (915) 533-8503; Fax: (915) 544-9276. Please include salary history. We offer excellent benefits, and salary is negotiable.

* * *

To: Jeff Leach/Discovering Archaeology Magazine
From: Michael Sedge/Strawberry Media Agency
Subj: Senior Editor

Dear Jeff,

Thanks for sending information on the Senior Editor position.

Having recently worked for Earthwatch and the Discovery Channel, as well as having a history of archaeological topics among my 2,800 articles, books, and photo archives the job is of interest.

I was an onsite writer/photographer for Discovery Channel's book and documentary project, Cleopatra, in Alexandria, Egypt. I spent weeks with French archaeologist and researcher, Frank Goddio, exploring the underwater finds of the ancient city of the Ptolemies. The documentary and book will be released in March.

This research also resulted in my feature on this topic for Mobil Oil *Compass* and Singapore Airlines' *Silver Kris* magazines.

My work includes several Earthwatch projects over the past fifteen years, including digs at Pompeii, Italy, in Switzerland, and the United States. Most recently my work on archaeology sold to Philippine Airlines' *Mabuhay*, *R&R Magazine* (Germany), *Tropi-Ties* (US-Internet), and *Informer* (Italy), etc.

Based in Europe, I additionally covered archaeology extensively for the Associated Press and Time-Life Books between 1980–90.

My books, *Commercialization of the Oceans* and *The Adventure Guide to Italy* also delve into the world of archaeology, both above and below the water's surface— i.e., the sunken Roman City of Baiae, Italian digs, etc.

The fact that I live in Europe (getting to the US 4/5 times a year) and work closely with a number of research and archaeology groups brings added advantage to you. I would bring the following benefits:

• Expanded coverage—Europe & Middle East—for *Scientific American Discovering Archaeology* magazine.

- An on-site photographer/writer for breaking news. For example, new finds in Pompeii (which is in my backyard).
- Rather than an employee, I am willing to work as a contractor—thus reducing the cost of benefits, social security, etc.
- As I am a long-time member of the American Society of Media Photographers and the American Society of Journalists and Authors (recently nominated as a member of the board of directors), you are ensured high quality and professionalism.
- Speaking fluent English, Italian, and some French and Spanish opens doors more easily.
- Modern technology would allow weekly and daily contact with *Scientific American Discovering Archaeology* editors for immediate needs. One of the aspects of my business that has pleased editors around the world is my ability to produce editorial packages (articles and text) on demand. This is a technique acquired through years of photojournalistic news coverage.

Given the above, I would anticipate two trips to the U.S. office a year to attend editorial/planning meetings. Beyond this, work would be conducted from the *Scientific American Discovery Archaeology* European Office and sent by e-mail/courier each month.

Below I am enclosing a recent biography, and will be happy to provide clips. If you'd like to check references, here are a couple of people:

John Buffalo, Discovery Channel
<J.Buffalo@discovery.com>

Blue Magruder, Earthwatch
<*bluemagruder@earthwatch.org*>
Marjorie Hess, *R&R Magazine*
<*mh.rrcom@ameritech.net*>

I look forward to hearing from you and hope we can work together.

Sincerely,

Michael Sedge
Strawberry Media
Via Venezia 14/b
80021 Afragola (NA) Italy
Tel. 011.39.081.851.2208
Fax. 011.39.081.851.2210
Toll free: 1-800-340-7713
E-mail. *pp10013@cybernet.it*
Web. *www.cybernet.it/sedge*

* * *

Michael:

Thanks for your lengthy message. Based on the information you provided, a good fit looks possible. However, we are looking for someone to work in-house. Nevertheless, I would like to figure out how we can work together.

A little about who we are: I started the magazine in June of this year and the first issue (bimonthly) will be on the stand in late December. We do have a European Editor . . . (who) provides us with a complete (edited,

images, copyright stuff etc.) "European" article for each magazine. . . . We get researchers to write most stories but . . . this has a drawback in that most of the articles require heavy editing. Most of the scientists write for their colleagues and not for a lay public. As it stands now, we rework the material with a small staff—however, with any new startup magazine, we are shorthanded and everyone is working on hundreds of things at once. This is where the Senior Editor(s) come in—and we need professional help.

As for you and me—how can we make this work?

1. Do you want to contribute the occasional (one or so an issue) short piece (the latest and greatest from your part of the world);
2. write longer pieces (and provide images) for each issue;
3. edit and clean up material I send you from El Paso;
4. or a combination of all three?

You also point out a problem I will face with (staff editors), the bucks. Just starting off, cash is a problem. This should get better by the second and third year. We are also planning an International version of the magazine for the second year as well as a German version.

So how can you and I work together (the communication is easy—e-mail solves those problems)? Do we put you on a monthly stipend and you agree to do this and that—or do we work on a piece basis? And the big question, how do I get you to work for less than you should get, with the agreement and hope that the magazine will grow and everyone's compensation with it?

Hope to talk to you soon.

Jeff D. Leach
Publisher & Editor-in-Chief
Discovering Archaeology Magazine
1205 N. Oregon St.
El Paso, Texas 79902 U.S.A.
Tel: (915) 533-8503
Fax: (915) 544-9276
jleach@elp.rr.com
www.discoveringarchaeology.com

Jeff and I eventually closed a deal that allowed me produce edi-
torial packages for each issue, as well as special assignment
work such as my recent trip to Malta and upcoming job in
Egypt. I am also listed as the Mediterranean/Middle East Editor
on both the print and electronic versions of the magazine. The
monthly compensation, by the way, is equivalent to some of the
highest-paying publications in North America. Not bad for a
client that came from a "help wanted." And best of all, I can
work in my PJs.

Internet Radio/TV Promotion—For a Fee

A relatively new business has developed as a result of the
Internet's surging popularity—showcasing freelancers (primari-
ly photographers and writers) for television and radio appear-
ances. While some people shun this type of marketing, others
rave about it. One of the companies currently enjoying fair suc-
cess—not only in obtaining customers, but in getting them book-
ings—is *ShowIdeas.Com,* subtitled "The Online Magazine for
Guest & Show Ideas."

Very simply, *ShowIdeas.Com* creates a marketing site for
you, within their own online archives. The listing contains your

name, address, phone number, fax number, e-mail address, your guest availability information and appropriate press kit material. Oh yes, there is a fee of $125 per listing.

"Then just sit back and wait for your listing to appear and for journalists to call," *ShowIdea.Com*'s instructions to potential clients explain. "We generally will put new listings on the site within two weeks or less of receiving the required materials."

Each listing is maintained for a minimum of twelve months. The site is operated by Susannah Greenberg Public Relations, 2166 Broadway, Suite 9E, New York, NY 10024. For more information, contact Robert Schechter by e-mail *(bob@bookbuzz.com)* or visit the *ShowIdea.Com* Web site.

If you're seeking radio gigs, try *www.RadioTour.com.* Operated by Broadcast Interview Source, the company reaches out to radio producers and talk show hosts across the country. As their promotion says, "Show the news media you're available. With RadioTour.com, we do all the work—and YOU do all the interviews."

There is a $295 fee for this service. For this you get: Web page space on a site frequented by print and broadcast media; your RealAudio® message included on your Radio Tour Web page; a press fax, including your interview availability, to 1,000 media outlets; a press e-mail to 10,000 shows and journalists; and guaranteed exposure—or your listing will be run again for free.

For more information visit the Radio Tour Web site or call (202) 333-4904.

A third company offering Internet promotional assistance is KeynotePage *(www.KeynotePage.com).* "KeynotePage is a full-featured talking Web page that links to and drives business to your main Web site," explain company ads. "Or, use KeynotePage to establish your presence on the Web."

Included in the KeynotePage package are: your voice, in RealAudio®—a five-minute demo you can record on the phone;

contact information; your photo; your text; your topics; and links to your Web pages. In addition, your page will be indexed in the YearbookNews.com search engine. This was created for journalists seeking interview contacts and received up to a quarter of a million hits each month.

The fee is $195 per year. For more information, visit the KeynotePage Web site or call 1-800-KEYNOTE.

Writer Turned Photographer Turned Web Marketer

I had my first contact with writer/photographer Lynn Seldon while I was executive director of the European stock agency, Medusa Photos. It was a simple postcard, promoting his services and offering his images to our company.

Inasmuch as we were not taking on new photographers at the time, his approach left a lasting impression. In the years that followed, I get regular mailings from Lynn— never aggressive, never too much, and always professional. He was constantly in the back of my mind, should we ever require a photojournalist from his geographical area or stock that he could provide.

The day I began writing this book another of the famous Seldon postcards arrived; this time promoting his new Web site.

Much of Lynn Seldon's success as a photographer is directly related to his success as a writer. He realized, long ago, that these arts go hand in hand and by combining them, he could establish a lucrative editorial business.

Additionally, the Virginia-based photojournalist understood the power of continuous marketing in achieving success. So, what better person to provide background and tips to other photographers seeking a formula for their own professional growth and increased income? That is why I sought out Lynn at his Richmond office and asked him to write . . .

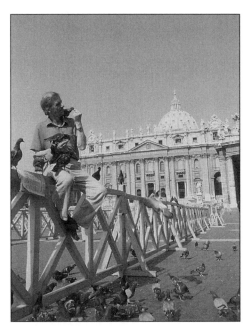

Every Picture Sells a Story
Marketing Methods Make Photojournalism More Lucrative

By W. Lynn Seldon, Jr.
© *W. Lynn Seldon, Jr.*
All rights reserved.
Used by permission.

Seemingly small changes in business tactics and marketing methods can mean big changes in a freelance career. About seven years ago, one visit to a camera shop resulted in huge progress in my full-time freelancing. I learned every picture can definitely sell a story.

Adding photography to my repertoire has led to an average 50 percent annual increase in my gross revenues each year for the past four years. There are many reasons: I sold some stories that would not have sold without my pictures; I made additional income from my own pictures accompanying stories I had written; I sold many pictures on their own; I garnered many freelance photography

assignments; and I now have several stock agencies selling my slides for me.

In addition, photography has allowed me to enhance many marketing techniques that I had already used quite successfully for the writing part of my career (e.g., postcard mailings marketing my work). The Internet (including my Web site) and other technological advances have also allowed me to greatly expand my photojournalism (and marketing) more quickly than I would have ever thought possible.

Ann and Carl Purcell, a top writing and photography team, have perfected this popular creative combination. In *Travel Writing and Photography*, they say, "We can never forget the advantage we gain in being able to deliver to an editor a ready-to-publish package of pictures and text."

Pictures can only make you money if you send them out consistently and correctly. In his excellent book, *Sell & Re-Sell Your Photos*, Rohn Engh says, "Photo buyers would gladly use your photographs, if they knew you existed, and if you'd supply them with the pictures they need, when they need them." This is true of writing as well as photography.

The key is getting your pictures to the right people at the right time. I do this by supplying my own pictures with every story I write; keeping magazine contacts posted on my travels and pictures available; constantly pursuing photography assignments; and providing several stock agencies with appropriate pictures.

I use the current *Photographer's Market* and *Writer's Market* every day to market my work. These guides help my pictures sell a story and lead to additional sales.

I consider freelancing a "contact sport" and spend more than 50 percent of my office time on marketing. I believe marketing is the most important part of freelance success and I believe the Internet has made the marketing side of the business even easier and more efficient.

You can be the greatest travel journalist since Marco Polo, but potential markets won't buy from you if they don't know what you have to offer. Along with standard query letters, faxes, and phone calls, there are many other effective methods of self-promotion (including post-

cards and the Internet). My self-promotion efforts have led to hundreds of assignments and repeat business.

Along with sending out at least fifty marketing pieces a day (pitching specific angles and my services in general) when I'm off the road, I also pursue a wide variety of promotional campaigns. My most successful efforts have revolved around general mass mailings to virtually everyone in my database, including magazine, newspaper, and book editors; public relations agencies; marketing offices; tourism industry officials; and anyone else who might be interested in my work. I currently have more than 10,500 contacts in my databases (including many multiple buyers at magazines and book publishers).

Though I have prepared extensive and specialized form letter campaigns, my mass mailings generally consist of a postcard highlighting my work for a wide variety of markets. While the printing and postage costs can be high, I always gain enough new business in a few weeks or months to pay for the mailing. I like to prepare some sort of postcard marketing mailing once (and sometimes twice) a year.

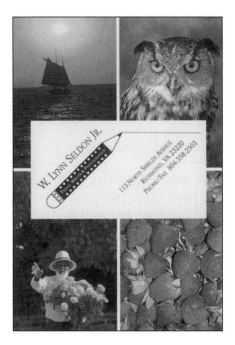

A postcard in 1998 included three general travel pictures—in "slide form"—recent publication credits on the front, and a "work update" on the back. I like to include information about recent and upcoming trips, as well as other items that could lead to a wide variety of assignments and sales. Each of the images on the front has produced more than $750 in direct sales, as well as several location shoots. Credits like *Golf, Porthole, EcoTraveler* and *Skin Diver* give my work credibility with target markets.

My most recent postcard announced my Web site *(www.lynnseldon.com)*. Going out to 9,500 contacts, this had the most obvious impact of any mailing I've ever done. As the postcard reached recipients, I was receiving more than a hundred e-mails a day and my Web site was being visited constantly (people can e-mail me directly from the Web site). This led to more than $5,000 in photo sales and many writing and photography assignments (this particular mailing cost about $2,500 for postage, $600 for printing, and $500 for design). It paid for itself within weeks.

We are constantly updating my Web site to improve its selling capacity. New pictures are added daily, including specific categories. We also update my searchable stock list after every shoot. Additionally, there's a "Requested" area for potential buyers who would like to see specific images. The Web site also includes more than a hundred previously published articles and much more.

While the Web site continues to reap rewards, I'm also using the Internet for additional marketing and research. I constantly look for e-mail addresses to add to my databases. We've done several mass e-mails with great results. We use these e-mails to update photo buyers on recent trips and specific coverage, as well as clips (a recent e-mail to more than 2,500 contacts concerning a feature I had in *USA Today* led to several photo sales and three assignments). Based on our success, we plan to continue mass e-mails as well as targeted ones with articles and photos "attached."

We also use the Internet to e-mail samples of work—generally attaching a low-resolution image. Another easy way to display your images is to post pictures on certain parts of your Web site, then e-mail the link to target markets.

The Internet is also a wonderful tool for marketing research. Through Yahoo.com and other search engines, we've found a variety of new markets. We also use the Internet to research the Web sites of magazine and book publishers we're targeting.

In addition to consistent postcard mailings and Internet target marketing and research, I prepare self-promotion mailings for specific groups and mailing lists (including recent clips, color prints of slides, and other marketing material). Possibilities of targeted groups and mailing lists that might be interested in your work could include: local hotel and tourism officials; public relations and other marketing firms; and many local and national groups. The thirst for editorial material by the travel industry is endless and many people need photographers and writers to help them get it on paper (my mailings remind them that I can help). These targeted groups and mailing lists are then added to my databases for future general mailings.

All of these marketing methods will lead to sales. Many aspiring photojournalists are surprised at the low pay that is often received. However, you can make more money from this business if you adopt the habit of negotiating fees.

Marketing publications often provide a guide as to what buyers typically pay, but these are rarely "fixed" prices. Though I sometimes negotiate with first-time markets if the fee is too low, I rarely decline work that I think may lead to additional assignments.

I will also negotiate with higher-paying publications and with editors with whom I have established a solid reputation and working relationship (i.e., asking for a "raise"). Though there are no easy rules for negotiating fees, I typically ask for 25 percent more than they originally offer. I'm often surprised at how frequently this is accepted. You just have to ask (and deliver the goods).

From clicking the shutter to cashing the check, it's easy to see why every picture can sell a story for me. With my marketing methods, many of my peers have done the same—and so can you.

12
Make the World Your Marketplace

Over the past twenty years I've sold thousands of images to foreign markets—that is, publications outside North America. I've taught the techniques of selling photography overseas at university workshops, provided one-on-one advice to freelancers, and even published a newsletter on this topic titled, naturally enough, *Markets Abroad*.

The number of excuses people come up with *not* to market their work overseas always amazes me. Some of the more common excuses are the following: the added cost of submitting to foreign markets just isn't worth it; it takes too long to get a reply; or how am I ever going to learn who the editors are and what they need? One of my favorites, which came in just last week: "I've always avoided trying to sell abroad because of the hassle with those little mail things, whatever they are called, that are required for foreign postage."

They are called international reply coupons, and thanks to modern communications, they are no longer required. Nor are long waits for replies from photo buyers or increased postal fees. And what about resources for publications and editorial

needs? That information too, thanks to electronic mail and the Internet, is at your fingertips.

I receive several newsletters by e-mail. Last week, for example, an issue of the twice-a-month *Inklings* newsletter *(www.inkspot.com/inklings)* arrived with a listing for *Quote* magazine in Australia. The editor, Tim Duggan, listed his editorial needs and rate of payment. I searched my archive and found two articles, with images, that appeared to fit the requirements and sent them electronically, along with a cover letter. All of this took ten minutes.

The next afternoon, Duggan's reply came in by return e-mail: "Your work blew me away! It is exactly what we are looking for." He went on to say that if I had additional material he would be interested in seeing it and, if things worked out, discussing a possible contributor spot in the magazine's masthead.

It is still too early to tell how things will turn out with *Quote*, but the initial sales, for something I had in stock, will bring me $300.

Not much, you say? Perhaps, but considering the fact that this material already sold in the United States, Singapore, Germany, Italy, and the United Kingdom, the sale in Australia was merely icing on the cake, adding to the $2,200 I'd already made—and it may lead to regular contributions. The only work involved was the ten minutes it took to pull the material from the electronic files of my computer, paste them onto an e-mail message, and transmit them. I consider $30 per minute *very* good pay.

10 Reasons to Go Global

Photographers who do not take advantage of global markets are doing themselves a great disservice. In addition to the joy of seeing your photographs in Japanese, German, Arabic, and other foreign-language publications, there are a number of other reasons why you should take your marketing efforts abroad. Here are ten:

1. Foreign publications—particularly the in-flight and travel sectors—utilize far more photo essays than do North American periodicals.

2. International publications, especially in Europe, seem to have a high respect for quality photographs and pay greater sums for their use.

3. Photographers often find a greater willingness on the part of foreign editors and art directors to cooperate and provide information on their needs. This is because the competition in many countries is not as aggressive as it is in North America.

4. Once you've established a good working relationship with a foreign editor or art director, it is relatively easy to become a "regular," or an in-house photographer.

5. If you offer an "exclusive" to a publication abroad, that exclusivity can be limited to the country or market in which the image appears. You could, therefore, simultaneously offer exclusivity in Italy, Spain, Germany, the United Kingdom, Japan, Singapore, and so on.

6. If you produce a photo essay, you can sell it over and over again in various countries without alteration. For instance, I have one picture-story that has sold eleven times (bringing in more than $7,000 to date) and it is still selling—the last time in South Africa.

7. The professionalism of most foreign editors and art directors is far superior to that of their counterparts in North America when it comes to handling and returning images. They have great respect for the work we do, and the ownership thereof.

8. The Internet has made global marketing as easy as selling to the local newspaper.

9. Once you know a market's needs, it is not difficult to provide monthly packages—pulling images from your stock—to fill the publication's requirements.

10. There is a world of markets out there waiting for good photographers. If you don't fulfill part of those needs, someone else will.

Used to illustrate a story on Italian wine, this picture captivated the editor of Milan's Informer *magazine, who liked "the composition and framing" of this photo, and used it as the lead page for the article.*
© *Strawberry Media*

Images That Travel Well

What type of images travel well abroad? Obviously, celebrities—international movie stars, authors, sports figures—do well. Travel is always a good seller. I began my foreign marketing, in fact, selling travel photographs to in-flight magazines. For every airline in the world there seems to be a super-slick, four-color publication that uses hundreds of images each issue, including photo essays.

The key is for you to focus your offering on the geographical areas that the airline serves—if the airline doesn't not fly to Detroit, don't try selling the in-flight magazine Motor City photography.

Once I exhausted my destination ideas, I found I could do well with adventure picture stories: exploring volcanoes; diving in a sunken Roman city; rafting in Switzerland. These images also sold well to popular travel magazines in Germany and the United Kingdom.

An Earthwatch expedition led me to write a 500-word story on environmental issues, which I could complement with nature photographs. Suddenly I was selling these not only to in-flight magazines, but to top-name general-interest publications like the *London Illustrated News* and, in Japan, *Mini World*.

South African and Middle East publications tend to favor photos on international sports like tennis and formula one racing, as well as topics of interest to women. A photo story on plant cultivation (actually five, step-by-step photos with captions) brought me $350 from South Africa's *Fair Lady*, while *Golden Falcon*, in Bahrain, paid $275 for a photo feature covering the World Cup soccer games.

The first step in successful international sales is to know the markets—particularly if you are targeting the editorial or advertising fields. International marketing requires general knowledge of the various social, political, and cultural habits of the country in which you hope to sell your work. Lack of such insight can sometimes make the difference between landing an assignment and getting a rejection letter. A single cultural or political error in your compositions or approach could also damage your credibility when it comes to future sales.

People living outside North America, for the most part, do not think like Americans and Canadians, and vice versa. In the freelance guidelines for *Muhibah*, the in-flight magazine for Royal Brunei Airlines, for example, editor Fong Peng Khuan warns, "Please be aware that as Brunei is an Islamic country, we cannot feature, mention, nor reference (even in images) alcohol, religion (other than Islam), dogs, pigs, political commentary, human body parts, or women in revealing clothing."

Colors, too, have different meanings in different countries. In Brazil, purple is a death color, while in Hong Kong, white signifies funerals. In Mexico, death is associated with yellow flowers and in France the same flora suggests infidelity. White lilies, while looking beautiful, are never given in England, unless you desire to give a death wish. Red is popular in all Chinese-speaking areas and in Italy. Red roses in the latter country could mean a special emotion.

Therefore, to enhance your chances of doing business overseas, it is best to familiarize yourself beforehand with the cultural, political, and religious customs of the countries in which you hope to sell. The U.S. Government Printing Office's series of "Background Notes" are excellent resources for this. Each *Background Note*—and there is one for nearly every country in the world, updated periodically by U.S. embassies and consulates—costs about $5 and can be ordered from the Superintendent of Documents, U.S. Government Printing Office, Washington, DC 20402. Internet users can obtain copies by addressing e-mail requests to *order@bernan.com* or through the following Web page: *www.bernan.com*. In this latter case, you go into the Government Printing Office database and search the library for the document number (by country you're investigating). The easiest way to do this is to use the name of the country you are interested in. Once you find the *"Background Notes"* you want, simply click on the order box.

Finding Global Markets

One of the first questions photographers pose when considering where to begin their global marketing efforts is how to locate foreign publications that purchase freelance images.

While there are many options, I normally suggest you first visit the closest international airport, where newsstands normally sell periodicals from around the world and in several languages. If you live in or near a major city, you could also stop by the local offices of foreign airlines—Singapore, Philippine,

South African, Scandinavian, Lufthansa, and so forth—to obtain copies of their in-flight magazines. Normally, the editors/art directors at these periodicals are frequent photo buyers, using lots of images and photo essays.

The easiest way to find potential editorial markets, however, is through the Internet. If you are seeking publications in, say, the United Kingdom, you can simply do a search, using any of the major search engines, of "United Kingdom Periodicals." This will provide a variety of lists of individual magazines and newspapers.

You may also want to look into Picture Source, a United Kingdom–based organization that lists photo needs from picture researchers throughout the country. Go to *www.picture-search.demon.co.uk*. Additionally, you can find information on various aspects of photo marketing and updates on stock agencies from the British Association of Picture Libraries and Agencies at *www.bapla.org.uk*.

Other Web sites to check out include:
www.webwombat.com.au/intercom/magazine/index.htm
http://britishcouncil.org/arts/literature/litfest.htm
www.fleet-street.com/top.htm
www.inkpot.com/news
www.journalismnet.com/papers.htm
www.mediainfo.com/emedia
www.newsdirectory.com

There are two very good directories, both found in major libraries, listing information on international publications around the world. These are *Willing's Press Guide* (two volumes with hundreds of thousands of publications) and the *International Writer's and Artist's Yearbook,* published by A&C Black of London and distributed in North America by the Talman Company in New York. The *Yearbook* contains over a thousand titles, editors' names, rates, and more. Another source is my own title, *The Writer's and Photographer's Guide to Global Markets* (Allworth Press; see Appendix A).

"NATO Officers" was the theme of this picture captured during an assignment on the Allied efforts in Bosnia. © Strawberry Media

Increasing Stock and Free Travel

As I write this, I am sitting at the Holiday Inn in Sarajevo, the city which, only a few years ago, was decimated by war. While I have two photo assignments, what really brought me here was a need by a U.S. telecommunications company.

Long ago I learned that I could offer my services as a world traveler to corporate America in exchange for free travel. Once I've locked in a destination, I then contact regular photo-buying clients around the world, informing them that I will soon be traveling to a certain country or region. My offer is very tempting: to provide them with images from that area without having to burden them with expenses.

The results are frequently overwhelming. In fact, this offer often results in assignments that clients would normally not have considered—and certainly would not have contacted me to handle. Even when I am not successful in obtaining a

photo assignment for a travel destination, I take advantage of the "free trip" to increase my stock for future sales.

So how does it work? Many companies have a need for experienced travelers. Over the past ten years I have specialized in working with telecommunications companies such as AT&T, MCIWorldcom, and Rapid Link. Currently, Arrowhead Space & Telecommunications is picking up my expenses for a four-day trip to Bosnia, because they needed someone to act as a contract administrator—that is, to meet with local personnel, collect payment receipts, and so on—at the U.S. military base in Tuzla.

I have conducted marketing activities—traveling through Germany, Italy, Belgium, Lichtenstein—for MCI; acted as a researcher for the Discovery Channel in Egypt; was a media coordinator for the Major League Alumni Association during a professional baseball player tour in Greece and Spain; and was part of a European tour for Mary J. Blige and Miss USA. All of these provided me with free travel and lodging, while offering an opportunity to increase my photo assignments and photo stock.

One of the best ways to get into the freebee travel business is to explore Internet help-wanted ads placed by corporations. Once you have a contact, send a letter spelling out your professional experience and offer your services under an expenses-only option. Use friends and Internet contacts to create a network of people who can assist in informing potential clients of your services. Finally, advise your current clients that you are willing to travel and provide images on an "expenses-only" basis. While you will not want to make a habit of this practice, it can open many doors, leading to an increase in paid assignments and great stock sales. Soon, you will find yourself not only selling your work abroad, but traveling there as well.

13

Odds 'n' Ends

Many aspects of good marketing do not fall into specific categories or under hard, fast headings. Some things can be applied to a single, target market, while others overlap and can be applied to all your efforts. One thing that does remain constant, however, is the necessity to make every idea and every tactic your own. Don't simply copy the methods in this book. Personalize them, make them fit your specific needs. Whether you are trying to sell an article, a book, a speech, a service, or yourself—marketing is your responsibility and no one else's. It is also up to you to develop your own style and approach.

Success breeds new opportunity for success.
—RUSH LIMBAUGH, *THE WAY THINGS OUGHT TO BE*

Once you get into the swing of marketing, you'll find the river of opportunity flows endlessly. Today's efforts will grow like wildflowers, creating the opportunities of tomorrow.

Spoofs

Getting media coverage for yourself and your company can sometimes be difficult unless you come up with a unique story angle. Alan Caruba discovered this in the early 1980s. After a while, in fact, he became bored with the entire process. Little did he realize that his emotional state would be the key to his future success.

"The Boring Institute *(www.boringinstitute.com)* began as a spoof of media hype," he recalls, "and continues with that purpose today. In 1984 I put out a news release, inventing the Institute, saying that it had concluded that the Macy's Thanksgiving Day Parade was, in fact, a ten-year-old videotape. That got an immediate response and, the next month, I initiated the first list of 'The Most Boring Celebrities of the Year' as a spoof of all the end-of-the-year lists of who's hot and who's not. It was an instant hit."

As a result of his "boring" spoof, Caruba made news across America, appearing on many of television's most popular talk shows, doing radio spots, and gaining coverage in *Newsweek, Time, People,* and *USA Today.* Today his "Most Boring . . ." lists continue to make headlines annually and he has become an international personality. To ensure year-round visibility in the news, he releases a spoof of the Academy Awards in the spring, a midyear serious look at boredom's impact on people's lives, and, in the fall, a commentary on the hideous—and exceptionally boring—new television shows.

"The Institute gives me name recognition and opens the door to many people in the media who, in fact, seek me out," Caruba says.

Alan's is a story of how a single individual, with intelligence and a bit of marketing know-how, can gain recognition

without writing a best-selling book. By breaking away from traditional molds—even using spoofs—you can always stay one step ahead of the crowd. And the more name recognition you generate, the more popular you become, the more clients will want you. So be creative. Think about ways to get your name out there. Break away from the traditional methods of marketing photojournalism.

"I do think that [photographers and] writers need to promote themselves every time anything they do gets in print," suggests Caruba. "Send out a release about [the images] . . . send copies to other media. Develop a reputation for speaking about your area of expertise on radio and TV. That sort of thing. The more famous you become, the more leverage you may have with editors [and other clients]."

Answering Machine Marketing

There is a thing in the movie business called a "log-line." If you ever get an opportunity to pitch a story to a movie producer, in fact, the first thing she will probably ask is, "What's the log-line?" What the producer is asking for is your story in a condensed version of, say, two or three sentences.

Prior to calling a potential client to pitch an idea—whether it is covering a event, corporate work, or even teaching a seminar—always prepare a log-line. Be ready to present your idea clearly, but concisely. By doing this, you will have a script to guide you through your talk once the producer has answered your call.

In the event that you get an answering machine, record the pitch for the producer to hear upon her return. If she likes it, you'll get a return call. On the other hand, if you simply ask for a return call, you'll probably never hear from her.

This photo of the Itaipu Dam Spillway in Brazil, made by Randa Bishop, is "probably my best photograph," she says. "I was on assignment in Brazil doing a story on the Itaipu Dam for a small Japanese magazine on the world's largest dam, in terms of power. The dam was under construction, and I liaised with an engineer to see the dam. I was attempting to get a photograph that would capture the concept of 'power.' None of the turbines were in operation yet, so all the river water was going through the spillway. The photograph has sold extremely well because of its element of surprise. It definitely displays the concept of power, and it is unusual. Now in its eighteenth year, the photograph has been used innumerable times in the United States and most major countries of Europe and in Japan. It has been in magazines, books, posters, annual reports, and advertising. It has commanded prices reaching into the thousands ($4,000– $7,000 for a single advertising use). For editorial it has been sold often at $500–$900, mostly because it is frequently used as a 'double spread' image in magazines. It can currently be seen on National Geographic Society's Web site as part of the book, Wonders of the World.*" © Randa Bishop*

Tips From a Pro

I first met Randa Bishop in the Philippines during a press trip sponsored by the Travel Journalists Guild. We immediately hit it off and I have fond memories of the two of us racing through the halls of the Manila Hotel and up the service elevator to the roof because, as she put it, "The light of the setting sun is perfect."

Randa is one of the finest travel photographers I've ever met, and she's worked with all the top media in this sector— from *National Geographic* to Germany's *Das Beste*.

So when I began writing this book, I asked her to offer a few tips for photojournalists. And, professional that she is, she provided far greater, and more valuable, information than I had hoped.

Comments and Tips

by Randa Bishop

These comments are based on my specialty in travel photography and travel "stock" photography, as well as feature story assignments.

1. *Ideas.* If you don't have any ideas, then pack up your cameras and give the little black boxes away. A while back I was on assignment for *National Geographic World* doing a story on how King Kong was being made for the exhibit at Universal Studios. The shoot required tons of strobe lighting (four power plants and sixteen lamp heads). I found two assistants for the gear and lighting. I also sought out someone with automobile photography experience. We were struggling with the lighting and technical problems on the set when one of the assistants glibly commented, "Why don't I have this assignment? I know more about lighting than you do."

"Yes, you do," I replied. "But I had the idea."

Simple as that!

2. *Where to take photographs.* Close to the beginning of my career, I had a lucky experience. I was invited to a photo "shoot-out" on Prince Edward Island. My venture into this tiny maritime province would bring me huge returns— within two to three years my material from this destination had appeared in some twenty different magazines.

The answer to why such a success for this small isle was that I had gone to a place where few others had been, and it got "hot" as a tourist destination. Another answer is that few editors are risk takers. They are often "keep up with the Jones" types. After Prince Edward Island was first published in a major travel magazine, other editors saw it and climbed onto the bandwagon. So photos of the island were in demand.

My photos of Prince Edward Island were published in *Signature*, *Popular Photography*, *Travel Holiday*, *Recommend*, and *Adventure Road*, among others. In addition, I wrote articles about the island which were published as full features (six to ten pages) with my images in *Islands Magazine*, *MD Magazine*, *Geo Mundo* (Mexico) and *Silver Kris* (Singapore). By writing these articles, I was able to sell many more photographs.

"Mariachi at Sunset" is another image by photojournalist Randa Bishop, this one made in Puerto Vallarta, Mexico. Says the author, "This image was used in Travel Holiday *magazine. The art director apparently loved all that open space and inserted some five other images over mine, plus the title, credit, and opening text of the article. Again, the photo is a concept image. It says peace, relax, enjoy, have fun, and above all, it is 'instantly' recognized with a mere glance as somewhere in Mexico."*

Writers who take photos [and vice versa] are often pushed into "package" deals. I always negotiate a separate price structure for photos. Don't accept package offers unless they are equivalent to the prices you get paid for your images alone, then an additional text fee.

Interestingly, my stock agents were also excited about the images of Prince Edward Island. One in particular told me he had "nothing" in the files from the area.

On another occasion I went to Saudi Arabia (before the Gulf War). The images from this trip sold extremely well around the world simply because they were available. Not many photographers can just "go" to Saudi Arabia. It is even more difficult for a woman photographer, particularly one who is unmarried.

If you are interested in long-term stock sales, then go to the places that advertise [on television or in magazines]. Don't go for advertising photos, but for editorial images. No matter what anyone might say about editorial ethics, it is simply a fact of life that countries which have fat pocket ad budgets get a lot of editorial space in magazines—it's no wonder that photos from Canada, Mexico, and the Caribbean are my biggest and most consistent sellers. Take just the Caribbean as an example. You'll see ten photo/articles or more on Puerto Rico to every one on Grenada or St. Lucia. Every time I go on "safari," I think of it as a vacation. I work just as hard, and with the same principles, but the images will never sell as well as if I had spent the same amount of travel time in Puerto Rico or Jamaica. The animal shots are better left to the specialists, and the city shots just are not big sellers.

Go anywhere that has sun, sea, and sand. Go anywhere that has good shopping and excellent food.

3. *Type of photos to make.* First, note that I use the word "make" instead of "take." Make photos. "Concept" and "dream" photos are the biggest sellers. Don't take photos that just say "This is a man." Make photos that say "This is a man enjoying himself—relaxing in the lap of luxury, playing golf, doing something, etc., etc." Make photos that say something, anything.

Make photos that are timeless. These are photos that will only retire if the country goes away. Timeless photos are generic beach scenes, costumed folk dancers. Beware of changing skylines; cityscapes have a relatively short life span, but may much later be rejuvenated by your grandchildren as historical images if they take over your stock sales.

Concept photos are often used in larger sizes as "double spreads," on covers, full page, and to open an article. They often make more money simply because they are

used in bigger sizes. They may also sell later in advertising or for corporate uses which pay higher fees.

"Dream" photos and concept photos often have a longer shelf life than some of the magazines that use them.

4. *Run a business.* Give your clients what they ask for, but also give them what will sell (them and the reader). A client may ask for a dog, though they really want a pig. You are the one that has to figure that out.

Don't be afraid to ask for higher prices and learn to negotiate.

Never let a client go with a simple "no." Use "no, but yes." If you are a dead end, your client won't come back. If you always have something to offer, on the other hand, the client will return again and again. For example, let's say a client calls with, "Do you have photos on Puerto Rico?" You have no shots on file, so reply, "None in my files, but call Joe Caribbean, he just returned from a trip from that area."

Get model releases—they are getting increasingly necessary for nearly everything. They are a fact of life. Get used to this idea, it is not going to get any easier and it certainly is not going to go away. Model releases refer to property as well as people. Imagine you've just taken a fabulous photo of a hotel in Las Vegas. If that photo shows up in some form of advertising, the rich casino owner just might breathe down your neck with a lawsuit.

5. *Tech advice.* Shoot verticals if you want to sell covers and be sure to leave enough clear space at the top of the image for the magazine's name. Do this when you are in the field shooting. Shoot horizontals if you want double-page spreads. When in the field, eye the photo as if it is going to be two pages in a magazine—and check out where the "gutter" will hit the image.

Make images with lots of clear space. The art director is looking for a photo where she can make her own mark, the one of design. Lots of clear space provides the designer the freedom to design the page the way she wants—and increases your changes of selling a photo. When you are making photos in the field, always remember an art director is going to judge your image on a light-box next to ten others. Yours had better be the best.

"Aspronisi" (white island) near Patmos, Greece, was the setting for Randa Bishop's "creation" of this image. It has appeared in Islands, Greek Accent, Geo *(Germany), and was exhibited in New York; Washington, DC; and Athens and Patmos, Greece. It normally brings $500 for editorial use.* © *Randa Bishop*

Use the rule of f16. If it is a bright, sunny day, and your aperture is set at f16, the shutter should read the same as the speed of your film. So if you are using 100 ASA or ISO film, the shutter speed will be close to 100 or 125 for the correct exposure. You can make the correct adjustments from there for different f-stops or shutter speeds and for bracketing.

More Free Tips

Periodically I like to explore what others are suggesting, with regard to marketing. After all, no one person has ever had all the answers. An Internet site I check from time to time to compare and incorporate into my own methods of business is Herman Holtz's *Tips for Marketing.*

Most ideas from this source revolve around the themes of "how to make more money teaching," "becoming a consultant,"

and so on—which are a natural extension for many niche photographers. Check it out at *www.bellicose.com/freelance.*

A popular, free, e-mail newsletter that focuses on marketing and the Internet is *Image World,* edited by Robert Zee. The people behind this publication believe that small and large businesses can all thrive by taking advantage of new digital technologies, and I cannot argue that point. To subscribe, send an e-mail to: *subscribe@imageworld.net.* The *Image World* Web site—*http://imageworld.net*—includes the 100-plus best places to promote your Web site for free.

Client Night

New York writer Leil Lowndes says, "There are more good writers than editors can use. The ones who market themselves are the ones who get contracts."

To ensure that he is one of the elite scribes who are consistently employed, Leil has initiated a unique technique, which you might want to try. He holds "Evenings with Editors" at his loft in Manhattan's SoHo that enhance his personal relationships with editors of top publications.

This same concept can easily be applied to photojournalists and the clients they wish to attract (editors, art directors, stock agency directors, advertising agency personnel, and corporate picture buyers). Here is how it works: Lowndes makes contact with assignment editors at some well-paying magazines based in New York City and invites them to attend an evening session to talk with writers and photographers about their needs and guidelines. Once he has confirmed an editor and date, he then invites between twenty-five and thirty colleagues.

"This gives me direct contact with editors," he says.

Collecting What's Due

Sooner or later, most photojournalists come across a client who either delays payment or, in some cases, never pays. While many professional organizations stress taking such clients to court, the

cost involved in this process often does not justify the effort. For example, let's say a newspaper owes you $250. Even in small claims court, it may cost you this much or more in time, paperwork, and communications to pursue legal action.

There is, however, a trick you can try for clients who fall into this non-paying category, if they have e-mail. You simply create an e-mail letter to a fictitious collection agency, copying the editor and anyone else at the publication who has influence on getting you paid. Here is my sample letter/message:

```
To:    jcook@usacollection.com
From:  msedge@aol.com
Cc:    dedwards@nopaymag.com
       Jsimon@nopaymag.com

Dear Mr. Cook,
In reference to our telephone conversation
of today, I am sending, by Federal Express,
the documentation related to the nonpayment
of $250.00 by No Pay Magazine for photograph-
ic services provided, by myself, in the
January issue of this publication. The terms
discussed for USA Collection Agency to handle
the recovery of this payment are acceptable.
I look forward to hearing from you on this
matter and thank you for your assistance.

Sincerely,

Michael Sedge
Strawberry Media
```

When you send the message it will be returned to you with an error message because the credit agency does not exist. The publication, however, does not know this. The editors and others at

No Pay Magazine have received their copy of the message and, at this point, should be sweating and/or cutting you a check.

I have used this technique successfully in two cases. Unless a publication is going bankrupt, it should draw an immediate response. Why? Because one of the first actions a collection agency takes is to place the person or company owing money on a "bad credit" list, which is circulated nationally. Therefore, should they apply for credit of any type—from a bank loan to a calling card—it raises a red flag, which often results in rejection. Eventually, if not paid, a bad debt could affect their permanent credit record.

When I introduced this technique recently to a newsgroup, I was slammed by some members who called it "terrible advice" while others praised me and asked if they could pass it on to other freelance organizations. Whether you use it or not, is up to you. My feeling on this is that any method that will allow me to recover money owed to me, no matter how small the sum, is worth a try.

Corporate Cooperation

I have worked for Holiday Inn, H&R Block, McDonald's Systems, MCIWorldcom, Rapid Link Telecommunications, and many other corporate clients. While the pay for corporate work is usually better than average, you often run up against a widespread reluctance on the part of marketing personnel to offer work to outsiders. I've been able to overcome this hurdle, however, by offering to work under a "fee plus percentage" payment arrangement.

For example, Holiday Inn paid me a fixed fee for marketing materials I created, and then, for a one-year period, a commission (10 percent) on all the business generated by the press kits, releases, and brochures. We assigned a booking code to all materials, which allowed me—and Holiday Inn—to constantly know the results of my work (a standard marketing technique).

At the end of the year, 271 rooms had been booked as a result of the promotional materials I created. At $120 a night, that was $32,520. I took home $3,252, on top of the initial $700.

For a feature in Mabuhay, *the in-flight magazine for Philippine Airlines, the author collected images such as this one of Andrew Lloyd Webber's hit musical,* Starlight Express. *The package brought $900. © The Really Useful Group*

In the case of MCI, I produced press materials (images for ads and brochures, plus text for the brochures)—as well as distributed them—and received a monthly commission on new customer telephone usage. Let's say, for example, the marketing director and I decided to promote the WorldPhone™ calling card to U.S. military personnel in Japan. I would create the marketing tools; MCI would foot the bills for distributing the materials and pay me $500. When customers applied for the service, a tracking code would be assigned that linked the customer back to my efforts. As each new client began calling, I would get a monthly commission—between 5 percent and 7 percent—based on the billed amount. Did it work? Let's just say that over a six-year period, I made nearly $300,000 from this corporate client.

The moral of the story? Be creative not only in your direct marketing, but also in the way you approach potential

clients and the payment arrangements you suggest. Make it easy for them to say yes. The best way to do that is by applying the right rule of marketing—find out what the customer needs. You may find that you can land more work and bring in more money if you ask yourself, "How can I help this company increase its business?"

Don't Overlook the Obvious

Sometimes the obvious is easy to overlook when you are focusing on tricks and techniques to market yourself, your products, and your services. This morning, as I put the finishing touches on the first draft of this book, my phone rang.

"Mr. Sedge?"

"Yes."

"This is Marco Guerra, from *La Repubblica* in Rome. During a recent trip to the United States I read the interview you did with Tom Clancy. We're interested in using the article in Italian, and the photographs, if the rights are available."

"Excellent," I say. "But I am curious. How did you find me?"

"At the end of the article, it said you live in Naples. I simply looked you up in the Yellow Pages."

Yes. I have a tiny, box ad in the Yellow Pages under *Photojournalist* . . . and so should every professional.

A Final Word . . . on Ethics

Photojournalism is a noble profession, when approached with the proper responsibility and ethics. The 1997 death of Princess Diana and the paparazzi scandal that followed brought worldwide attention to the ruthlessness of some photographers. At the time, David R. Lutman, president of the Executive Committee of the National Press Photographers Association, summed it up by saying, "In every profession, there are people who go too far— who stretch the notions of ethics and decency. Perhaps those

who make their living from 'tabloid journalism' will learn from this disaster that there are real human consequences to their professional behavior."

As you go forward in your career, be aggressive, be a marketer, but most of all, be a professional. Maintain the highest ethics and human concern. Be a proud member of the global community of photojournalists.

Good luck!

Appendix A
Resources for the Photojournalist

Internet References to Associations and Organizations

AMERICAN SOCIETY OF MEDIA PHOTOGRAPHERS (ASMP)
www.asmp.org/

ASMP SPECIALTY GROUP
http://205.234.16.2/specgrp/pj.html

BRITISH ASSOCIATION OF PICTURE LIBRARIES AND AGENCIES (BAPLA)
www.bapla.org.uk

BROADCAST EDUCATION ASSOCIATION
www.beaweb.org/

EASTERN CANADIAN NEWS PHOTOGRAPHERS ASSOCIATION (ECNPA)
www.execulink.com/~ecnpa/

INTERFOTO
www.interfoto.ru

HONG KONG PRESS PHOTOGRAPHERS ASSOCIATION (HKPPA)
www.hkabc.net/~hkppa/ehkppa.htm

MICHIGAN PRESS PHOTOGRAPHERS ASSOCIATION (MPPA)
www.mppa.org

MINNESOTA NEWS PHOTOGRAPHERS ASSOCIATION (MNPA)
www.mnpa.org

NATIONAL ASSOCIATION OF BROADCASTERS (NAB)
www.nab.org

NATIONAL PRESS PHOTOGRAPHERS ASSOCIATION (NPPA)
www.sunsite.unc.edu/nppa

RADIO-TELEVISION NEWS DIRECTORS ASSOCIATION (RTNDA)
www.rtnda.org

ROYAL PHOTOGRAPHIC SOCIETY (RPS)
www.rps.org

SOCIETY OF PROFESSIONAL JOURNALISTS (SPJ)
www.spj.org/spjhome.htm

WHITE HOUSE NEWS PHOTOGRAPHERS' ASSOCIATION (WHNPA)
www.htnpa.org

WORLD PRESS PHOTO (WPP)
www.worldpressphoto.nl/

Miscellaneous Net References

THE DIGITAL JOURNALIST: forum/information source
http://dirckhalstead.org

EDITORIAL PHOTO: e-zine/professional information/links
www.editorialphoto.com

E-MAIL LINKS: professional information
www.gugerell.co.at/gugerell/media/

LAW RESOURCE CENTER: legal services
www.lawresearch.com

LIBRARY OF CONGRESS: research tools/copyright information
www.loc.gov

MILITARY PHOTOJOURNALIST CONNECTIONS: e-zine/discussion
group/contests/jobs/links
www.threeoaksphoto.com

NEWSIES: professional information
www.newsies.com

PDN'S PHOTO SOURCE: reference/links
http://photosource.netsville.com

PHOTO DISTRICT NEWS ONLINE: e-zine
www.pdn-pix.com

PHOTOSOURCE INTERNATIONAL: marketing information and publications
www.photosource.com

PICTURE OF THE YEAR: photojournalism competition
www.poy.org

REPORTER'S INTERNET GUIDE: professional information
www.crl.com/~jshenry/rig.html

VIDEOMAKER: e-zine/professional information
http://videomaker.com/

YAHOO! PHOTOJOURNALISM RESOURCES: references/links
www.yahoo.com/Arts/Visual_Arts/Photography/Photojournalism

ZONEZERO: e-zine/professional information
www.zonezero.com

Books and Publications

ASMP PROFESSIONAL BUSINESS PRACTICES IN PHOTOGRAPHY
The most authoritative source of information on business practices, standards, and resources for professional photographers—from the foremost organization for photojournalists. $24.95. Allworth Press, 10 East 23rd Street, New York, NY 10010. Tel. 1-800-491-2808. Web. *www.allworth.com.*

BIG BUCKS SELLING YOUR PHOTOGRAPHY
Written by two-time "Travel Photographer of the Year" Cliff Hollenbeck, this title should be read and studied by everyone interested in photography as a business. $15.95. Amherst Media, P.O. Box 586, Amherst, NY 14226. Tel. 1-800-622-3278.

BIG IDEAS FOR SMALL SERVICE BUSINESSES
Authored by veteran marketers Marilyn and Tom Ross, this title provides a wealth of marketing strategies for any business. $15.95. Communications Creativity, P.O. Box 909, Buena Vista, CO 81211-0909. Tel. 1-800-331-8355.

BOOK MARKETING UPDATE
A twice-a-month, eight-page newsletter with marketing tips and contacts in various media, including print and broadcast. $247.00 a year. Bradley Communications Corp., 135 East Plumstead Avenue, P.O. Box 1206, Lansdowne, PA 19050-8206. Tel. 1-800-989-1400.

BRADLEY'S GUIDE TO THE TOP NATIONAL TV TALK SHOWS
Find out who picks guests for Larry King. Learn how to get on *Good Morning America, Oprah, Montel,* and many, many more. $75.00. Bradley Communications Corp., 135 East Plumstead Avenue, P.O. Box 1206, Lansdowne, PA 19050-8206. Tel. 1-800-989-1400.

BUSINESS AND LEGAL FORMS FOR PHOTOGRAPHERS
Shutterbug magazine says, "Every photographer needs this book." It is the most complete book of forms for photographers who work in commercial, editorial, stock, wedding, fine art, and even video. $24.95. Allworth Press, 10 East 23rd Street, New York, NY 10010. Tel. 1-800-491-2808. Web. *www.allworth.com.*

EMPIRE BUILDING BY WRITING AND SPEAKING
This is a how-to guide for entrepreneurs looking to build or enhance their business. By Gordon Burgett. $12.95. Communications Unlimited, P.O. Box 6405, Santa Maria, CA 93456. Tel. 1-800-563-1454.

ESSENTIAL BUSINESS TACTICS FOR THE NET
If you are new to Internet business and marketing, check out this title by Larry Chase. $29.99. John Wiley & Sons, 605 Third Avenue, New York, NY 10158-0012. 1-800-ALL-BOOK.

GETTING BUSINESS TO COME TO YOU
The perfect resource for small businesses, by Paul and Sarah Edwards and Laura Clampitt Douglas. Second edition, $18.95. Putnam Publishing Group, 200 Madison Avenue, New York, NY 10016.

HOW TO SELL PRODUCTS VIA THE INTERNET

An excellent, twenty-page report. $5.00. Open Horizons, P.O. Box 205, Fairfield, IA 52556-0205. Tel. 1-800-796-6130.

HOW TO SET UP AND MARKET YOUR OWN SEMINARS

Gordon Burgett does a great, step-by-step job of telling you how to jump into the lucrative seminar business. Audiotape set, 180 minutes, and a twenty-six–page workbook. $44.95. Communications Unlimited, P.O. Box 6405, Santa Maria, CA 93456. Tel. 1-800-563-1454.

NICHE MARKETING

If you want to make yourself indispensable as a writer and speaker, this title will help you achieve this goal. $14.95. Authored by Gordon Burgett. Communications Unlimited, P.O. Box 6405, Santa Maria, CA 93456. Tel. 1-800-563-1454.

SELLPHOTOS.COM

This 265-page book by Rohn Engh provides valuable insights into the power of the Internet in photo marketing and self-positioning in the electronic marketplace. It removes the mystery of building your own Web site; shows you how to make CD-ROM portfolios; gives tips on how to promote yourself, and much more. $22.49 (shipping included). Pine Lake Farm, 1910 35th Road, Osceola, WI 54020. Tel. 1-800-624-0266, ext. 21. *www.sellphotos.com.*

THE PUBLICITY HOUND

Bimonthly newsletter featuring tips, tricks, and tools for free (or really cheap) publicity. Written by Joan Stewart. $49.95 for U.S. subscription, $59.95 outside the United States. Sample copy $3.00. Send check to the Publicity Hound, 3920 Highway O, Saukville, WI 53080. Tel. 414-284-7451. E-mail. *jstewart@execpc.com.*

WEB MARKETING COOKBOOK
This is a book/CD combination providing over twenty ready-to-use templates for site design, searching, viewing, etc. It is subtitled "All the Ingredients You Need to Implement a Five Star Electronic Marketing Strategy" and holds true to this claim. $39.99. John Wiley & Sons, 605 Third Avenue, New York, NY 10158-0012.

THE WRITER'S AND PHOTOGRAPHER'S GUIDE TO GLOBAL MARKETS
Written by yours truly, this 292-page, hardcover title covers working with foreign editors, art directors, book publishers, and stock houses. $19.95. Allworth Press, 10 East 23rd Street, New York, NY 10010. Tel. 1-800-491-2808. Web. *www.allworth.com*.

About the Author

More than two decades ago, Michael Sedge learned that he could sell more and gain more respect in the publishing industry by working under an agency heading. Thus began the Strawberry Media Agency. Most of his many publishing credits—more than 2,800 articles, eight books, and thousands of photographs—have been sold through this one-man stock photo/editorial/marketing operation.

A long-time photojournalist, Sedge's clients span the globe, from Cape Town to Chicago, Houston to Heidelberg, Manila to Manchester, and Sydney to Singapore. His success in

international sales led to his self-published book, *Double Your Income through Foreign & Reprint Sales*. Allworth Press then released his *Writer's & Photographer's Guide to Global Markets*. Sedge's other titles from Allworth include *Marketing Strategies for Writers* and *Successful Syndication*.

Contributing Photojournalists

Randa Bishop
9720 Camden Hills Avenue
Las Vegas, NV 89145 USA
Tel. 702-240-4777
Fax. 702-240-4747
E-mail. *randa@pobox.com*
Web site. *www.randabishop.com*

Born in Manhattan, Randa Bishop has specialized in travel photography and photo feature stories for more than two decades.

"I was on a travel writing assignment in Brazil, when an acquaintance gave me a pocket camera. It was love at first sight. I knew I had found my niche," she says. "And after a decade as a marketing executive in the cruise line business, I turned to professional photography."

Bishop has since photographed in many countries and tourist destinations throughout the world, and on over fifty islands. "My photographs are representative of my love of travel, the world's diverse scenery, and the beautiful people who inhabit our earth."

Randa's photographs have illustrated numerous books and publications around the world, including *Islands, MD Magazine, National Geographic World, Travel & Photography, Relax Magazine,* and twenty-two guidebooks in the *Travel Bug* series.

She has been honored with Kodak's "Professional Photographer's Showcase Award"; as a result, her work was exhibited at Epcot Center in Orlando, Florida, and she was one of the honored photographer's included in *Ten Thousand Eyes*—the book celebrating the 150th Anniversary of Photography. She has had solo exhibitions in Washington, DC; New York City; Athens, Greece; and on the island of Patmos, Greece. Her photographs have been shown in museums, such as the Smithsonian and in the Monastery of St. John of Patmos Treasury.

A selection of her photographs of Patmos, Greece, is on permanent display at the Scala Hotel in Patmos, and in Periyali restaurant in New York City.

She is a member of the Travel Journalist's Guild and the American Society of Media Photographers.

Jim Bryant

4440 Marlyce Court SE

Port Orchard, WA 98366

Tel. 360-874-9132

E-mail. *phojo@oz.net*

Web. *www.oz.net/~phojo*

Over the past two decades, Jim Bryant has won over fifty awards for excellence in photojournalism, including the Chief of Naval Information Award, the Military Photographer of the Year Award, and several prizes awarded by the Washington Newspaper Publishers Association.

"Like my love affair with my wife, photojournalism has been one of my great passions, and has made life worthwhile," says the 1983 Pulitzer Prize nominee. "I am convinced that, in the long run, that passion for the work is probably the most necessary ingredient that will produce a successful photojournalist. Only passion can provide the drive to keep you shooting effectively toward the end of an exhausting, sixteen-hour day. It is passion that forces you to wade through a muddy ditch with cameras held high overhead, hoping the angle will be better from the other side. And when the thrill of being published subsides, and the realization sets in that the big bucks are in advertising, it is only passion that can cushion the letdown. And the knowledge that somehow, some way, you are taking pictures that matter.

Bryant currently lives in Washington, where he is senior photographer for Sound Publishing's *Port Orchard Independent.*

Rohn Engh
PhotoSource International
Pine Lake Farm
1910 35th Road
Osceola, WI 54020
Tel. 715-248-3800
Fax. 715-248-7394
E-mail. *psi2@photosource.com*
Web. *www.photosource.com*

Rohn Engh, founder and director of PhotoSource International, is one of the country's most published stock photographers, a photo columnist, and a seminar presenter. He is the author of *Sell & Re-Sell Your Photos* (over 100,000 copies sold), considered by both veteran photographers and newcomers to be the premiere desktop guide for the stock photographer. His new book, *sellphotos.com,* has already also received outstanding reviews.

In 1988 Engh pioneered using a daily fax bulletin to send his subscriber photographers the stock photo listings of magazine and book photo editors. Earlier, in 1983, he was among the first to use the groundbreaking online service, NewsNet, to deliver his products and services to his customers.

Engh lives on an eighty-acre Wisconsin farm with his wife, Jeri, a writer whose articles have appeared in *Reader's Digest, Saturday Review, Redbook,* and many other magazines plus newspapers. Jeri is editorial director of PhotoSource International.

Phil Norton
3 Hillcrest
Chateauguay, QC
J6J 3P6 Canada
Tel/Fax. 450-692-5701
E-mail. *phil@philnorton.com*
Web. *www.philnorton.com*

Phil Norton is a contract photojournalist and stock photo administrator for *The Gazette,* Montreal's English-language daily newspaper. He resides in southwestern Quebec Province, with his wife and three children. He immigrated to Canada in 1981 from his native Mars, Pennsylvania, USA. In 1986 he launched a handmade, photo greeting card line and in 1987, he joined Valan Photo Agency. His favorite photography and writing subjects include the Canada-U.S. border, environmental issues, the maple syrup industry, and regional documentaries that have appeared in *Time, Canadian Geographic, Reader's Digest,* and *Adirondack Life Magazine* as well as a number of books, including Towery's *San Diego* and *Montreal.* Norton produced a self-published color photo calendar as a Year 2000 project, donating 100 percent of the profit to charity. He is currently preparing to commercialize his personal Web site for the sale of his greeting cards and stock images at *www.philnorton.com.*

W. Lynn Seldon Jr.
113 N. Shields Ave.
Richmond, VA 23220
Tel. 804-254-1942
Fax. 804-254-1943
E-mail. *lynn@lynnseldon.com*
Web. *www.lynnseldon.com*

Lynn Seldon has been a full-time freelance travel writer and photographer since leaving the U.S. Army in 1996. He got his start with *Stars & Stripes* in Europe. He now averages more than fifty articles and hundreds of pictures published annually. His credits include: *USA Today,* the *L.A. Times,* the *New York Post, Golf Magazine, Travel & Leisure Golf, Golf & Travel, Backpacker, Ski Magazine, Caribbean Travel & Life, American Heritage, Travel America, Skin Diver,* and more than four hundred other publications. He has published eight writing/photography books and his most recent book, *Country Roads of West Virginia,* was published by NTC. He was also the sole contributor for a Virginia photography calendar. A Virginia native, he is based in Richmond, Virginia.

Robert Schwartz

Via Franza, 3

10010 Lessolo (TO) Italy

Tel. +39-0125-58100 (home)

Tel. +39-0125-56210 (office)

Fax. +39-0125-58671

E-mail. *bob@dido.net*

Born in Beckley, West Virginia, the eldest of an family of eight children, Bob Schwartz began taking photographs when he was ten years old as part of a 4-H project.

"I noticed almost right away that I seemed to have a knack for photography," says Schwartz. "Shortly afterward I sold a couple of prints to friends, and that's when I knew I wanted to be a professional photographer."

After serving in the U.S. Navy, then spending several years traveling and working in the Far East, he set up shop in Honolulu, Hawaii, where he pursued a dual career in advertising and photojournalism. He moved to Italy in 1981, propelled by a desire to see Europe, and has lived there since. He currently resides in a small village north of Turin with his partner, Flavia Capra, whom he met in Milan in 1987.

Although Schwartz's work has appeared in a variety of media outlets—from CBS television to Barron's pet series to the Iams company's advertisements—since 1988 he has specialized in taking photographs of cats and dogs for a number of

books and magazines, both general interest and specialty. He has been included in *Who's Who in the World* (1999 and 2000) as well as *Outstanding People of the 20th Century* (1999 and 2000), published by The International Biographical Centre, Cambridge, England.

Robert Wickley
4006 Misty Glade
San Antonio, TX 78247
Tel. 210-602-9910
Fax. 240-331-0865
E-mail. *bob@wickley.com*

Bob Wickley has been a photographer for over thirty years. He began playing with cameras while still a boy and the magic of photography has captured his interest and energy ever since. His career in photography began in the U.S. Air Force, where he was a combat photographer in Vietnam. He took part in over sixty combat photo missions there. He continued his career in the Air Force after completing photojournalism studies at Syracuse University. Wickley has received assignments from Pacific *Stars & Stripes* in Tokyo and Allied Forces Southern Europe (NATO) Headquarters in Naples, Italy; he's been given combat camera assignments in California; and he has worked as an Air Forces advertising photographer. During his career, he has traveled extensively to every continent and fifty countries and has flown in nearly every Air Force aircraft capable of carrying a photographer.

For the past several years, Bob has pursued a career as a corporate/commercial and stock photographer based in San Antonio, Texas. He jumped on the digital bandwagon six years ago. Today, digital imaging makes up nearly half of his photography business.

Index

Books from Allworth Press

The Writer's and Photographer's Guide to Global Markets by Michael Sedge (softcover, 6 × 9, 292 pages, $19.95)

The Photographer's Guide to Marketing and Self-Promotion, Second Edition by Maria Piscopo (softcover, 6¾ × 10, 176 pages, $18.95)

How to Shoot Stock Photos That Sell, Revised Edition by Michal Heron (softcover, 8 × 10, 208 pages, $19.95)

Pricing Photography: The Complete Guide to Assignment and Stock Prices, Second Edition by Michal Heron and David MacTavish (softcover, 11 × 8½, 152 pages, $24.95)

Business and Legal Forms for Photographers, Revised Edition by Tad Crawford (softcover, 8½ × 11, 224 pages, includes CD-ROM, $24.95)

The Law (in Plain English) for Photographers by Leonard Duboff (softcover, 6 × 9, 208 pages, $18.95)

ASMP Professional Business Practices in Photography, Fifth Edition by the American Society of Media Photographers (softcover, 6¾ × 10, 416 pages, $24.95)

Photography Your Way: A Career Guide to Satisfaction and Success by Chuck DeLaney (softcover, 6 × 9, 304 pages, $18.95)

Creative Black-and-White Photography: Advanced Camera and Darkroom Techniques by Bernhard J Suess (softcover, 8½ × 11, 192 pages, $24.95)

Mastering Black-and-White Photography: From Camera to Darkroom by Bernhard J Suess (softcover, 6¾ × 10, 240 pages, $18.95)

Historic Photographic Processes: A Guide to Creating Handmade Photographic Images by Richard Farber (softcover, 8½ × 11, 256 pages, $29.95)

Travel Photography, Second Edition by Susan McCartney (softcover, 6¾ × 10, 360 pages, $22.95)

Re-Engineering the Photo Studio: Bringing Your Studio into the Digital Age by Joe Farace (softcover, 6 × 9, 224 pages, $18.95

Please write to request our free catalog. To order by credit card, call 1-800-491-2808 or send a check or money order to Allworth Press, 10 East 23rd Street, Suite 510, New York, NY 10010. Include $5 for shipping and handling for the first book ordered and $1 for each additional book. Ten dollars plus $1 for each additional book if ordering from Canada. New York State residents must add sales tax.

To see our complete catalog on the World Wide Web, or to order online, you can find us at *www.allworth.com*.

The Photojournalist's Guide to Making Money